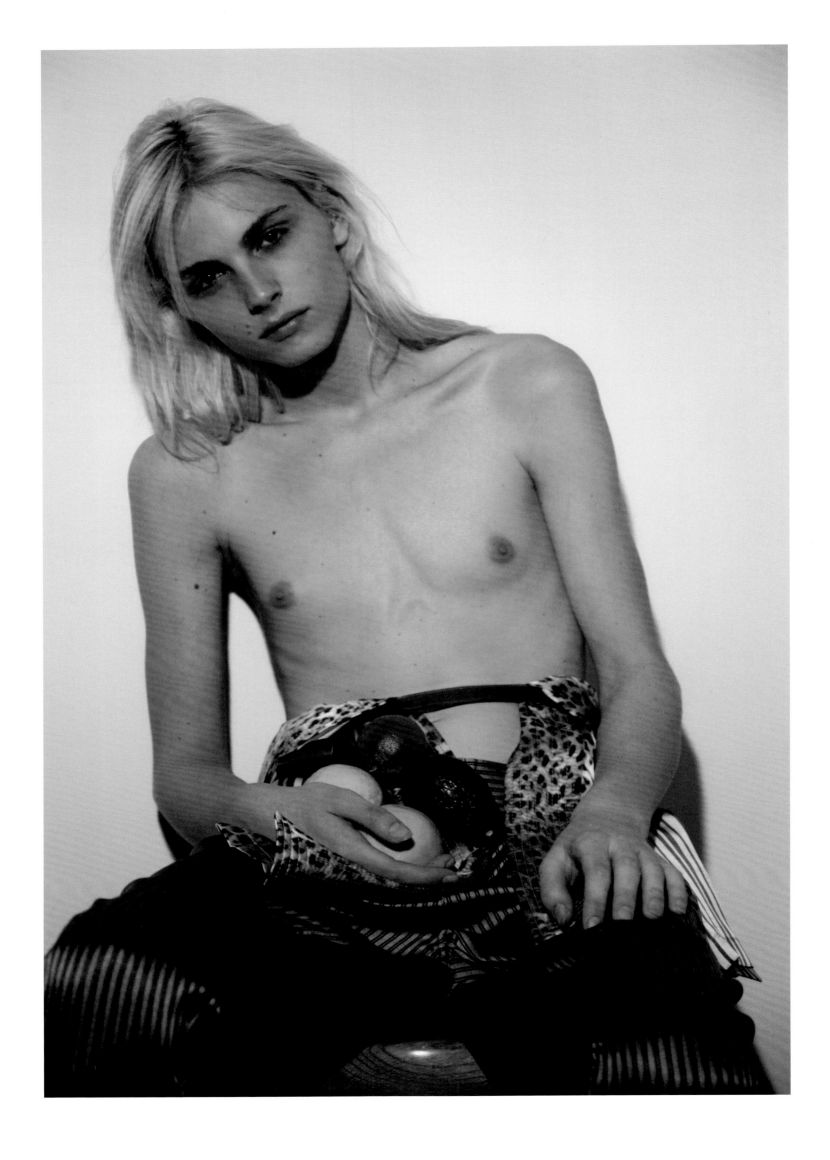

Andreja Pejić, *Dossier*, 2011. Photograph by Collier Schorr

Patrick Mauriès

ANDROGYNE

Fashion + Gender

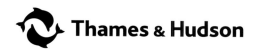
Thames & Hudson

'*He is attractive to those who see the woman
in him, to those who perceive the man,
and to others whose souls are moved
by the supernatural sex of beauty.*'

Jean Cocteau, *Deux travestis*, Paris, 1926

CONTENTS

Hermaphroditus and Silenus, Roman fresco, Pompeii, Italy, AD 45–79

BENEATH
THE VEIL

The distant origins of this book probably lie in a case of hiccups in Athens in the fifth century BC. The hiccups were those of the comic dramatist Aristophanes, caught just as he was getting ready to speak in Plato's *Symposium*. After recovering, he went on to describe a strange vision of love that combined a primordial cosmogony, the influence of the moon, the patience of the god Apollo and bizarre spherical creatures with four arms and four legs, who were the original – and androgynous – form of humanity.

We shall come back to this incongruous attack of hiccups, which shifted the tone and the nature of the conversation between the *Symposium*'s guests, and which has been the subject of endless discussion and varying interpretations. A strange speech, a strange theme, a strange figure: it is hardly surprising that the androgyne, the very embodiment of duality, ambivalence and fundamental confusion, should have had such a disconcerting first exposition in western culture.

More prosaically, at the other end of the temporal and cultural spectrum, the perhaps trivial – but nonetheless crucial – driving force behind this book can be traced to what I would call the flood of androgyny that occurred at the turn of the new millennium, especially in fashion images – runway shows, photo shoots, magazines and advertising. This era seems to echo the *fin-de-siècle* of the nineteenth century, years which lent their name to a period in art history that also made great use of androgyny as a motif, in contexts ranging from Symbolist literature and painting to esoteric and neo-mystical movements.

It would be impossible to list all the articles, newspaper columns, magazine covers and artists' portfolios that have been devoted to some aspect of this phenomenon, particularly since the 1990s. Their sheer volume alone justifies the recognition of this theme as one of our era's most persistent motifs – if not one of its mythologies – and calls for explanation, reflection and analysis.

Ambiguous and ambivalent, androgyny has been of central importance not only in mythology, philosophy, religion, mysticism, alchemy and biology, but also in sociology, literature and the visual arts; the idea of approaching it through the lens of fashion may seem at the very least tangential. But this would be wrong. While it took all the penetrating intellect and perseverance of figures as eminent as the sociologist Georg Simmel in the early twentieth century, the psychologist John Carl Flügel in the 1930s, and the cultural historian Anne Hollander and the semiologists of the 1970s to recognize the full semantic significance of fashion, and its status as a cultural object, today it is impossible to deny the importance of its message or its role. One could even argue that there has been a degree of overexposure of the subject, due to its dominance of the media, and its control by a handful of corporate conglomerates vying with each other for the largest share of the market.

In the interests of streamlining the text, footnotes have not been included. However, interested readers can find sources and bibliographical references listed at the end of the book.

When the blond and ethereally slender bride closing the Jean Paul Gaultier spring-summer haute couture collection in January 2011 turns out to be a male model, one of the first to walk for both the men's and women's collections, or when the son of a famous Hollywood actor appears in a leading luxury brand's 2016 ad campaign in a dress, nail polish and eye shadow, it tells us something fundamental about the spirit of the age. Choosing a particular selection of fabrics, dusting oneself with a cloud of powder, reshaping the face with make-up, hoisting oneself up on high heels, enjoying the glitter of jewels, whether real or fake: these are not gestures of mere frivolity and assumed femininity, but declarations, uncompromising expressions (not for nothing do we talk of the 'language of clothes'). They are a way – the most immediate and most visible way – of declaring who we are and what we believe or want to be. They are a statement that challenges the very notion of identity. 'What has primacy in everyday life is the gender that is performed, regardless of the flesh's configuration under the clothes,' observed the psychologist Suzanne Kessler, commenting on the biologist Anne Fausto-Sterling's influential essay 'The Five Sexes: Why Male and Female Are Not Enough' (1993). The poet and philosopher Paul Valéry famously said that the deepest thing about man is his skin, but it seems that what we wear is even deeper.

For over half a century now, the notion of gender has been subject to constant questioning, and it is no coincidence that the theory of deconstruction should find its logical extension in the discipline of gender studies. The feminist Simone de Beauvoir, when discussing the construction of female identity in *The Second Sex* (1949), first distinguished between biological sex (which is 'natural') and gender (which is social and cultural). One of the most significant consequences of this approach was to emphasize the fundamental autonomy of these two concepts, despite the fact that centuries of metaphysical tradition had merged them together within a definition of personal identity that reflected an unchanging and unchangeable natural order.

This is the illusion that we have seen shattered in the last decades. Despite some reactionary voices continuing to be raised, the established order has been radically transformed, conclusively undermining any remaining belief in a 'natural' state and affirming that every 'fact' (not least that of 'sex') is a historical and social construct derived from a series of representations. In short, there is no such thing as a fixed identity. 'Gender' comes before 'sex'.

The following book sets out to represent this truth in an informal, even naive manner. Its illustrations provide a thread that we can follow, teasing out a few explanations and unpicking certain contexts or preconceptions – whether conscious or otherwise – as we pause to examine particular aspects of a topic that by its very nature is elusive and unsettling. In doing so, we will approach it primarily from an *aesthetic* (in the widest possible sense) point of view and via a literary form that in itself is ambiguous, uncertain, stylistically fluid and falls between genres: the essay.

Gustave Moreau, *Hesiod and the Muse*, oil on wood, 1891

'A LENGTH OF HORSEHAIR TWINE'

The comic playwright Aristophanes' contribution to Plato's *Symposium* is literally out of order. In this account of an account of a party at which seven speeches are made on the theme of love, the first to speak on the subject is the aristocrat Phaedrus, who talks about emulation between the lover and the beloved and the exaltation of courage as both the driving force and the highest expression of passionate love. Then comes the pedantic Pausanias, who contrasts the love inspired by the goddess Aphrodite Pandemos (vulgar Aphrodite) – indiscriminate, base, unseemly and focused only on pleasure – with that of Aphrodite Urania (heavenly Aphrodite) – virtuous and elevated, between lovers who once again seek to emulate each other. Next, the physician Eryximachus steps in to take the place of Aristophanes, who is afflicted with the hiccups ('Eryximachus' means 'belch-fighter'); he takes a medical, physiological and natural approach, but also contrasts a balanced form of love that is truly fulfilled with one that is unbalanced and self-indulgent.

Finally, it is the turn of Aristophanes. Abandoning the straightforward and analytical style of the earlier speeches, his contribution takes the form of a fable and a creation myth. 'In the beginning,' he explains, 'there were three types of people: the two sexes, who still exist, and a third, composed of the first two and comprising them both. This third type were called androgynous: they have since vanished, leaving only their name as a term of reproach. All of these people were spherical in shape, with their shoulders and ribs joined together, and four legs, four arms and two faces, facing in opposite directions and exactly alike, emerging from a single neck and belonging to a single head.'

The threatening arrogance of this spherical race incurred the wrath of the supreme god Zeus, who set out literally to cut them down to size. But instead of slaying them with a thunderbolt, as he had their enormous predecessors the Titans, he chose to slice them in half 'as you would slice through an egg with a length of horsehair twine', separating them into two halves that were fated to search desperately for their missing portion. 'Each of us is therefore only half a person, a half that has been separated from its whole, with one side only, like a flat fish.'

Karolina Kurkova and Andreja Pejić for Jean Paul Gaultier.
Photograph by Inez & Vinoodh

For Aristophanes, the perfection of love has less to do with the power of admiration, and the need to excel under the beloved's gaze, than with a pull towards fusion and an impossible reconciliation. What the androgyne embodies is nostalgia in the earliest sense of the word: a longing to return home. 'Our species may find happiness if we carry love through to its fulfilment and if each of us meets the beloved who is his alone, so rediscovering his original nature,' postulates the playwright loftily.

Ironically, in view of the qualities later associated with androgyny, of the three types of 'more than complete' beings that made up the primordial human race in Aristophanes' tale, the androgynous type is the least perfect because of its hybrid nature, and because it is the source of heterosexual desire: 'The men that are born of this combination of the two sexes, known as androgynous beings, love women, and most adulterers belong to this group, as do women who love men.' In Aristophanes' vision of the world, which was shared by most of the other guests at the *Symposium*, and is diametrically opposed to our own, desire is not satisfied by the lack of symmetry and the complementary differences between the two sexes, but instead by the tension that draws like to like, the attraction of women for other women, and – even more desirable – of men for other men.

In this hierarchy of love, the difference between the three types was originally an echo of the fundamental arrangement of the cosmos: 'the male sex is produced by the sun, the female sex by the earth, and the combination of the two by the moon, which is made up of both the earth and the sun'. Following a principle found in many different circumstances and cultures throughout history, the constitution of each individual, and their personal (and sexual) identity, were indissolubly linked with the world order, forming part of an interplay of correspondences that gave legitimacy and structure.

This hierarchy was later justified by varying degrees of 'nobility', purity and truth. The relationship between the male lover and his male beloved surpassed the vulgar liaisons personified by Aphrodite Pandemos, because its goal was not 'the shameful act of reproduction'. 'They have no desire to marry and have children,' says Aristophanes of the male lover and beloved, 'and do so only to satisfy convention; they prefer bachelor life with their friends.' The superior love embodied by Aphrodite Urania did not seek to perpetuate itself through procreation, and thus avoided the illusion of a false eternity, the simple opposite of death. Instead it transcended the pleasure of the senses, culminating in 'what their soul cannot express, what it merely divines, and what it may express enigmatically through its prophetic transports'.

One of the fundamental texts of western thought, the *Symposium* has been the subject of endless theories and interpretations. But it is less important here for its overall philosophy than for its influence in the field of aesthetics, particularly via its rediscovery in the Renaissance and Baroque. This included the writings of esoterics and mystics such as the doctor Jean Liébault, who wrote of Aristophanes' fable in his *Treasury of Secret Remedies for Women's Maladies* (1585): 'Through this imaginary history, Plato demonstrates the violence of the sin that sunders one to make two: and the power of love, which in reconciling and restoring the two halves makes them one again, and drives each of the two halves to come together to make a single whole.' Most notably, the Platonic commentaries of the fifteenth-century humanist Marsilio Ficino had a profound influence on the artists working at the court of the Medicis, and, through them, on Pre-Raphaelite and Symbolist art in the second half of the nineteenth century.

But before we follow the thread of some of these texts, it is worth reminding ourselves of some of the themes from the *Symposium* itself: the sublime nature of sterility, a quest for unity through fusion, a return to the original state of humanity, and also the influence of the moon on the human body. Through these elements, Aristophanes' speech lays out a typology of desire that history, literature and criticism have never tired of debating – particularly where the idea of androgyny has been concerned.

A BODY
OF IVORY

Along with androgyny, another of the core ideas of Aristophanes' speech in the *Symposium* is youth. It lay at the heart of the supposedly 'superior' relationship between the lover, a mature man, and the beloved, an adolescent boy, with the youth being expected, with the passage of time, to take on the adult role with a new, younger partner; from this viewpoint, youth was the main driving force and dynamic of a loving relationship. It is even more central in the description, by Pliny in the first century AD, of 'monstrous births of various kinds', where youth becomes the locus of ambivalence and confusion between the sexes.

Also from the first century AD, the story of Hermaphroditus in Ovid's *Metamorphoses* is one of the most remarkable classical accounts of androgyny. It is interwoven with many of the threads that are entangled with the idea of androgyny throughout history – among them, youth. Hermaphroditus, as the Plato expert Luc Brisson notes, 'has barely reached the age of puberty, for he is only fifteen years old.… As an adolescent, he is not yet included in the man/woman opposition, for his is still a state of disturbing indistinction.'

According to Ovid, Hermaphroditus is the son of the deities Mercury (Hermes) and Venus (Aphrodite) and is the embodiment of innocence. He loves to roam and one day, with the curiosity of youth, discovers a spring that is home to the indolent and solitary water nymph Salmacis:

> *As any boy*
> *That heedless deems his mischief unobserved,*
> *Now here now there, he rambled on the green;*
> *Now in the bubbly ripples dipped his feet,*
> *Now dallied in the clear pool ankle-deep; –*
> *The warm-cool feeling of the liquid then,*
> *So pleased him, that without delay he doffed*
> *His fleecy garments from his tender limbs.*
> *Ah, Salmacis, amazement is thy meed!*
> *Thou art consumed to know his naked grace!*
> *…Quickly disrobed,*
> *She plunged into the yielding wave – seized him,*
> *Caressed him, clung to him a thousand ways,*
> *Kissed him, thrust down her hands and touched his breast….*

Carried away by her passion, Salmacis seizes the boy in her arms and implores the gods never to separate her from him:

Propitious deities accord her prayers:
The mingled bodies of the pair unite
And fashion in a single human form.
So one might see two branches underneath
A single rind uniting grow as one:
So, these two bodies in a firm embrace
No more are twain, but with a two-fold form
Nor man nor woman may be called – Though both
In seeming they are neither one of twain.
When that Hermaphroditus felt the change,
So wrought upon him by the languid fount,
Considered that he entered it a man,
And now his limbs relaxing in the stream
He is not wholly male, but only half, –
He lifted up his hands and thus implored,
Albeit with no manly voice; 'Hear me
O father! hear me mother! grant to me
This boon; to me whose name is yours, your son;
Whoso shall enter in this fount a man
Must leave its waters only half a man.'

This ambiguous dual body, according to the great eighteenth-century art historian Johann Joachim Winckelmann, was the underlying principle of classical art, and a model of incomparable aesthetic beauty, which sought 'to express in the mixed nature of the two sexes an image of higher beauty; this image was ideal.' The composite art form based on the image of the androgynous body shared with it the quality of youth, as Winckelmann explained: 'The most beautiful forms, thus selected, were, in a manner, blended together, and from their union issued, as by a new spiritual generation, a nobler progeny, of which no higher characteristic could be conceived than never-ending youth'. This immutable agelessness was embodied in figures such as the god Bacchus (Dionysus): 'The forms of his limbs are soft and flowing, as though inflated by a gentle breath, and with scarcely any indication of the bones and cartilages of the knees, just as these joints are formed in youths of the most beautiful shape, and in eunuchs.'

The essential youth of the androgynous figure did not merely indicate confusion or ambiguity; it also embodied the physiology of a fluid, jointless body: what the literary theorist Roland Barthes would have called 'the seamless'. This body was immaculate too, as seen in Ovid's tale of Hermaphroditus, where the first sign of a form of sexual neutrality, even before the metamorphosis takes place, is the snowy whiteness of the adolescent's body, like 'a statue's ivorine' or 'a lily in a lake of glass'. Such translucency carries connotations of ambiguity, since in many cultures a delicate skin, milky complexion and unblemished body remained, well into the twentieth century, the characteristic traits not only of an aristocratic body, protected and never exposed, but – on a more fundamental level still – also of a feminine one.

A striking example of this can be found in Honoré de Balzac's novella *Sarrasine* (1830), which Roland Barthes famously analysed in *S/Z* (1970). The central character, La Zambinella (actually a castrato opera singer), is described as follows: 'Her mouth was expressive, her eyes loving, her complexion dazzlingly white.... The artist never wearied of admiring the inimitable grace with which the arms were attached to the torso, the marvelous roundness of the neck, the harmonious lines drawn by the eyebrows, the nose, and the perfect oval of

the face, the purity of its vivid contours and the effect of the thick, curved lashes which lined her heavy and voluptuous eyelids. This was more than a woman, this was a masterpiece!'

This unique body, ambiguous, unsettling and more than human, is a source of fascination to the novella's eponymous hero, who turns it into a much admired (and wholly fictional) sculpture, described as a 'monument to his folly'. The statue is said to have been copied (again fictitiously) by the artist Joseph-Marie Vien in 1791, as well as to have inspired Anne-Louis Girodet's actual painting of the same year, *The Sleep of Endymion*, which is one of the most memorable images of androgyny in art. As Barthes observed, everything in Girodet's depiction of the sleeping Endymion – a mortal shepherd boy with whom the moon goddess Selene falls in love – connotes femininity: 'the "exquisite grace", the "contours" (a word used only for the flaccid academic paintings of romantic women or mythological ephebes [youths]), the elongated pose, slightly turned, open to possession, the pale and diffuse color – white (beautiful women of the period were always very white), the abundant, curling hair'. The moonlight acts as a revelatory force on this initial denaturing, distilling and intensifying the essential ambiguity of youth and creating an image that inverts the established order of things: 'In love with Endymion, Selena [*sic*] visits him; her active light caresses the sleeping and unprotected shepherd and steals into him; although feminine, the Moon is active; although masculine, the boy is passive'.

Just over fifty years after the publication of *Sarrasine*, this pale and languid figure, the embodiment of an overlap between the sexes, was turned into the mainspring of another striking fictional treatment of gender confusion. It was written by Rachilde (the pen name of Marguerite Eymery), a now-forgotten novelist who was a prominent literary figure in late nineteenth-century France. In *Monsieur Vénus* (1884), the hero, a beautiful red-haired young man with translucent skin, is the plaything of the imperious and masculine noblewoman Raoule de Vénérande. The twisted sensuality and the various forms of unabashed androgyny displayed by the characters ensured a *succès de scandale* for both the book and its author, as well as a special place in the Decadent movement – to which we will return later.

THE INVERTED BODY

Alongside the masculine form of erotic love lauded in the *Symposium*, the classical world used a physiological and medical model that was also based on the male body. According to the Greek physician Galen in the second century AD, a central authority for classical medicine, every part of the male anatomy was also found in the female. 'There was only one point of difference,' observes the historian of medicine Jackie Pigeaud: 'starting from the region known as the perineum the female parts were internal and the male parts external'. In various incarnations, this model dominated western descriptions of human anatomy until the Enlightenment: instead of drawing a distinction between the two sexes on the basis of their respective configurations and unique features, it brought them together as an invisible unified whole, and shaped and controlled the definition of the androgynous body until the dawn of the modern era.

Basing his arguments on a close study of the philosophical and medical literature from Galen to the influential sixteenth-century anatomists Andreas Vesalius and Ambroise Paré (together with the accompanying illustrations), the historian Thomas Laqueur in his study *Making Sex: Body and Gender from the Greeks to Freud* (1990) provides an intriguing demonstration of one of the central tenets of Nietzsche's thought (following Schopenhauer): that of the primacy of the representation of reality over its supposed innate truth. This primacy conditions our gaze and is particularly important in the case of androgyny, which does not appear to be 'what it is' and could therefore be defined as a form of visual disturbance or optical illusion. Indeed, in eighteenth-century legal treatises, transvestism – another form of confusion between the sexes, as we shall see – was called the 'crime of falsity' or 'falsity in deed'.

'Profoundly dependent on cultural meanings', the model of the 'one-sex body', in Laqueur's words, was set within a wider world view; it 'served both as the microcosmic screen for a macrocosmic, hierarchic order and as the more or less stable sign for an intensely gendered social order'. It was a fundamental locus of the correspondence between the elements of the cosmos, between the worlds above and the worlds below, between the infinitely vast and the infinitely small, which indirectly shaped the structure of society.

This ancient model also reflected the theory of the humours, which saw the female body as 'inferior' because it was more 'cold' and 'moist' than the male body, with the difference between the sexes somehow obeying a thermodynamic principle that generated different amounts of heat. This theory explained physical constitution, as women 'were essentially men in whom a lack of vital heat – of perfection – had resulted in the retention, inside, of structures that in the male are visible without'. The indirect result of this was a continuity between the sexes, meaning that there were 'hirsute, virile women – the virago – who are too hot to procreate and are as bold as men; and there are weak, effeminate men, too cold to procreate and perhaps even womanly in wanting to be penetrated'. Following such reasoning, the seventeenth-century physician (and metaphysician) Sir Thomas Browne observed that there were some animals, such as the hare, that could naturally change their sex, as could humans: 'As for the mutation of sexes, or transition into one another, we cannot deny it in Hares, it being observable in man: for hereof beside Empedocles or Tiresias, there are not a few examples; and though very few, or rather none which have emasculated or turned women, yet very many who from an esteem or reality of being women have infallibly proved men: some at the first point of their menstruous eruptions, some in the day of their marriage, others many years after: which occasioned disputes at Law, and contestations concerning a restore of the dowry'.

In a world where, as Laqueur explains, 'girls could turn into boys, and men who associated too extensively with women could lose the hardness and definition of their more perfect bodies and regress into effeminacy', the body occupied a sliding scale depending on the strength of its internal heat; it could be subject to substantial variations, and was 'far less fixed and far less constrained by categories of biological difference than it came to be after the eighteenth century'. This apparently paradoxical mobility, within a world view that was otherwise rigidly hierarchical and fixed, resulted in the primacy of gender over genitals, or biological sex. According to Laqueur: 'in these pre-Enlightenment texts, and even some later ones, sex, or the body, must be understood as the epiphenomenon, while gender, what we would take to be a cultural category, was primary or "real." Gender – man and woman – mattered a great deal and was part of the order of things; sex was conventional.... To be a man or a woman was to hold a social rank, a place in society, to assume a cultural role, not to be organically one or the other of two incommensurable sexes.'

It is, however, impossible to compare this plasticity and tension between sex and gender with the resistance to traditional categories and the demand for greater fluidity of roles that are now shaking contemporary society, and which are the chief subject of this book. In fact, they seem to be diametrically opposed: while mobility within the model of the one-sex body was a social, political and cultural phenomenon, nowadays it derives its authority primarily from psychological truth, subjective authenticity and unprecedented demands for society's acceptance. If there is any overlap between the two viewpoints, it lies in the repeated demonstration that the 'nature' of sex is never simply 'biological', but is always the result of discourse; in other words, it is relative and cultural. 'Sex, in both the one-sex and the two-sex worlds, is situational; it is explicable only within the context of battles over gender and power.'

Striking evidence of this relativity may be found in the remarkable persistence and resistance of the model of the one-sex body over the centuries, which challenged the gaze and shaped – or even distorted – scientific observation. It was not until the move towards greater scientific freedom during the Renaissance, as seen in some of Leonardo da Vinci's famous drawings, that these limitations were overcome. Even empirical evidence – in this case, anatomical dissection of the human body – was constrained by belief: 'Seeing is believing the one-sex body. Or conversely,' summarized Laqueur. The visual and sometimes organic disturbance represented by the androgynous body could not escape this blinding simplification: it all boils down to a difference in temperature.

OPPOSING
ANATOMIES

According to Thomas Laqueur, 'in or about the late eighteenth [century]…human sexual nature changed.' The androgynous figure was no exception: 'thus the old model, in which men and women were arrayed according to their degree of metaphysical perfection, their vital heat, along an axis whose telos was male, gave way by the late eighteenth century to a new model of radical dimorphism, of biological divergence. An anatomy and physiology of incommensurability replaced a metaphysics of hierarchy in the representation of woman in relation to man.' With this radical change of perspective, the one-sex body of gradations was erased by a body made up of contrasts: the role that formerly had been accorded to gender by culture was now attributed entirely to nature and biological sex: 'Sex, in other words, replaced what we might call gender as a primary foundational category.' And thus a paradigm was established that remained undisputed until a few decades ago.

Based on observations and descriptions of increasing precision, the scientific approach of the eighteenth century asserted the existence of an intractable opposition between two bodies, two anatomies, two physiologies united only by a common regard for reason. But immediately it found itself confronted with a dilemma: 'how to legitimate as "natural" the real world of male dominion of women'. This became a key subject of discussion for the great female activists of the French Revolution, such as Théroigne de Méricourt and Olympe de Gouges, and a matter of indignation for philosophers like Nicolas de Condorcet, who from 1790 onwards denounced the contradiction between the proclamation of the universal rights of man and the absence of the rights of women. But progress, the recognition of otherness and the switch from one paradigm to another did not preclude the continuing subjugation of women, the legal enshrinement of which remained in force until the twentieth century. That is to say, there was a new kind of hold over the imagination, positioning 'reality' within a discourse that counteracted perception.

The late seventeenth and eighteenth centuries provided further evidence of the fact that 'two sexes are not the necessary, natural consequence of corporeal difference' in the lives of the flamboyant transvestites (another aspect of androgyny) who punctuated the history and literature of the period, from Philippe, Duc d'Orléans (younger brother of Louis XIV), to the Abbé de Choisy, and from the Abbé d'Entragues to the Chevalier d'Éon. At this time, the very idea of 'woman' was being defined in essays such as Charles

de Saint-Évremond's *The Character of a Woman: That Never Was, and Never Will Be* (1668) and poems like those in Lorenzo Magalotti's collection *The Imaginary Lady* (published posthumously in 1762), among other expressions of this reality of anatomical differences. But it was also the time when the ideal's shadow image was both asserted and played with through the dissociation of outward appearance and inner being that was represented by transvestism. Transforming and disguising one's body in this way meant besmirching the image of God through his creations and disobeying biblical strictures: 'The woman shall not wear that which pertaineth unto a man, neither shall a man put on a woman's garment: for all that do so are abomination unto the Lord thy God.' It meant being guilty of the 'crime of falsity' (as mentioned earlier), or of 'impersonation by means of disguise'. 'Transvestism separates the biological order of the body from the external signs that are attached to that biological order,' the historian of gender Sylvie Steinberg explains. 'In so doing, it reveals that some signs that seem to be linked to the sexualized body may in fact be separated from it; at the same time, these signs appear to be artificial or, to use an eighteenth-century term, "instituted".'

The 'denaturing' of the visible that can be found in masquerades and carnival festivities – which were a distinguishing feature of seventeenth- and eighteenth-century fashion- able society – has always had the power to challenge and subvert the established order; it flouts the rules, reverses roles, turns the world upside down, albeit in a temporary fashion. Thus, although the epicene figures of the period reflected 'a hierarchical conception of the difference between the sexes' – which Enlightenment philosophy did not overturn – they reduced it to a handful of signs that they used in a playful manner: the way a garment was worn, the use of cosmetics and beauty patches, gestures and what Steinberg more generally calls 'bodily habits', quoting the memoirs of the Abbé de Choisy: 'I had pierced ears, diamonds, mouches [beauty patches], and all the other little affectations that are easy to become accustomed to and difficult to give up.'

Steinberg also quotes the lawyer Gayot de Pitaval, who refers in his compendium of *Celebrated and Interesting Cases* (1735–89) to 'a person's air', the '*je ne sais quoi* that every- one understands and no one can explain', to describe the straightforward self-presentation that the 'dupery' of transvestism disrupted. 'As a sign of sex, social rank, dignity, age and so forth,' Steinberg makes clear, 'dress ought to provide infallible information'. It is therefore legitimate to wonder whether the 'modesty' and 'reserve' that were thought to be 'natural' in women – expectations that lasted well beyond the eighteenth century – were not so much the cause as the effect of the tightly corseted garments imposed by fashion, of the gestures they made necessary, and of the reshaping of their silhouettes.

The remarkable life of the Chevalier d'Éon (to which we shall return later) offers, among many other things, a perfect illustration of the importance of this kind of decorum when defining a sense of assumed femininity. The Chevalier – or Chevalière – ran the full gamut of guises, from the ravishing ingénue whose delicate charms and exquisite manners at the Russian court in 1756 teased or seduced the Tsarina Elizabeth, her surly advisor Count Bestuzhev and the French ambassador, to the coarse-mannered virago whose 'obscenity', loud voice and slovenly appearance twenty years later aroused the indignation of memoir- ists of the time. The youthful Charles-Geneviève-Louis-Auguste-André-Timothée d'Éon de Beaumont could create a convincing illusion by adhering to all the outward signs of femininity; the weary, disenchanted and ageing Chevalière, by contrast, caused revulsion and scandal by looking unkempt and swearing like a trooper, for failing to play by the rules, and for offending polite society by not displaying the modesty expected of the fairer sex.

Christopher Owens and Caroline Trentini, *Vogue*, 2015.
Photograph by Patrick Demarchelier

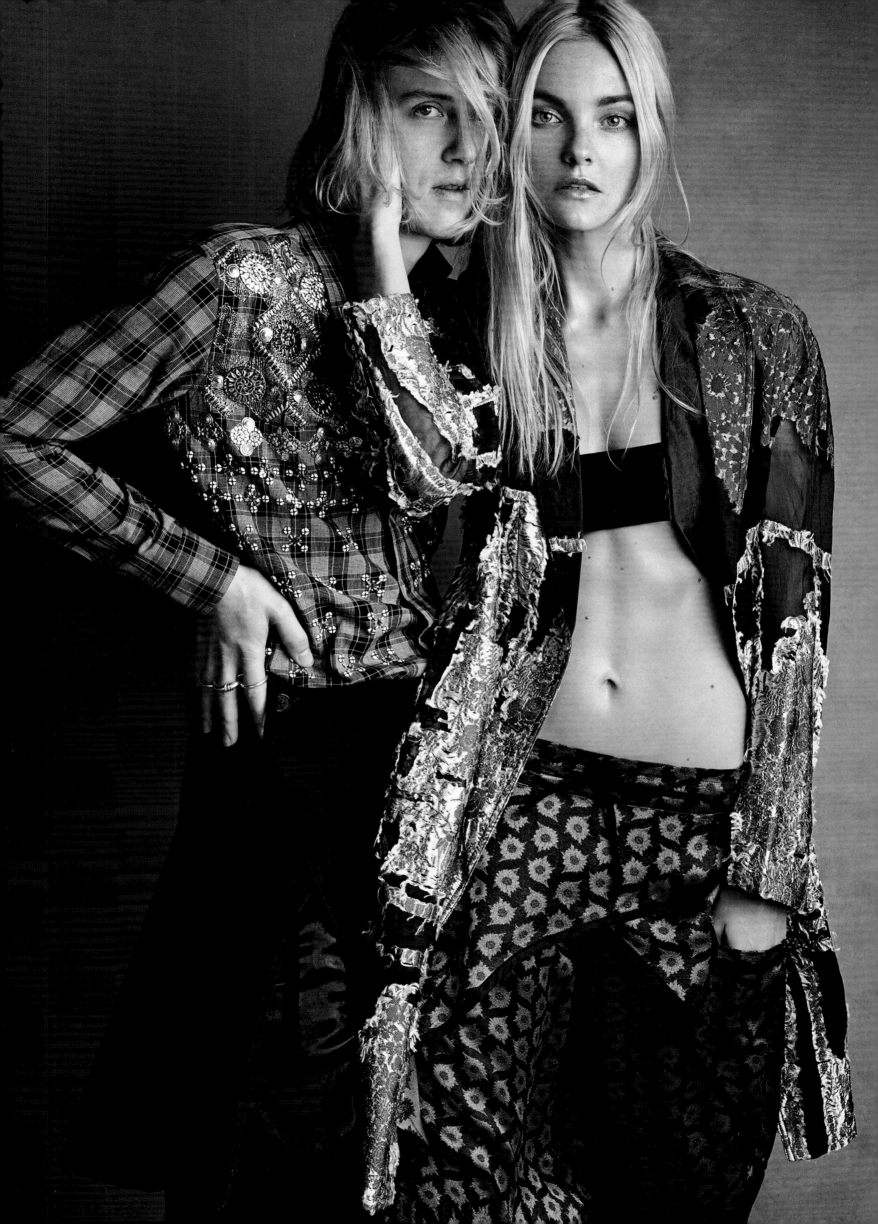

The Androgyne, oil on panel, Flanders, *c.* 1550

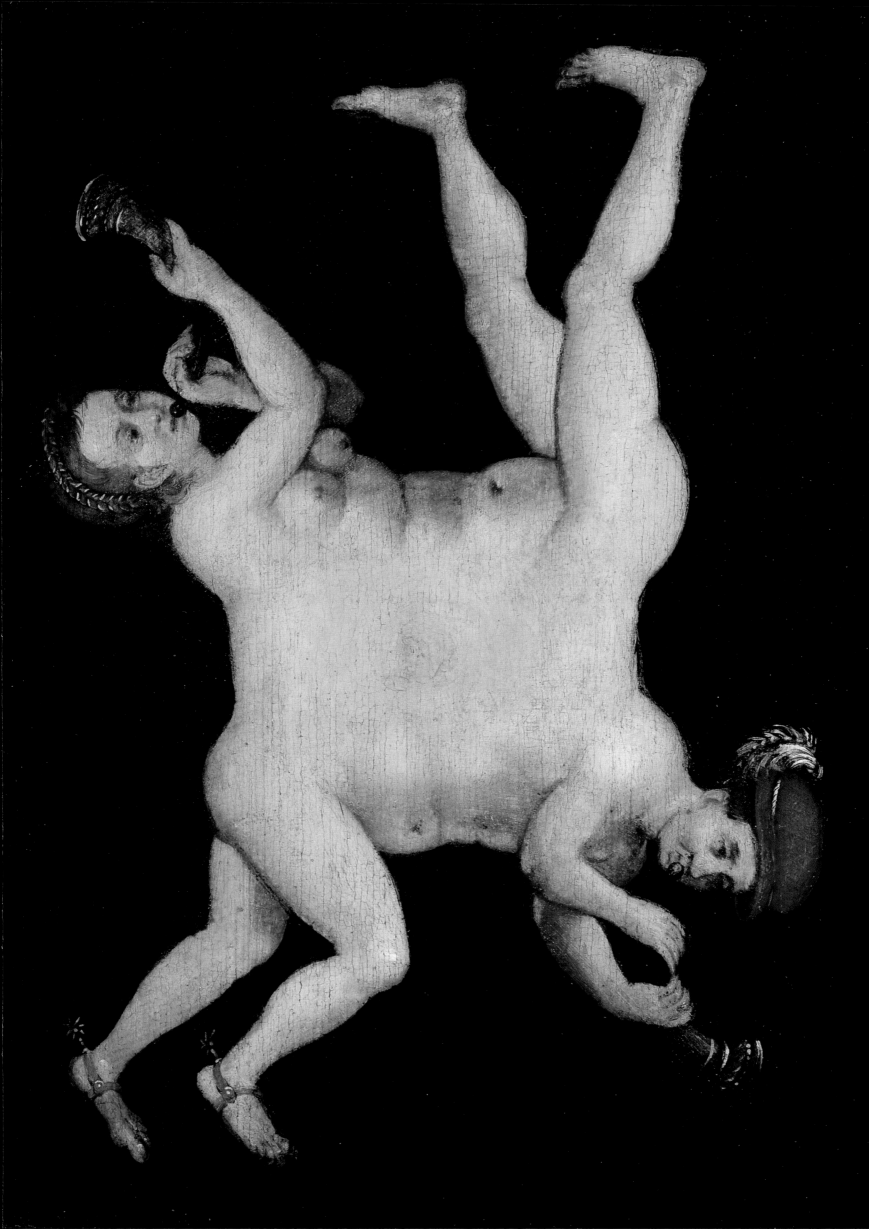

Dancers, 2000. Photograph by Dominique Douieb

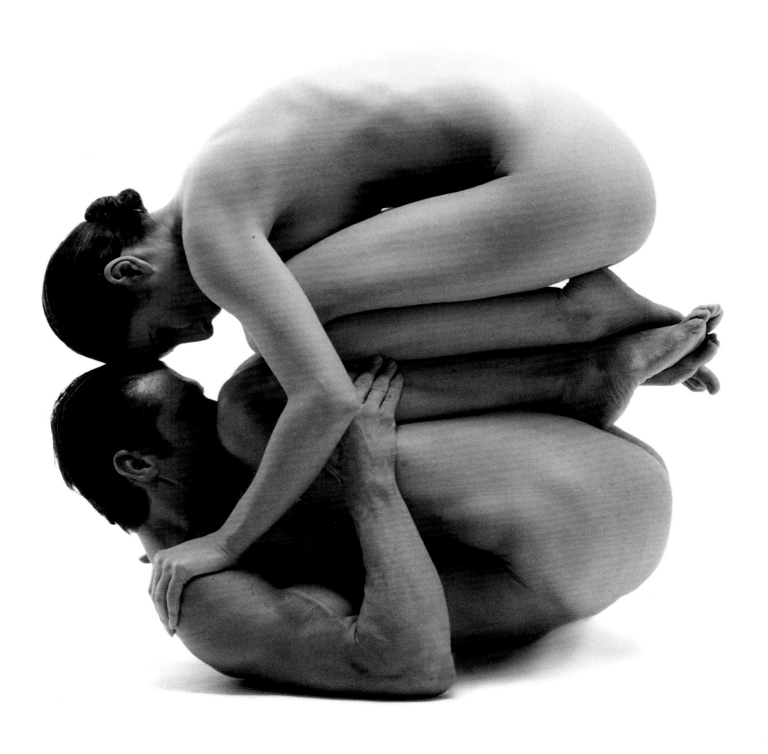

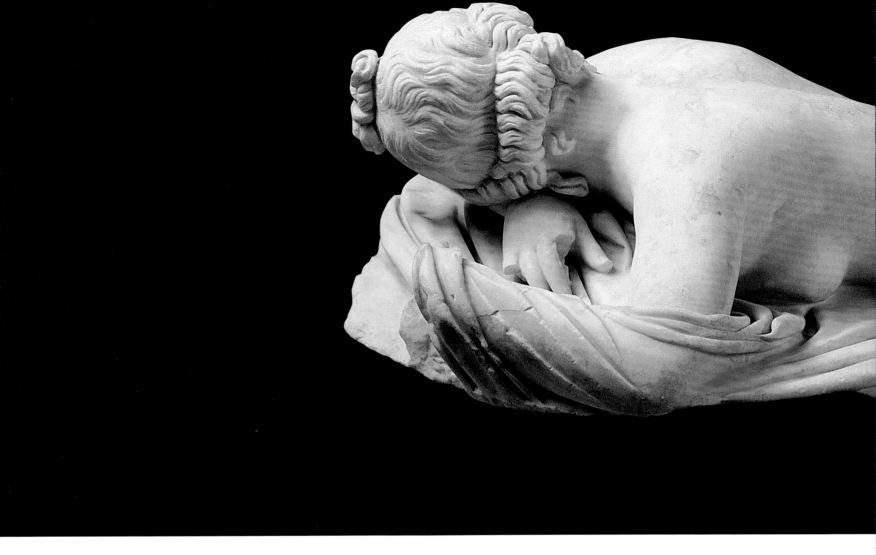

26 *Sleeping Hermaphrodite*, Roman marble, 2nd century AD

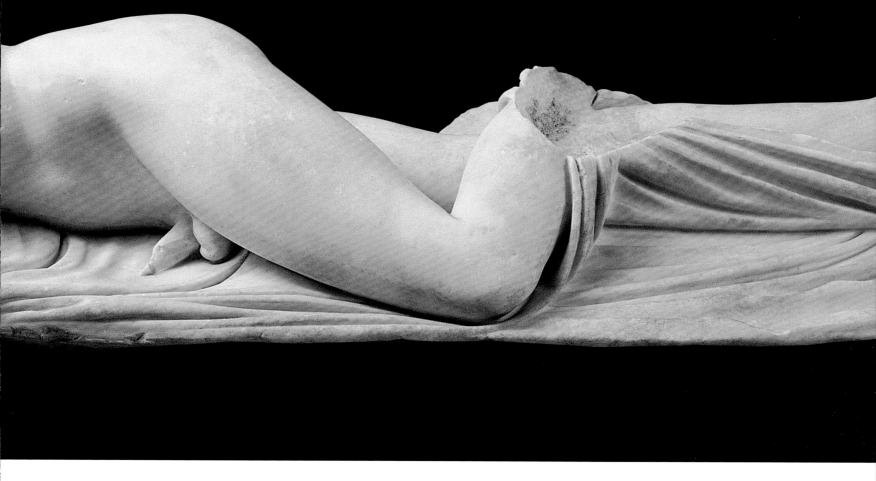

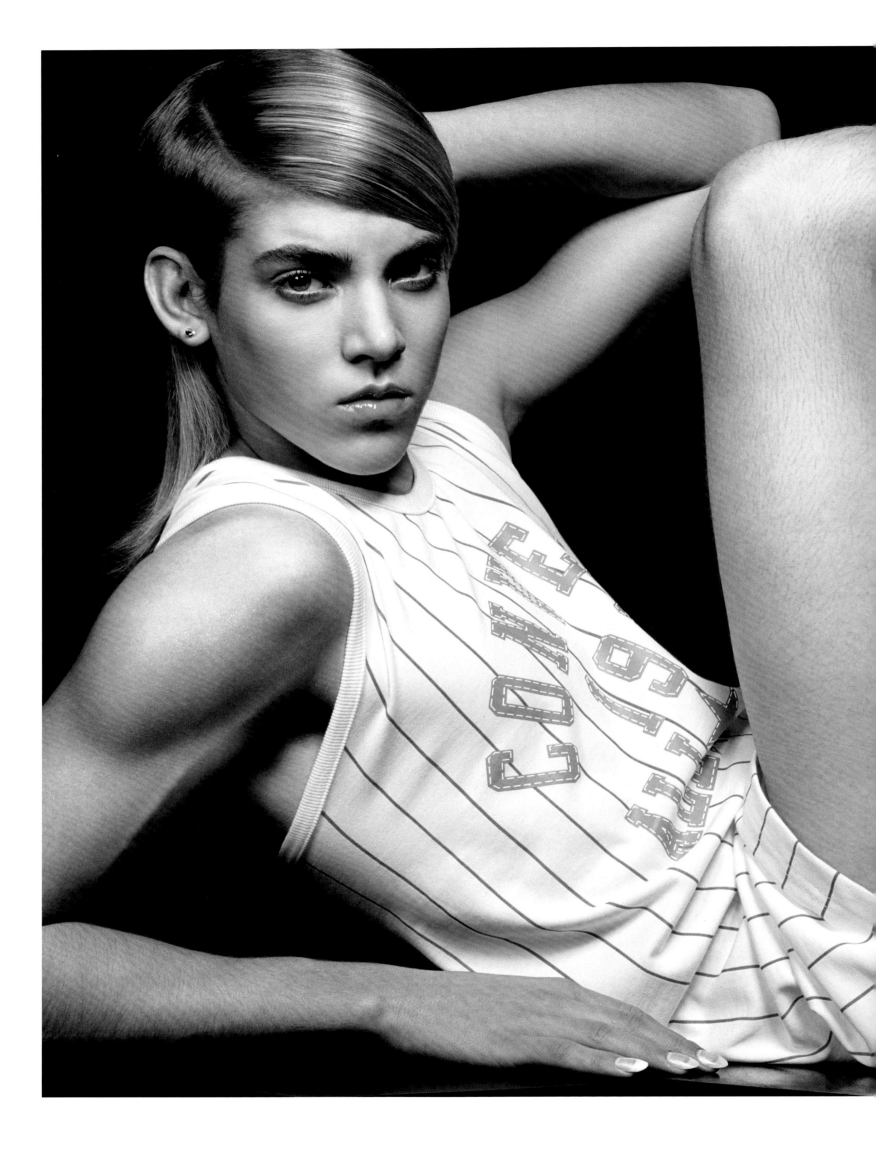

Chris Humphrey, 2006. Photograph by Liz Collins

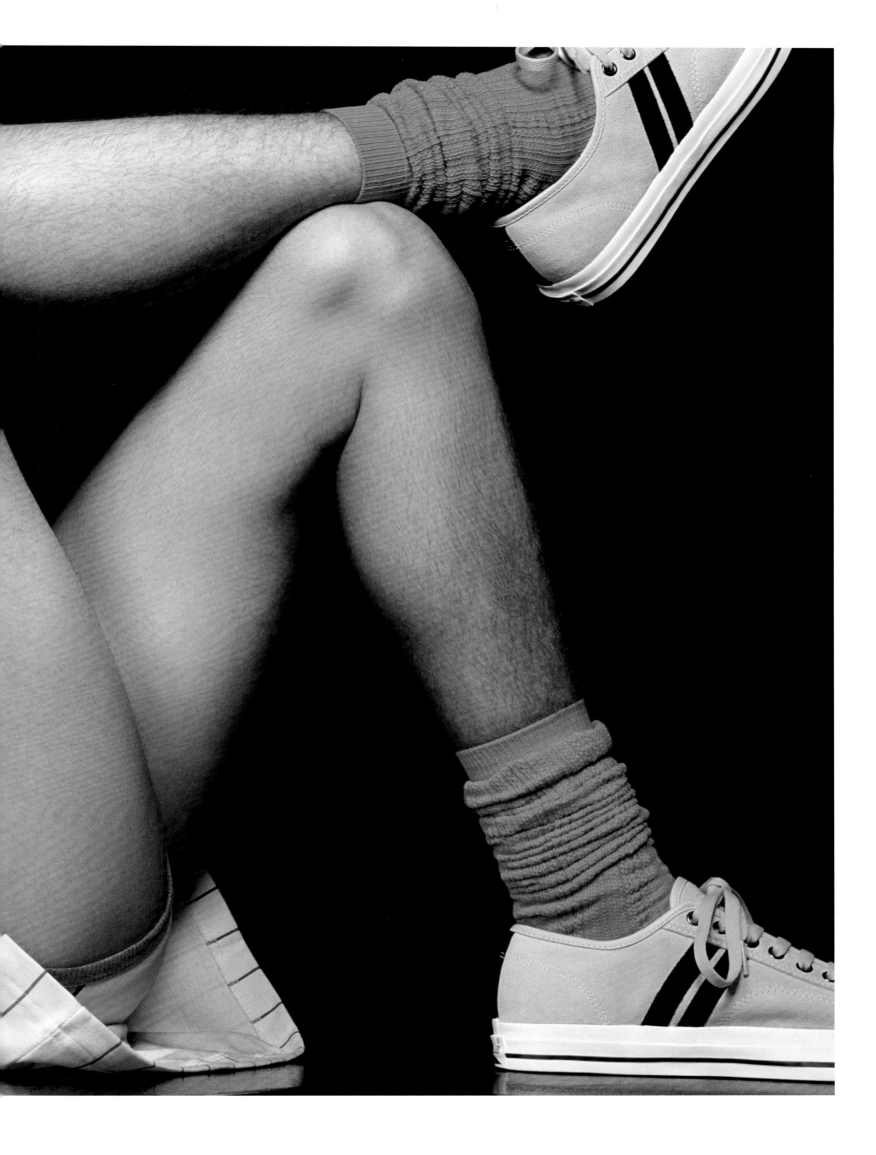

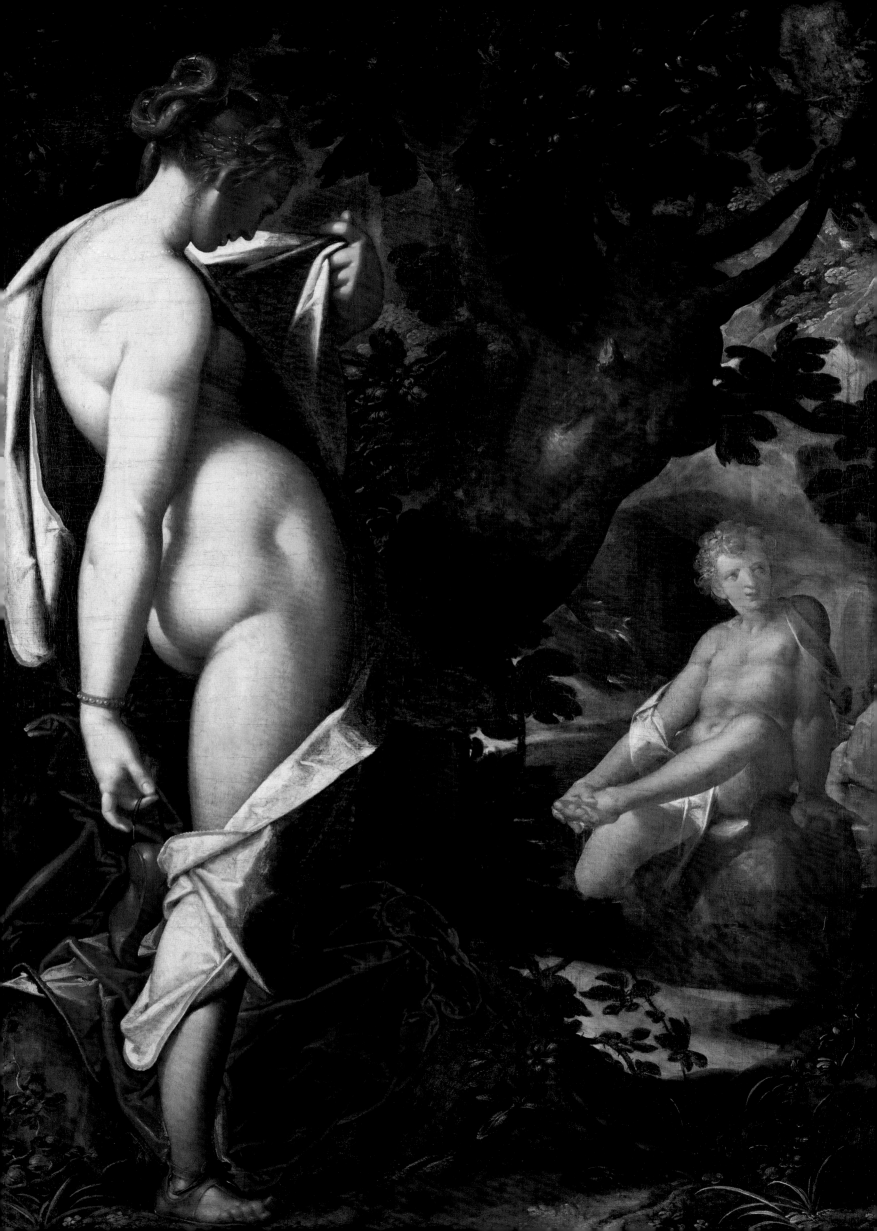

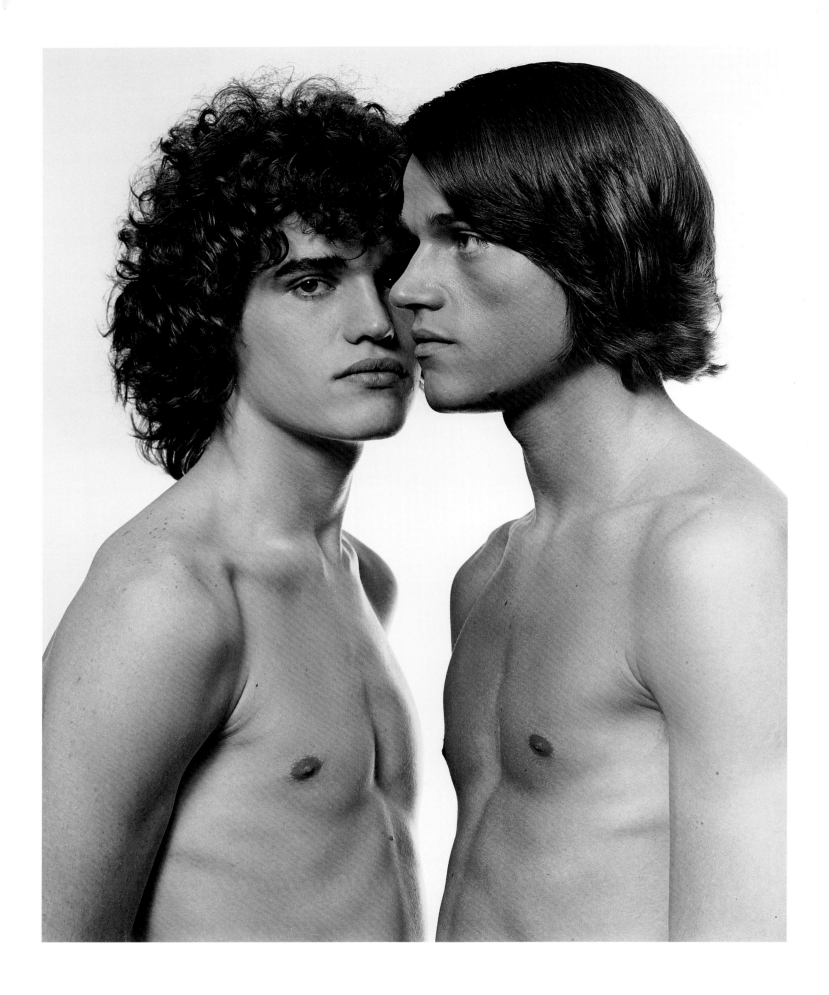

Jay and Jed Johnson, 1970. Photograph by Jack Mitchell

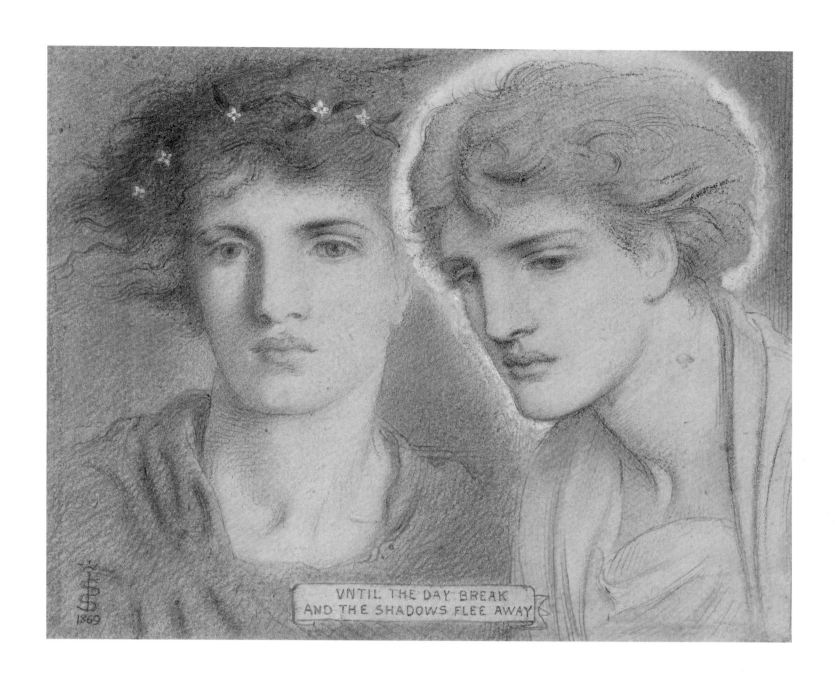

Simeon Solomon, *Until the Day Break and the Shadows Flee Away*, graphite and black chalk with bodycolour and red chalk, 1869

Jack Brannon, *Arena Homme +*, 2004. Photograph by David Sims

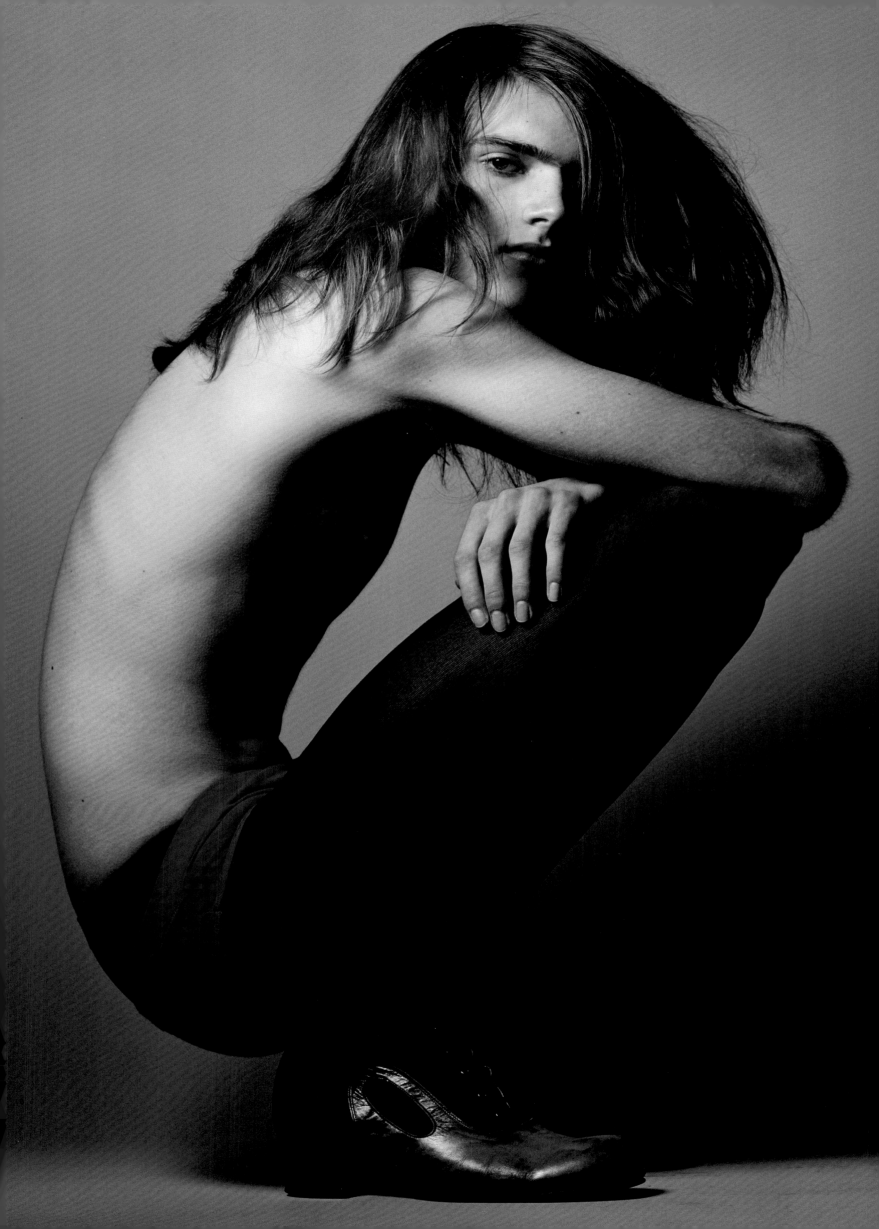

Leonardo da Vinci, *Saint John the Baptist*, oil on wood, 1513–16

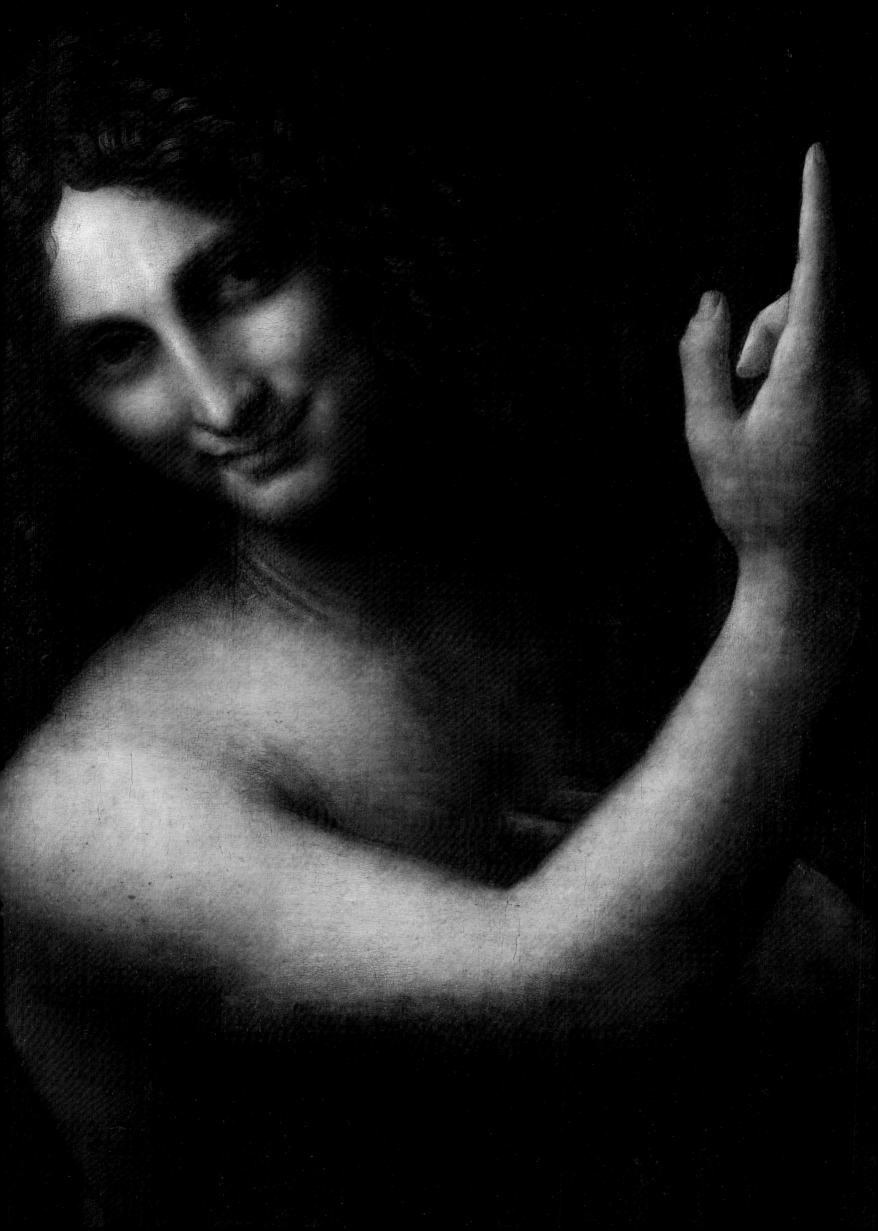

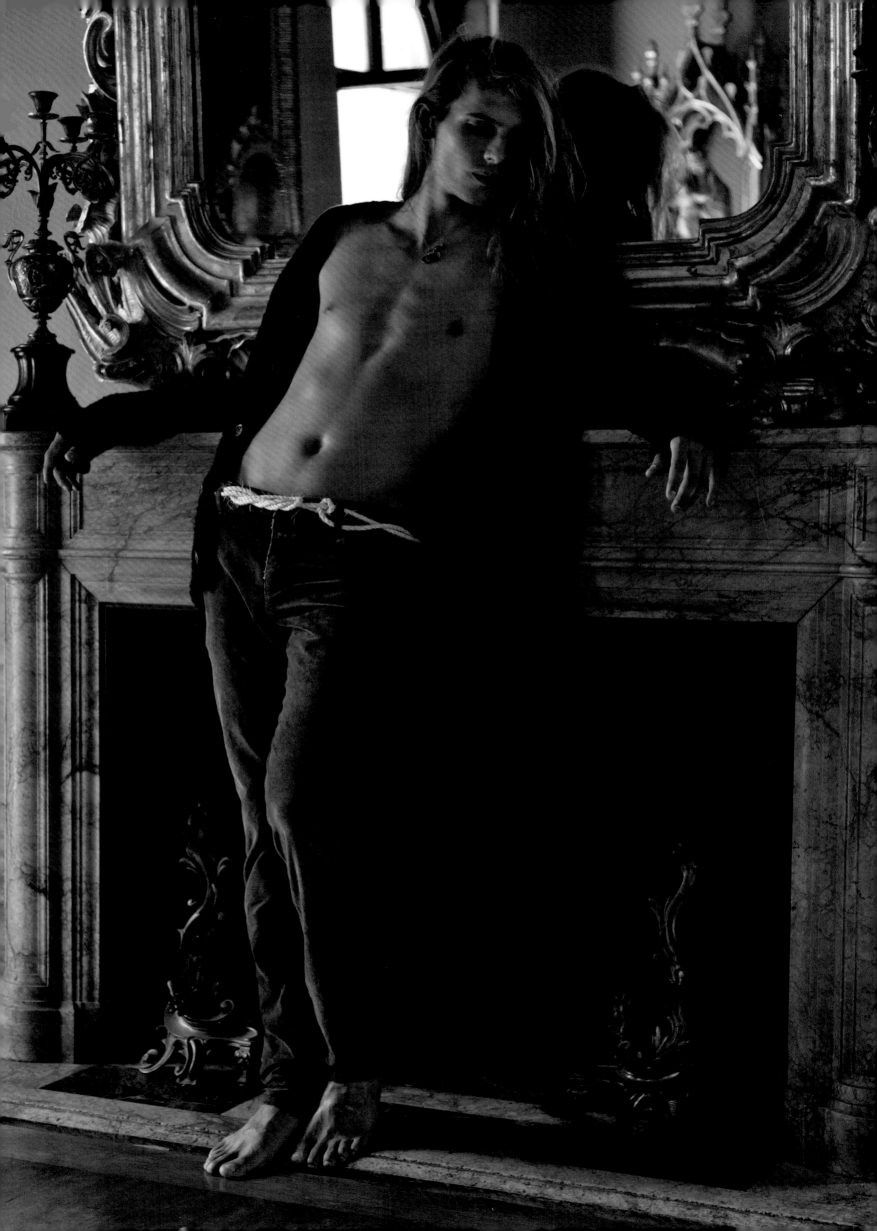

Dylan Fosket, 'On the LA Make', *Arena Homme +*, 2014. Photograph by Alice Hawkins

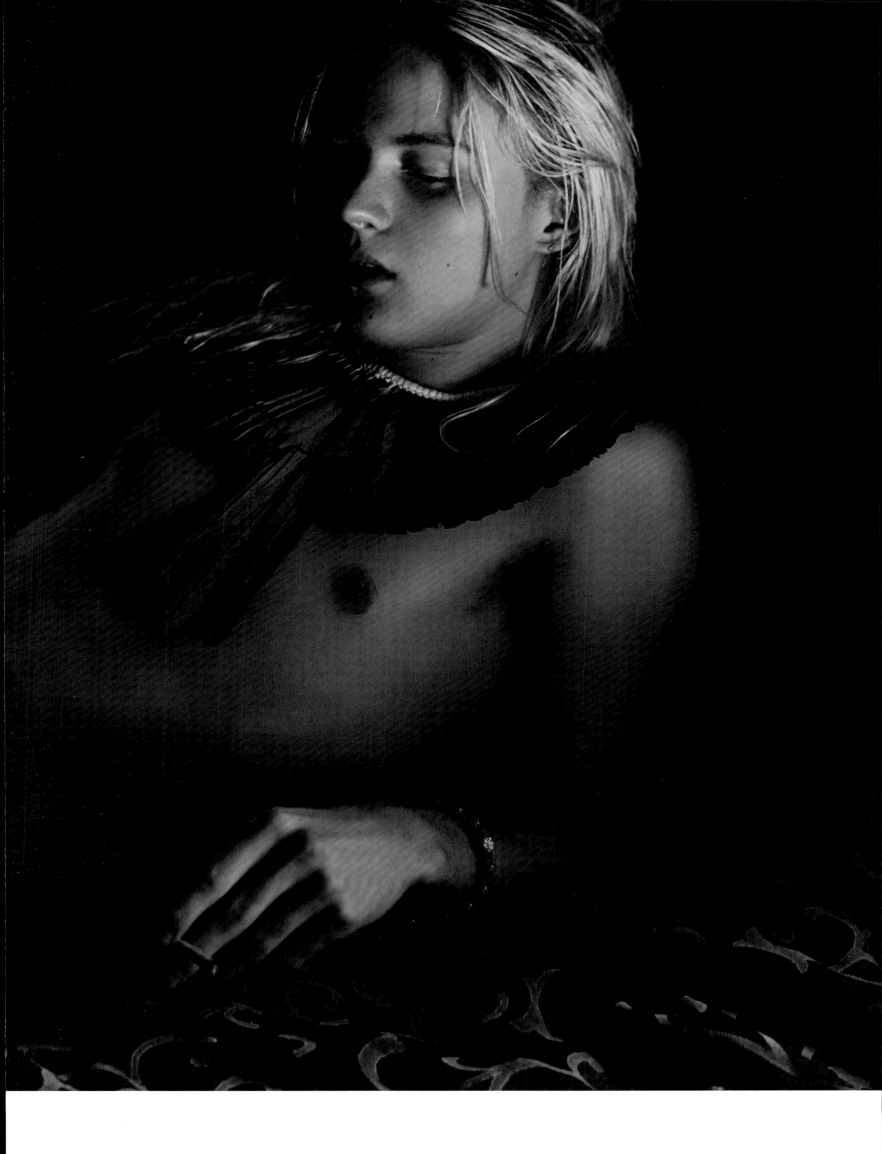

Below: Giovanni Antonio Boltraffio, *Idealized Portrait of Girolamo Casio*, oil on panel, *c.* 1490
Opposite: Erin Mommsen, *Numero Homme*, Germany, 2015. Photograph by Alexei Hay

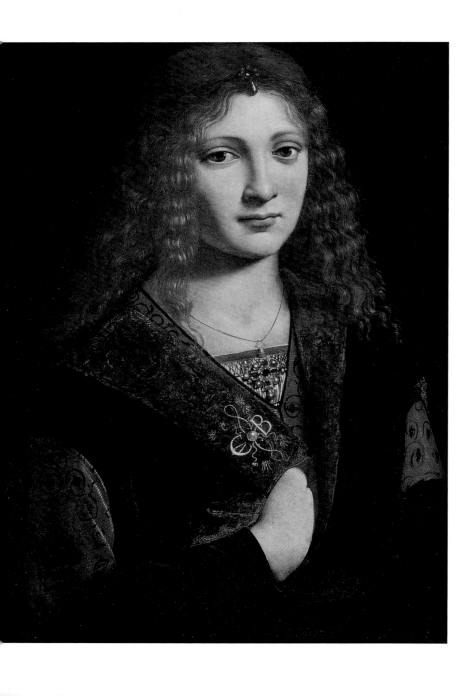

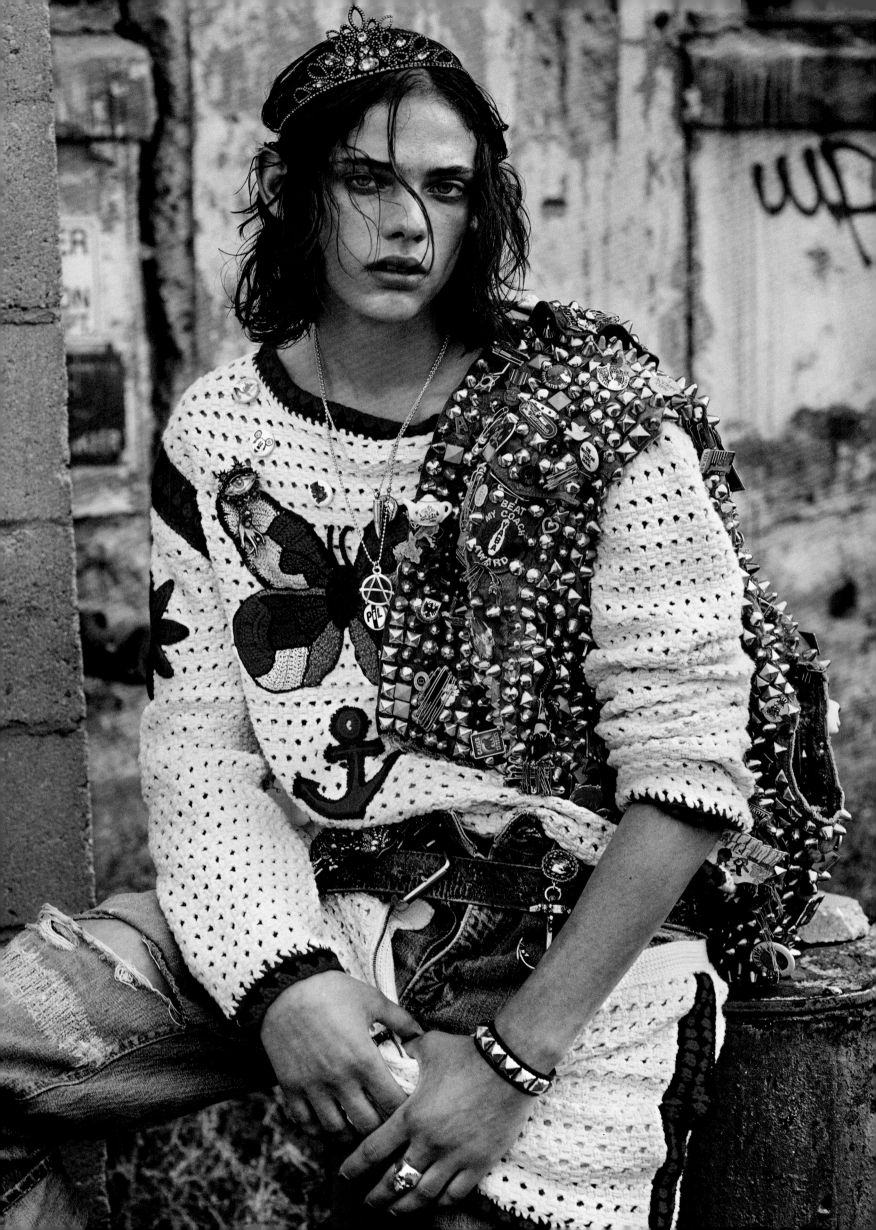

46 Edward Burne-Jones, *Love and the Pilgrim*, tapestry, woven by Morris & Co., 1909

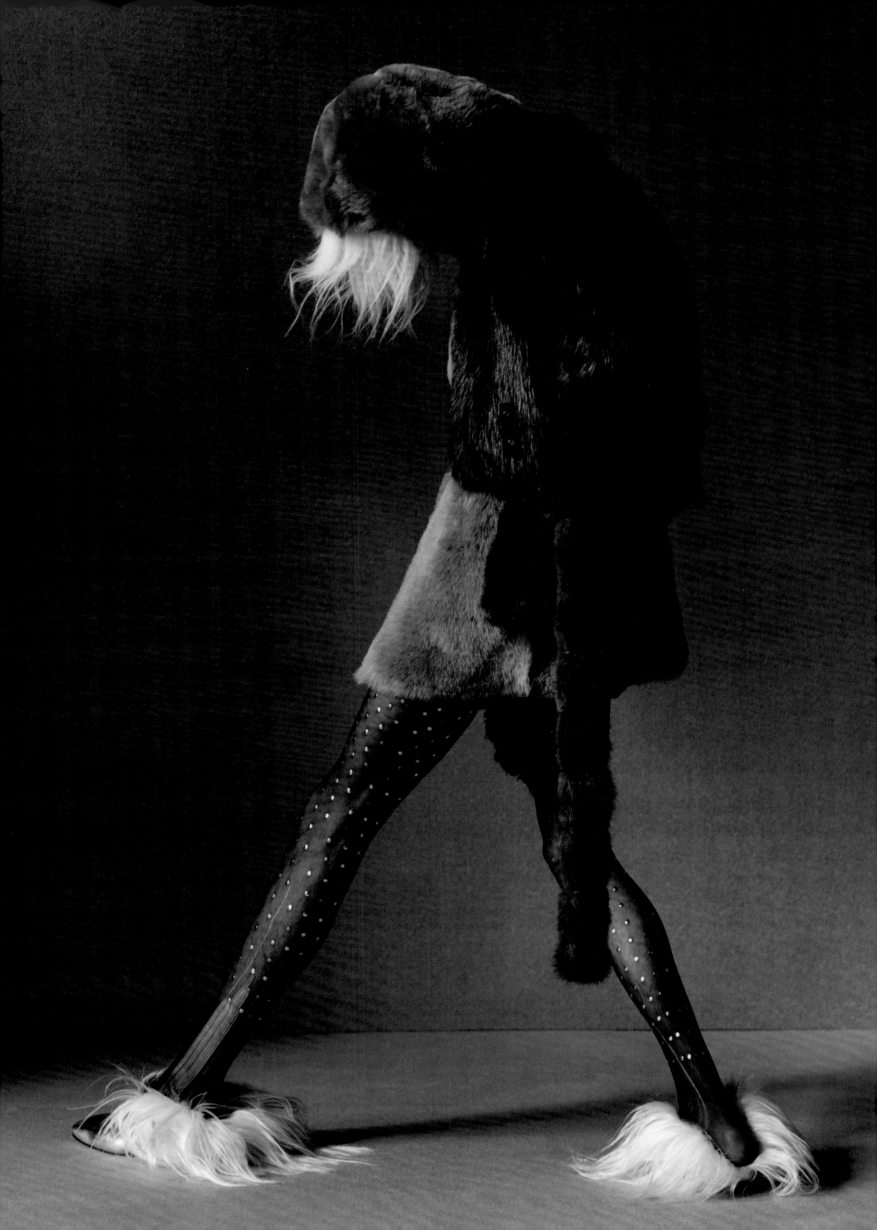

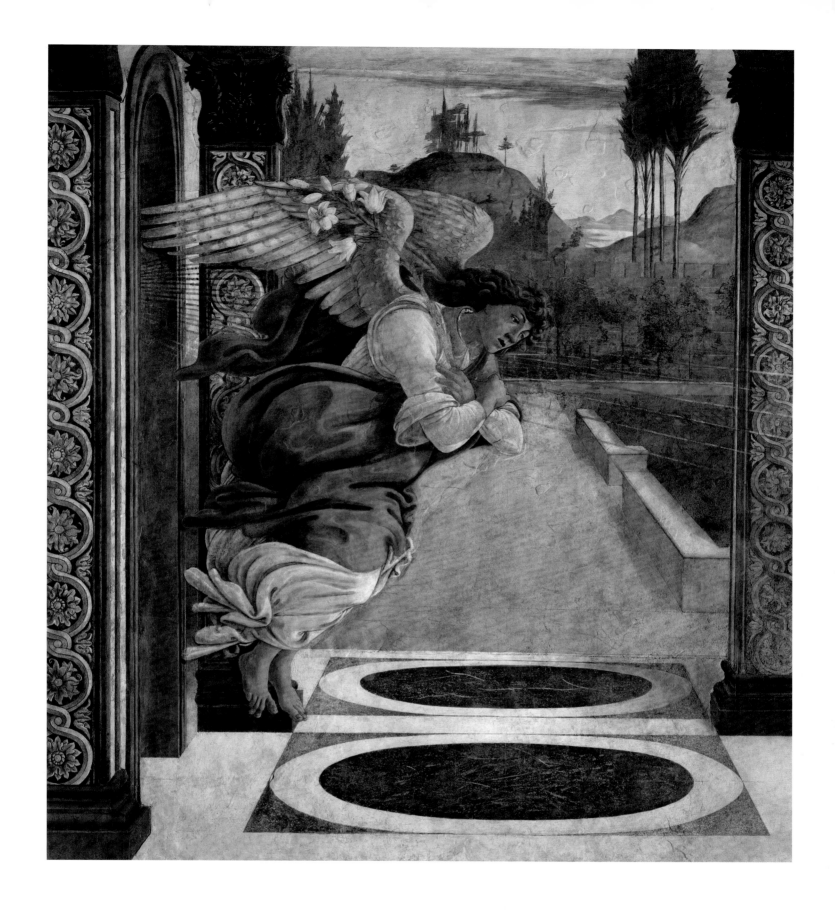

Above: Sandro Botticelli, *The Annunciation* (detail), fresco, 1481
Opposite: *Man About Town*, 2016. Photograph by Jamie Hawkesworth
Overleaf: Evelyn de Morgan, *Night and Sleep*, 1878

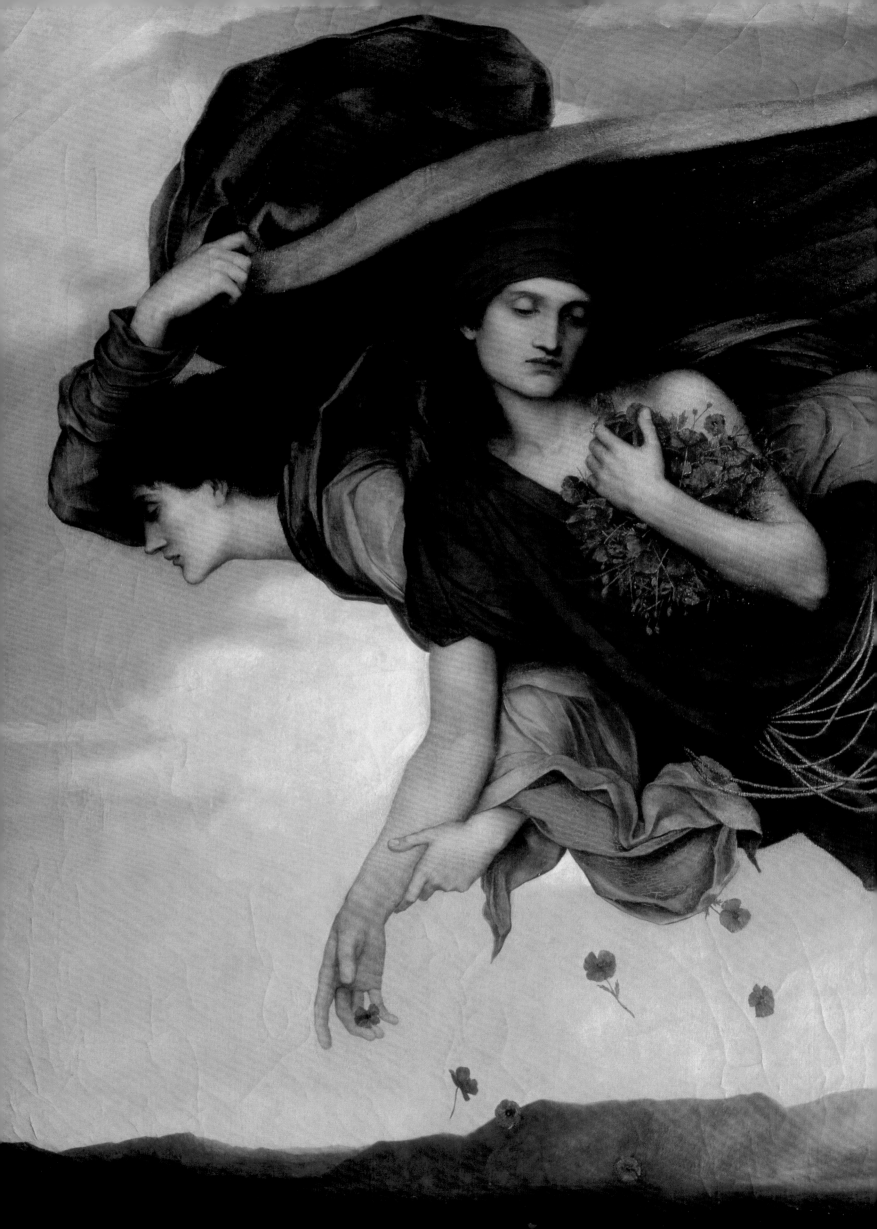

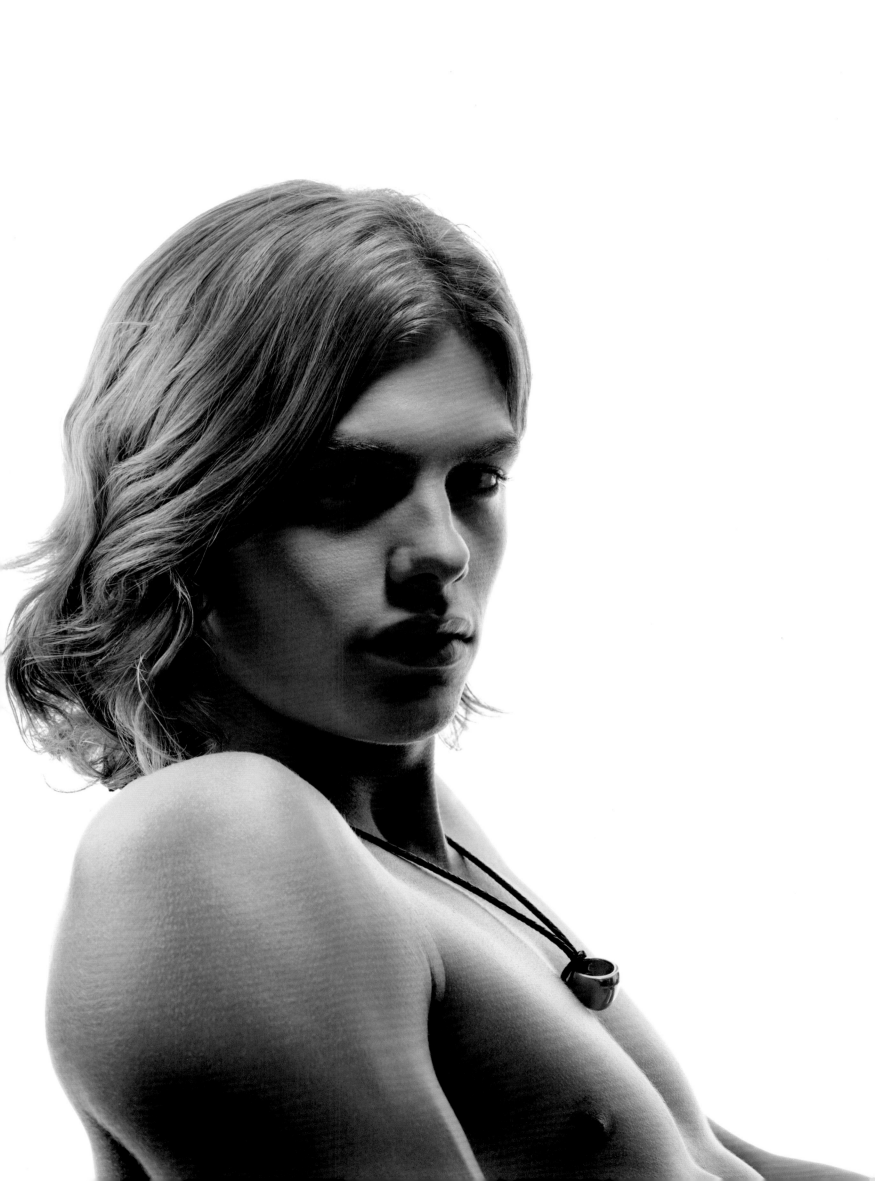

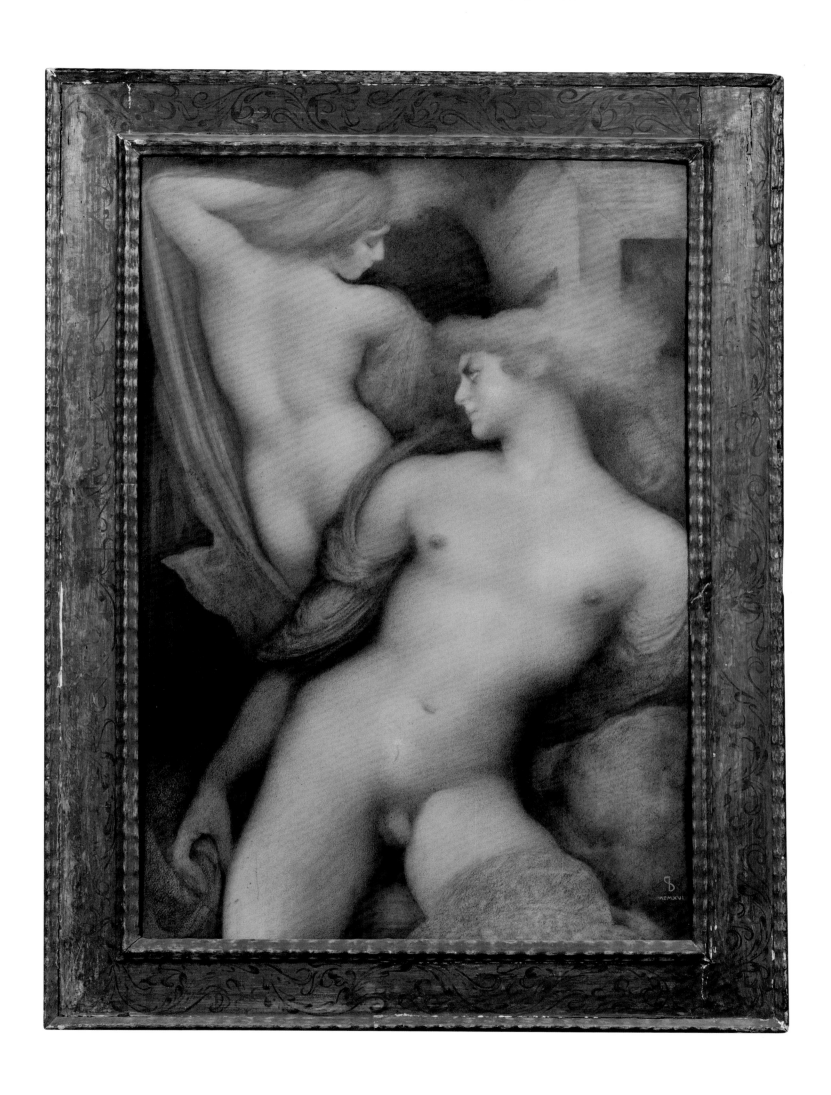

Above: Leonard Sarluis, *Androgynes*, oil on canvas, 1916
Opposite: Vidal Sassoon shoot. Photograph by Kim Andreolli

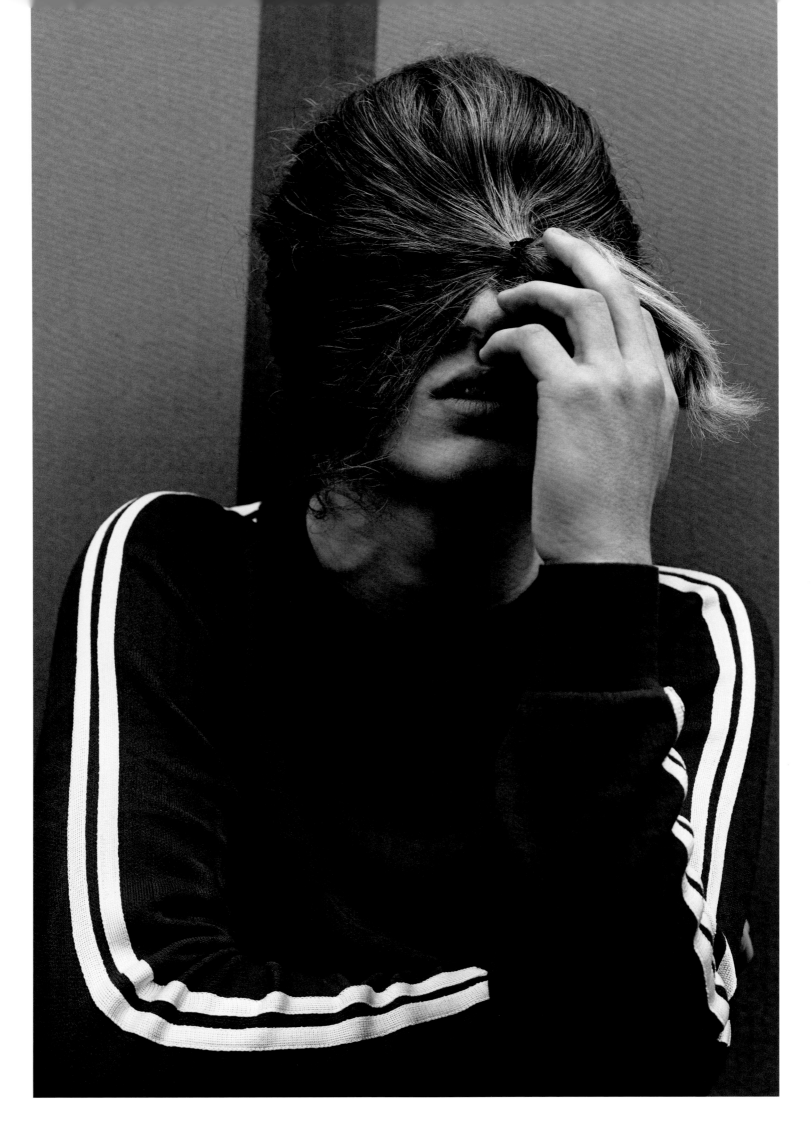

Above: Ville Sydfors, *Interview Magazine*, 2016. Photograph by Craig McDean
Opposite: Sandro Botticelli, *Portrait of a Youth*, tempera on panel, 1482–85

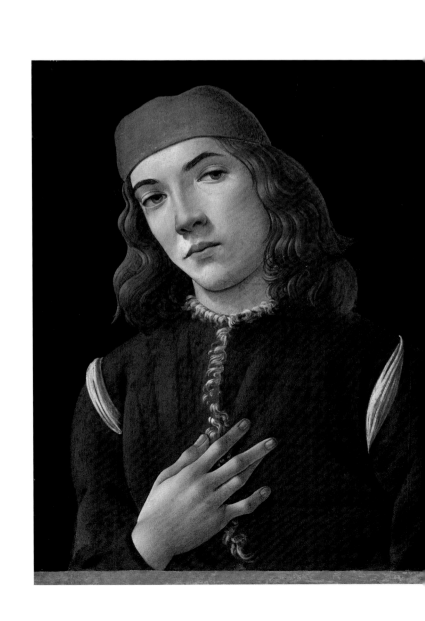

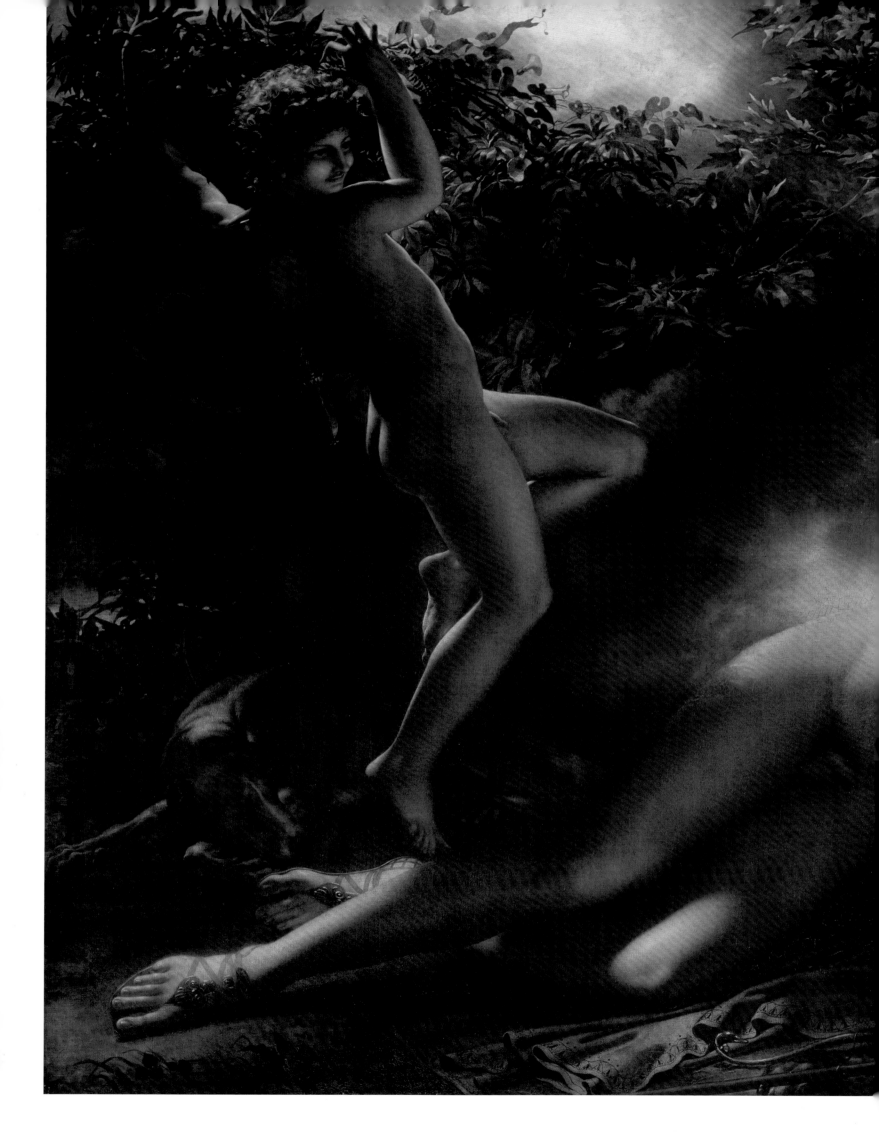

Anne-Louis Girodet, *The Sleep of Endymion*, oil on canvas, 1791

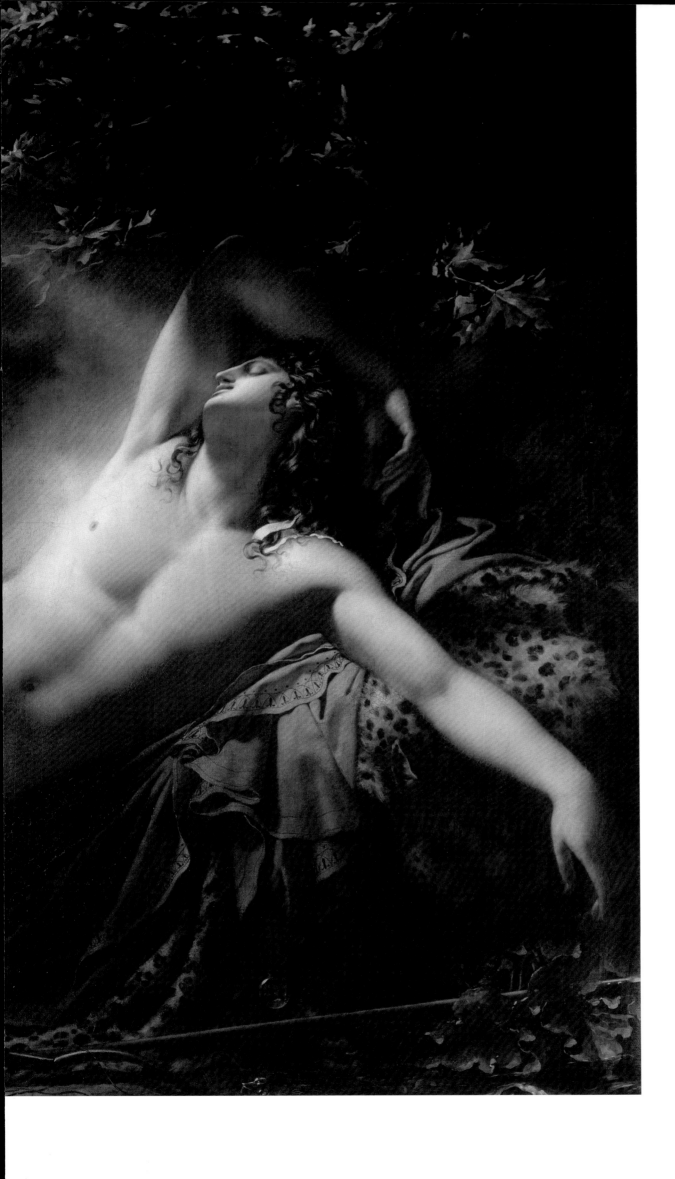

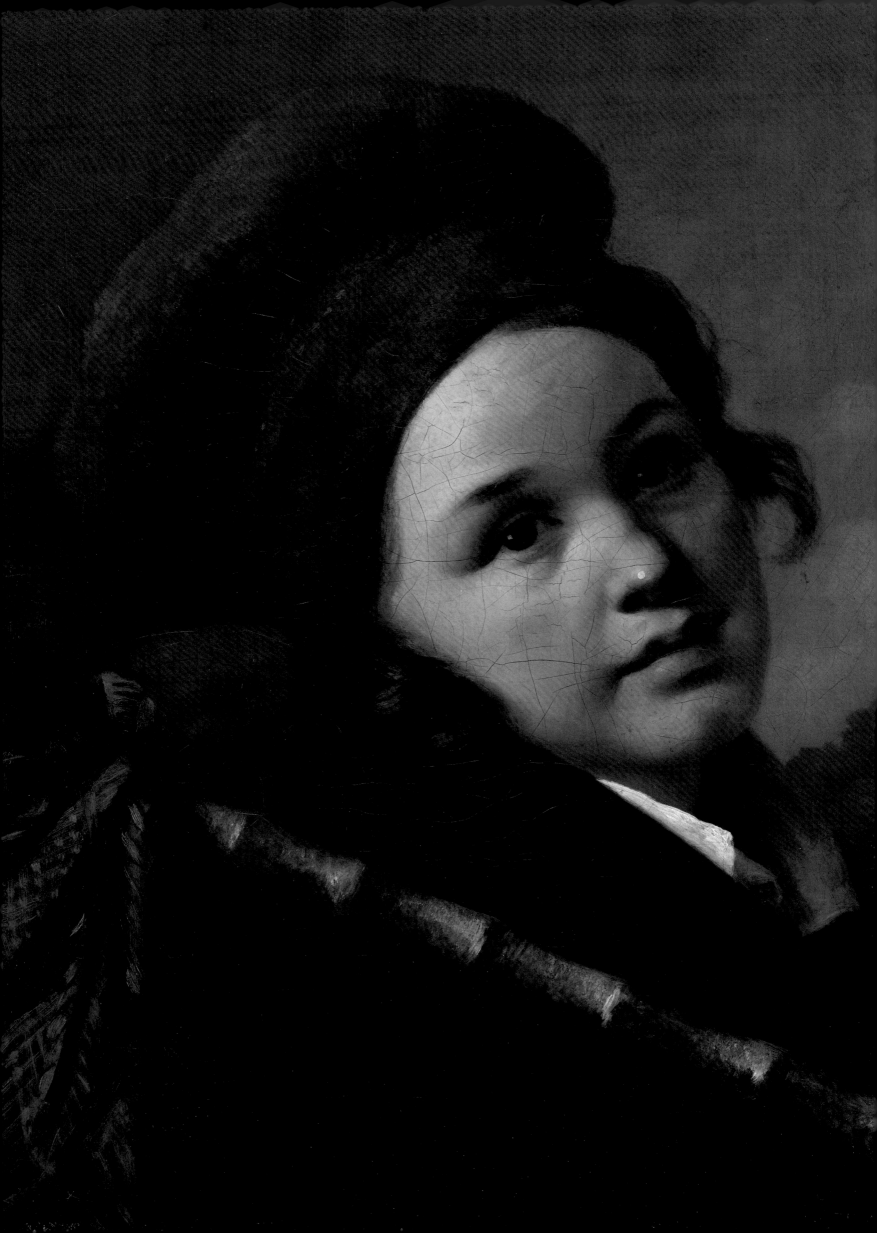

LIFE AS A
NOVEL

The extraordinary careers of the famous androgynous figures of the eighteenth century, as captured in their memoirs, have helped to mask the truth of a phenomenon that was in fact much more widespread. Sylvie Steinberg has tracked down more than three hundred examples of 'transvestism' between the Renaissance and the French Revolution documented in the archives of the French authorities. Alongside cases of hermaphroditism – the most famous of which was Herculine Barbin, whose mid-nineteenth-century memoirs the historian Michel Foucault rediscovered and edited in 1978 – the majority of these unusual tales concern men and women who chose to adopt the garments of the opposite sex at considerable personal risk. One such was Pierre-Aymond Dumoret, the son of a Toulouse lawyer, who spent his life dressed as a woman under the name of Mademoiselle Rosette and was tormented and harassed in countless ways until his death in 1725. The forgotten lives rescued from oblivion in the pages of Steinberg's *The Confusion of the Sexes* (2001) appear beside some better-known figures – such as the seventeenth-century opera singer and duellist Mademoiselle de Maupin, who became the eponymous heroine of a novel by Théophile Gautier in 1835; or the celebrated eighteenth-century actresses Sophie Arnould and Mademoiselle de Raucourt, who dressed as men and even held their own wedding ('Our lady performers', noted the weekly review *Correspondance secrète* gravely, 'have given themselves over to the most reprehensible of tastes').

Despite their diversity, all the figures whose stories were unearthed by Steinberg seem to share the quality of having stepped out of a romantic novel: not only did they live in defiance of convention, but their adventures 'seem genuinely unbelievable, to the point where their veracity is sometimes in question'. Indeed, their fates seem to mirror the conventions of contemporary fiction. Many of Steinberg's clandestine heroines ran away from their families at a very young age, fleeing one threat or another, to be disinherited, or to join the army in male attire like the androgynous soldier Marie-Joseph Barbier, 'every episode of whose life matches what we might expect of the heroine of one of the romances featuring cross-dressing characters that were popular towards the end of the seventeenth century'.

Martin Drölling, *Portrait of Mademoiselle de Saint Aubin, Half-length, in the Guise of Michel the Savoyard*, oil on canvas, late 18th century

Where more prominent individuals are concerned, we need only leaf through one of the many works devoted to the astonishing career of the Chevalier d'Éon – beginning with the Chevalier's own memoirs, which take a sly delight in muddying the waters – to realize the extent to which this life story is steeped in the tropes of romantic fiction. As if to demonstrate the bond between truth and fiction, the Chevalier's first biographer, Frédéric Gaillardet, published two different versions of d'Éon's memoirs, in 1836 and 1866. The latter is fairly faithful to the original (although repeating some of the Chevalier's own fabrications), but the former is stuffed with outlandish tales that skip blithely between the plausible and the frankly impossible – including one in which the epicene protagonist claims to be the father of the future King of Great Britain, George IV. Even if not a work of fiction, the destiny of a transvestite or androgyne as a creature of appearances – whether flamboyant or discreet, famous or anonymous – is apparently only able to be fulfilled when balanced on the tightrope between reality and imagination.

Curiously, the boldest of these personalities – from the Chevalier d'Éon and the Abbé de Choisy to the unfortunate Pierre-Aymond Dumoret – have something else in common. When they try to explain their way of life, they all refer to a specific social custom whose extreme nature had – so they believed – distorted their sense of identity and their very definition of reality. This was the custom, dating back to the Renaissance and continuing into the late nineteenth century, of dressing children of both sexes as girls until the age of six or seven. 'It is a curious thing,' wrote the Abbé de Choisy in his memoirs, 'that it is impossible to rid oneself of a habit instilled in childhood: virtually from birth, my mother got me accustomed to wearing female attire; I continued to do so throughout my youth; I played the part of a girl for five months continuously on the stage of a major town; everyone was fooled; I had suitors to whom I granted small favours, while retaining a great reserve about large ones; people spoke of my chastity. I enjoyed the greatest pleasure that may be tasted in this life.'

This custom was rooted in the ancient theory of the humours, the thermodynamic approach to the body that the Enlightenment had bolstered, as we have seen, by recognizing the reality of the two sexes. Male children were thought to be affected, like women, by an excess of moisture, beginning life with an imperfect body that would gradually be corrected as it matured: to become a man was a form of drying out. The 'dual' body of a boy, fragile, fickle and afflicted with a degree of softness, would follow the organic curve of life, according to which, as the seventeenth-century physician David Laigneau postulated, 'heat cools, and nourishing virtue grows dull and loses more than it gains, lessening constantly until death. It therefore appears that natural heat is the cause of growth and preservation'. This cycle of progress, stabilization and loss was thwarted by the existence of the androgyne (whether self-determined or not), because that figure remained indelibly marked by a uniform mode of dress which, according to Steinberg, 'does not express the difference between the biological sexes, but only their original femininity'. This incidentally provides another illustration of the fact that dress was not merely an accessory but an integral part of expressing the being or identity of these 'little rouged master[s] and fop[s]'.

As Steinberg notes, 'in the eighteenth century, as in earlier centuries, young people were reputed to possess feminine graces'; from childhood to adolescence was merely a difference of degree. Before membership of one sex or the other could be fixed, nuances or imbalances of 'temperament' might cloud the issue, as these had a direct influence on the complexion and the physique: affecting, in women, their softness, fleshiness, slenderness, roundness, moistness, smallness, slightness, delicacy, thinness and fragility; in men, their sinewiness, hardness, suppleness, dryness, boniness, largeness, corpulence and strength; in adolescents, some of both. (We have already seen, in Girodet's depiction of the body of Endymion, the implications that can be drawn from this opposition of characteristics.)

In a curious passage on this theme from his *Philosophical Dictionary* (1764), Voltaire went so far as to describe a type of illusion, or rather delusion. If we love young boys, he wrote, 'it is because nature is mistaken: homage is paid to the fair sex by attachment to one who possess its beauties, and when age has made this resemblance disappear, the mistake ceases'. In this new variation on the motif of youth which was exalted in the eighteenth century, the appearance of grace and beauty served to erase temporarily the biological markers of sex. As Joséphin Péladan (of whom more later) wrote of that era in one of his many treatises on the theme of androgyny, in 1910: 'This century of wit and recklessness cannot be embodied by either a philosopher or a fool, so when we want an image to represent it, it will have to be a transvestite, because the key figure (words by Beaumarchais, music by Mozart), the truly historic figure, is Cherubino, the delectable page boy'. Youth, through its asexual prettiness, overcomes the masculinity that is signified by ugliness and strength, and remains in a no-man's-land that is also the realm of androgyny.

CIVILIZATION AND ITS DIS-CONTENTED

The ambivalence and feminization of youth in the eighteenth century was connected with a stage in life, or rite of passage, celebrated in carnivalesque revelry and masquerades, and which – like cross-dressing – could become a source of endless illusion and equivoca-tion that stirred aesthetic pleasure. Viewed more generally, in the context of society as a whole, it could also be viewed as pernicious, turning into a negative force that might eventually threaten the very foundations of civilization.

Some eighteenth-century writers harked back to the imagery and issues discussed by the Renaissance diplomat Baldassare Castiglione in *The Book of the Courtier*. Published in Venice in 1528, this handbook of elegant manners soon circulated throughout the courts

of Europe, its impact playing a key role in what the sociologist Norbert Elias called the 'civilizing process'. But although Castiglione advocated the refinement of etiquette, clothes, conversation and self-presentation, compared to the brutality and coarseness of earlier times, he remained anxious to set limits on this spirit of sophistication. He was, in the words of Laqueur, frightened 'that men engaged in such pursuits – in consorting closely with women – could become like them and, even more threateningly, that women could become like men'. If taken too far, men's obsession with outward appearance – not only curling their hair and plucking their brows, but pampering 'themselves in every point like the most wanton and dishonest women in the worlde' – could put masculine identity at risk and lead to confusion between the sexes. According to common belief, falling into feminine ways meant coming undone and losing integrity: 'their members were ready to flee one from an other...a man would weene they were at that instant yielding up the ghost'.

Two centuries later, Louis François Luc de Lignac, exponent of popular science and author of a treatise entitled *A Physical View of Man and Woman in a State of Marriage* (1772), stigmatized the 'languid degeneracy' of 'some men...because these men are effeminate, and willingly lose their heads to the vapours and to imaginary maladies', believing that this weakened society as a whole by sapping its strength and causing premature ageing. This was the same danger that the philosopher Jean-Jacques Rousseau feared in his horror of artifice and his quest for a utopian natural state. Expressing his worries regarding the place occupied by women in society, their loss of the 'modesty' that was natural to them and the general 'softening' of manners and morals that would result from this, he opined: 'I said it before concerning women, I say it now concerning men. They are affected as much as, and more than, women by a commerce that is too intimate; they lose not only their morals, but we lose our morals and our constitution; for this weaker sex, not in the position to take on our way of life, which is too hard for it, forces us to take on its way, too soft for us; and no longer wishing to tolerate separation, unable to make themselves into men, the women make us into women.'

This unshakeable opinion played a central role in the opposition, regularly reiterated by Rousseau, between life in the country – simple, tough, authentic and more 'suitable for man' – and the welter of emotions, affectations, deceits and posturings that were part of daily life in the city, 'full of scheming, idle people without religion or principles, whose imagination, depraved by sloth and inactivity, the love of pleasure, and urgent desires, engenders only monsters and inspires only crimes'. In his remarkable twelve-volume *Portrait of Paris* (1781–88), Louis-Sébastien Mercier, a fervent follower of Rousseau, described a typical citizen of the French capital as the very exemplar of 'the delicate parasite, the effeminate sybarite, so voluptuous and sensual, whose table is laden with the produce of every climate most apt to flatter and stimulate the palate, who is the first to seek out every pleasurable sensation, and who rapturously immerses himself in the arts in order to hold ennui at bay'.

Reviving a very old *topos*, Mercier saw the characteristic demasculinization of the city-dweller and the blurring of gender divisions as the repellent but inevitable consequence of becoming overly civilized and divorced from the fundamental values of nature. In doing so, he anticipated in negative form the motif that would evolve over the following century: a humanity hopelessly fascinated with the idea that it was born too late and without a future, detesting the idea of nature, and desperately striving to escape its bonds by cultivating every possible refinement and ambiguity. This was to be the common cause that united the dandies inspired by Charles Baudelaire, the aesthetes engendered by Oscar Wilde and the fictional Jean des Esseintes, and the decadent androgynous figures celebrated by Gustave Moreau and Joséphin Péladan. Faced with the oxymoron of a young generation that had already read all the books, experienced every sensation, exhausted every pleasure, the 'delectable page boy' of the eighteenth century vanished in favour of *éros vanné* – the 'exhausted Cupid'.

AN AMPHIBIOUS CREATURE

Before we turn to the age of Decadence, we cannot leave the eighteenth century behind without first looking at the extraordinary life and meandering tale of a legendary yet living embodiment of the blurring of genders – that true phenomenon of the Enlightenment, the Chevalier d'Éon. 'Posterity will never believe such matters,' the Chevalier once wrote to a confidant, 'if you and I did not have the necessary evidence to prove both them and even more incredible things....'

Over the last two and a half centuries, countless books and articles have been devoted to the 'enigma', the 'mystery', the 'strange case' of a life that refused to be fenced in by any boundaries – starting, as we have already seen, with the boundary between fact and fiction. Yet despite all the literature that the Chevalier d'Éon produced or has inspired, the psychological depth and 'internal reality' of the Chevalier remain as elusive today as ever. The mask appears to lift and reveal only a void or absence, leaving open the full spectrum of interpretations and fantasies.

The principal mystery surrounding the Chevalier lies in the way he presented himself as the victim not only of his appearance, a natural gift that he could do nothing to change, but also of the political and cultural purposes to which he was put, and against which he was similarly powerless; he expressed no desires, confessed no pleasures; he merely accepted a contingency that had become a necessity. 'I am quite mortified,' the Chevalier wrote to his close associate the Comte de Broglie in May 1771, 'at being what nature has made me, and that my naturally quiet demeanour has never led me into pleasure-seeking, which has caused my friends in France, as well as in Russia and England, to imagine in their innocence that I was of the female sex; this has been reinforced by the malice of my enemies.' The terms in which the Chevalier defined himself were invariably negative. 'I have always lived in every land,' he declared in a letter in September 1763, 'with no horses, no open carriage, no dog, no cat, no parrot and *no mistress*', and he famously summarized his career as a life with 'neither head nor tail'. He portrayed himself as a blank canvas and, all in all, an androgynous figure despite himself ('I dare say that had I naturally

been as weak and timid as I appear by a fluke of nature, great harm would have resulted from this'). But the reality of the Chevalier's life was clearly more complex than this, and contrariness was an integral part of his character.

When he was born on 5 October 1728, into a family of minor Burgundian nobles, nothing seemed to mark out Charles-Geneviève-Louis-Auguste-André-Timothée d'Éon de Beaumont for the destiny as a remarkable 'burlesque of fate' (to quote Beaumarchais) that awaited him. After excelling at his studies in Burgundy and Paris, and graduating in civil and canon law, he joined the Parlement de Paris as a lawyer at the age of twenty. In 1753, he published his *Historical Essay on the Differing Conditions of France*, which enjoyed a modest success and granted him access to the circles of power and the entourage of Louis XV. Small, slight and delicate in build, with a lively and intelligent mind, he attracted the attention of the Prince de Conti – a member of 'the king's secret', or clandestine diplomatic service – who is believed to be the first, along with the future Foreign Minister the Duc d'Aiguillon, to have had the idea of making the most of the Chevalier's pretty looks by transforming him into a woman.

Whatever the origins of his transformation – Gaillardet at one point even suggested it was the result of an unusual bout of witty banter between Madame de Pompadour and Louis XV – the fact remains that in 1756 and 1758, the first time dressed as a woman and the second dressed as a man, the Chevalier was despatched to the court of the Tsarina Elizabeth in St Petersburg in order to thwart the influence of her advisor Count Bestuzhev and the British and to consolidate the foundations of a Franco-Russian alliance – a mission that seems to have been carried out with some success. Equally passionate about weapons and riding as he was books, the Chevalier subsequently took part in several military operations in Germany, and was rewarded with the rank of captain of dragoons, which he was wont to flaunt during his misadventures.

The Chevalier's military career, which was far too brief for his liking, was cut short when he was appointed secretary to the French embassy in London in 1762. Since he was used to presenting two faces to the world, living a double life followed naturally: he continued to work on behalf of Louis XV's secret service, including – on the king's orders – gathering information to aid a potential French invasion of England, a plan that, if it had been discovered, would have had potentially devastating consequences. In any event, its impact on the Chevalier's own life was devastating: he fell out spectacularly and publicly with the Comte de Guerchy, the French ambassador to London since 1764, causing a string of wildly improbable incidents (both real and imagined), including attempted poisonings and assassinations, libels and counter-libels, and rumours regarding the Chevalier's true gender. The 'uncertain sex' of the 'Epicene d'Éon' became the subject of such frenzied speculation that the threat posed by those who wanted to come and find out for themselves forced the Chevalier to flee London disguised as a woman.

After years of arguments, escape attempts, court cases, and general disgrace cast on all concerned, and despite his protestations of innocence – many of which were justified – the Chevalier remained the victim of Louis XV's double-dealing and regarded as a virtual traitor. 'For the last twelve years in England,' d'Éon wrote to the Comte de Broglie in July 1774, 'I have sacrificed my entire fortune, my advancement and my happiness, wishing to give strict obedience to his [Louis XV's] secret order of 3 June 1763…. He believed it was his duty to make me a public sacrifice, to the fury of Ambassador Guerchy and his ministers and to the hysterics of La Pompadour'.

Within a year of Louis XV's death in 1774, the Comte de Vergennes, minister of foreign affairs under Louis XVI, decided to send a special emissary to England with orders to sort the matter out. His agent was special in more senses than one, as it was none other than Pierre-Augustin Caron de Beaumarchais – virtuoso in the arts of ambivalence and mistaken identity and the creator of Cherubino, the youthful embodiment of ambiguity. Vergennes's orders were unambiguous, however: Beaumarchais was to 'suggest that

this individual who had identified as female should return to wearing the attire of that sex, in the interests of her own peace and tranquillity, as her enemies were watching and would not easily forgive what she had said about them'. Far from viewing the proposed enforced transformation as the consequence of his own actions and words, and as a means of protecting himself, the Chevalier merely reiterated his protestations of innocence to Beaumarchais: 'I will respond to you that it was not I who asked for this metamorphosis. It was the late king [Louis XV] and the Duc d'Aiguillon, it is the young king [Louis XVI] and the Comte de Vergennes; it is you yourself by virtue of the powers invested in you; it is the Guerchy family, who trembled at the mere mention of the masculine name that is still mine by baptism.'

Beaumarchais soon wearied of the demands and caprices of 'Mademoiselle d'Éon'. 'She is a woman,' he wrote to Vergennes, 'and keeps such dreadful company that I forgive her with all my heart; she is a woman, the word says everything!' He drew up a contract, read and corrected by both parties, under the terms of which the Chevalier renounced forever any claim (as his adversaries put it) to be a man, and recognized that he belonged to the female sex. 'I, Caron de Beaumarchais,' read a section of this document, 'require, in the name of His Majesty, that the transvestism that until this time has concealed the person of a woman behind the outer appearance of the Chevalier d'Éon should cease forthwith.... I demand absolutely that the ambivalence of sex that hitherto has been an inexhaustible subject of discussion, indecent wagers and malicious jokes…that the spectre of the Chevalier d'Éon should disappear entirely, and that a clear, precise and unequivocal public declaration of the true sex…should determine public opinion on this matter for ever'.

To this, the Chevalier replied: 'And I, Charles-Geneviève-Louise-Auguste-André-Timothée d'Éon de Beaumont, adult woman, known until this day by the name of the Chevalier d'Éon…do submit to declaring my sex publicly, to putting my condition beyond any doubt, and to wearing my female garb once again and until my death'. Signed on 4 November 1775, after Beaumarchais had made a trip to Paris, the contract was backdated to 5 October, the Chevalier's birthday, as though to mark the birth of a wholly new person: 'M. de Beaumarchais', explained the former Chevalier, 'wished to pay Mlle d'Éon the compliment of marking this document, which for her was a kind of new baptism, with the date of her birth.'

In a life marked by constant switching between one sex (or its appearance) and the opposite, the reversal was complete. It was now the Chevalier's biological sex that was to become the 'spectre'; while, under the stupefied gaze of the false version, his imaginary shadow, with all the impedimenta and trappings of the female sex, was recognized as 'real'. However, the Chevalier was not averse to shuffling the cards again, nor to playing Beaumarchais at his own theatrical game: 'He claimed', wrote Gaillardet, that Beaumarchais 'had paid court to him, and had led him to believe that he would marry him, if only she would be a good girl and earn a few million for him' from the frantic betting over his gender. A month after signing the contract, the Chevalier wrote with lofty serenity to the loyal but naive Comte de Broglie: 'Monsieur le Comte, it is time to disabuse you. You have had for a captain of dragoons and an aide-de-camp in war and politics nothing but *the outward appearance of a man*. I am a mere woman who would have continued playing that part to perfection until death, had political manoeuvrings and your enemies not rendered me the most unfortunate of women'.

This radical reinvention earned 'Mademoiselle d'Éon' a presentation at the court of Versailles in August 1777, along with the aloof curiosity of Louis XVI and the close interest of Marie Antoinette, who determined to pay her dressmaker, Rose Bertin, to create a new wardrobe for the impoverished Chevalière. 'After heaven, the king and his ministers,' declared the beneficiary of this largesse, 'Mlle Bertin deserves the greatest credit for my miraculous conversion.' With the exception of a few escapades that led to two years of exile in her hometown, where she was the object of much curiosity, d'Éon

spent the rest of her life dressed as a woman. In 1785, she returned to London, where she became a fairground attraction, taking part in fencing matches before a paying crowd. In 1791, she was forced to sell her most precious possession, her library; and in 1804 she spent time in a debtors' prison. Six years later she died in poverty – the autopsy revealing, in a final coup de théâtre, its truth.

The many reversals or switches of identity that punctuated d'Éon's life provide a dazzling example of androgyny as a visual disturbance or optical illusion. At various points in time, several figures encountered d'Éon in different incarnations without recognition, or rather without believing their eyes, preferring instead to cling to their convictions and to a fundamental misunderstanding. But these strange cases of seeing things were nothing compared with d'Éon's ultimate 'mystery' or 'enigma': how d'Éon self-identified. After many years spent scrutinizing the exploits and actions of the 'Epicene d'Éon', Gaillardet posed the same question in his own way: 'If the Chevalier d'Éon was nothing more than the innocent victim of Louis XV's ambitions, later taken up by Louis XVI, how can we explain the fact that, when these two kings were dead, when the French monarchy itself no longer existed, when d'Éon, having returned to London, had no further need – either for money or position – to suffer the transvestism imposed on him, how can we explain why he persisted in retaining it right up to his death?'

PUER
SENILIS

According to Frédéric Gaillardet, the Chevalier d'Éon's 'dual life was divided almost equally'. 'Out of a span of eighty-three years, forty-nine were spent as a *man* and thirty-four as a *woman*.' Such longevity also made d'Éon an intermediary between the 'delectable page boy' of the eighteenth century and the 'pernicious' androgynes of the nineteenth. However ardent a follower of Rousseau the Chevalier d'Éon might have claimed to be, in the eyes of Louis-Sébastien Mercier he undoubtedly personified a humanity debased by a surfeit of civilization and the corruption of primordial nature. And this theme was closely linked with another recurrent motif of androgyny, which was to occupy a central position in the vision of the nineteenth century.

When 'Mademoiselle d'Éon' died in 1810, an unrecognizable and forgotten octogenarian, she foreshadowed the fate of a fictional character who first appeared twenty years later, but whom we have already encountered. This was the central figure of Balzac's *Sarrasine*, La Zambinella: neither man nor woman, whose wondrous grace was preserved in eternal youthfulness in the artworks she inspired. Balzac's narrative unfolds around

this image of superhuman perfection, culminating in absolutely classic fashion in a riveting revelation. This graceful creature, it transpires, is actually the same person as the terrifying apparition glimpsed at the beginning of the novella, a fleeting presence in the salons of Paris: 'Hidden for whole months in the depths of a secret sanctuary, this family genie would suddenly come forth, unexpectedly, and would appear in the midst of the salons like those fairies of bygone days who descended from flying dragons to interrupt the rites to which they had not been invited.'

Despite the reactions of the other characters, however, there was in reality nothing about this vision that was either devilish or supernatural: 'Although not a vampire, a ghoul, or an artificial man, a kind of Faust or Robin Goodfellow, people fond of fantasy said he had something of all these anthropomorphic natures about him…. The stranger was merely an old man.' 'This creature for which the human language had no name, a form without substance, a being without life, or a life without action', this 'walking corpse' or 'ghost' in which some thought they saw the figures of the famed eighteenth-century men of mystery Alessandro Cagliostro and the Comte de Saint-Germain, was of course none other than La Zambinella, who had reached – after a series of indescribable events – the twilight of life: like the sun, or death, an elderly androgyne cannot be stared in the face. In combining, through the prism of decay and horror, androgyny with its polar opposite, the fate of La Zambinella – both the 'real' and the 'imaginary' versions – foreshadows the striking evolution of the theme throughout the nineteenth century.

The 'decadent' androgyne was the product or symptom of an overripe culture that touched upon reality only in the most sophisticated and ambiguous ways. It was the absolute embodiment of the spirit of an age that had abandoned the classical figure of the *puer aeternus*, whose eternal youth blurred the signifying features of gender, in favour of the *puer senilis*, whose juvenile appearance was only the mask, or the flip side, of a knowledge, an awareness, a history, that were too heavy to bear. Leaving aside Dorian Gray, who later gave moral weight to the theme, this duality was a quality shared by the dandy of Baudelaire's writings, in his opposition to the 'mindless woman' ruled by her instincts and dominated by her animal nature; by the Symbolist Jules Laforgue's effete and blasé version of Hamlet; by the incestuous and epicene central character of Algernon Charles Swinburne's unprintable novel *Lesbia Brandon*; by the subversive figures of Rachilde and her fellow writer Jean Lorrain. Pride of place, however, belongs to the undefeated champion of this strain of bloodless humanity, in which (to echo Mercier's worst fears) 'the effemination of the males had continued with a quickened tempo': Joris-Karl Huysmans's great invention, Jean des Esseintes, 'a slender, nervous young man of thirty, with hollow cheeks, cold, steel-blue eyes, a straight, thin nose and delicate hands,' whose 'pointed, remarkably fair beard and ambiguous expression' bore a striking resemblance to his distant ancestor, one of the 'pretty boys' who found favour at the dissolute court of Henri III.

Two years after Huysmans published *Against the Grain (À rebours)* in 1884, *The Decadent* magazine saw in this literary boom a burgeoning sociological mutation, if not the transformation of human nature itself: 'The delicate faces of the new generations shall be smooth and immaculate. Already the Decadents, precursors of the society of the future, are close to the ideal type of perfection. The few fine, silky hairs on their faces are only remotely reminiscent of the animal. Man is growing more refined, more feminine, more divine.' These 'members of a dying breed' were reflections of a civilization that was burning itself out and inexorably losing its substance; they represented a vitalist conception of society, which the novelist Paul Bourget summed up in a sentence later made good use of by Nietzsche: 'A society may be compared to an organism, and like an organism it grows old and dies.'

If we contrast the caricature-like figure of Hyacinthe Duvillard in Émile Zola's novel *Paris* (1898) with Des Esseintes, we see that even the great proponent of naturalism was not immune to the grip of this concept of aetiolation: 'In four generations the vigorous

hungry blood of the Duvillards, after producing three magnificent beasts of prey, had, as if exhausted by the contentment of every passion, ended in this sorry, emasculated creature, who was incapable alike of great knavery or great debauchery.' What had traditionally been merely a trivial, repugnant and rather insufferable aspect of the archetypal androgyne, bathed in the dazzling whiteness of eternal youth and meant in some sense to be outgrown, in the hands of the Decadents became an essential and conspicuous trait of devitalized youth, haunted by the conviction of having been born too late, and reflecting a society that was reaching its end.

The finest expression of this sentiment as the authentic spirit of the times is the bravura passage in the critic Walter Pater's *Studies in the History of the Renaissance* (1873) in which the enigmatic Mona Lisa bears the weight of the world and of its memory: 'Hers is the head upon which all "the ends of the world are come," and the eyelids are a little weary. It is a beauty wrought out from within upon the flesh, the deposit, little cell by cell, of strange thoughts and fantastic reveries and exquisite passions.... All the thoughts and experience of the world have etched and moulded there in that which they have of power to refine and make expressive the outward form, the animalism of Greece, the lust of Rome, the reverie of the middle age with its spiritual ambition and imaginative loves, the return of the Pagan world, the sins of the Borgias. She is older than the rocks among which she sits; like the vampire, she has been dead many times, and learned the secrets of the grave; and has been a diver in deep seas, and keeps their fallen day about her; and trafficked for strange webs with Eastern merchants....' In this pluperfect world, this twilight realm, the androgyne – that ambiguous being who unites all opposites – occupied a vital place. In the galaxy of imaginary beings that the critic Mario Praz described in his comprehensive survey *The Romantic Agony* (1930), the androgyne stood alongside figures such as the femme fatale, the vampire and the fallen angel as embodiments of the end of history.

These themes were also explored by Rachilde. Thirteen years after the seductively flame-haired and milk-skinned hero of *Monsieur Vénus* mentioned earlier, they were taken to new extremes in the depraved figure of Paul Eric de Fertzen, the 'uncommonly perfect being' at the centre of *The Unnaturals* (1897), significantly subtitled *Modern Manners*: 'He no longer dressed as a woman but looked like a woman in disguise…, cutting his hair very short, so that it completely bared the nape of his neck…he kept two natural waves, forming an extraordinary diadem in which could be detected a hint of devilish horns, thus turning him into a *he* after having been very much a *she*. And these two charming creatures merged, ever more inseparably, into a terrible hermaphroditism.'

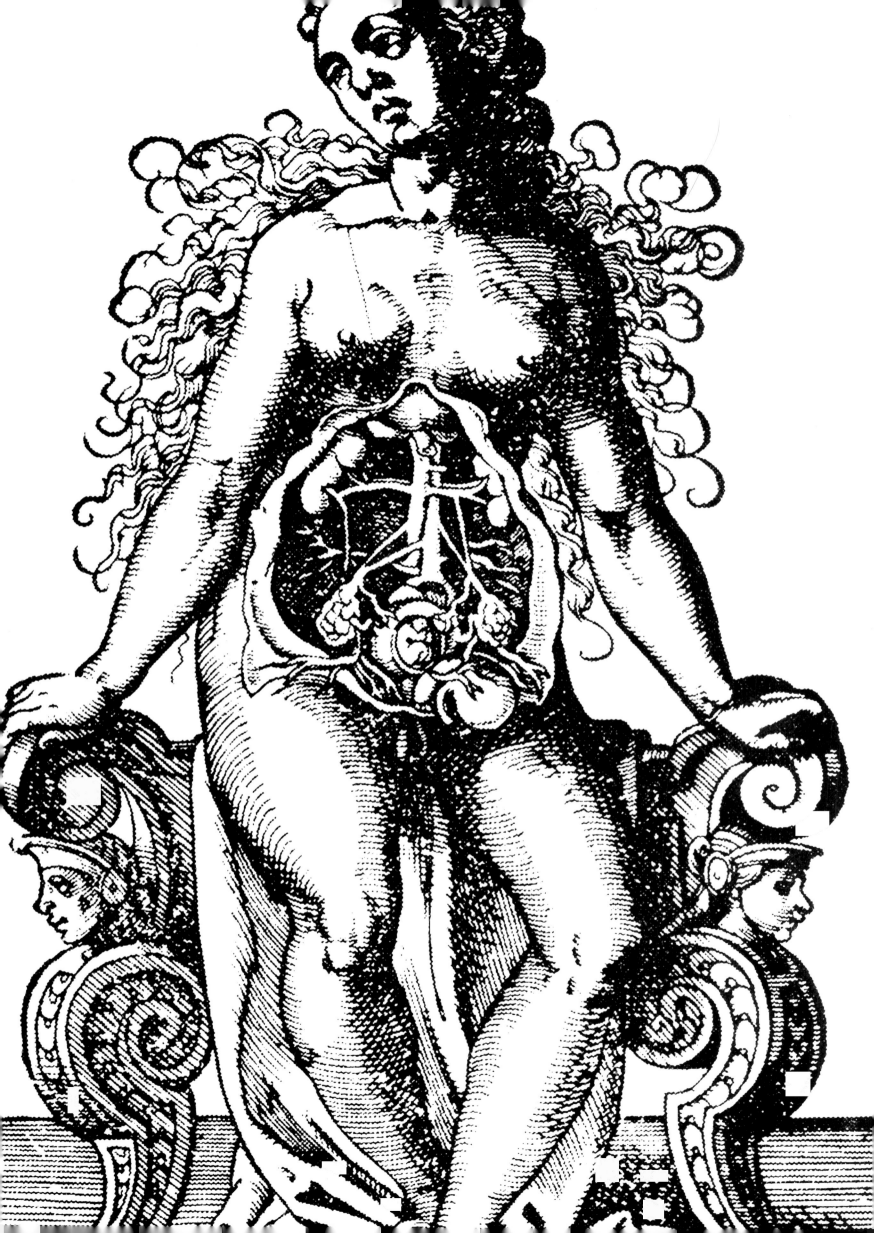

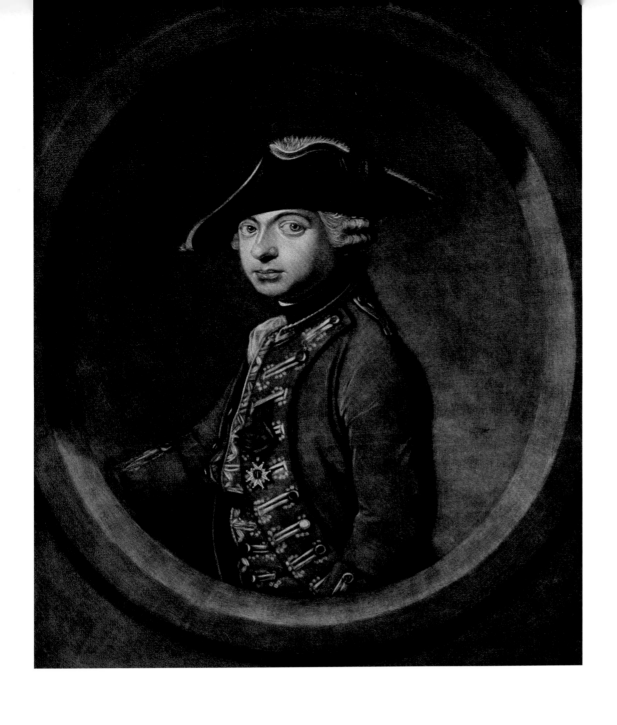

Above: Portrait of the Chevalier D`Éon by V. Vispré, mezzotint, 18th century
Opposite: Jarrod Branch, *GQ* Japan, 2006. Photograph by Frederic Auerbach

Overleaf: Portraits of the Chevalier d`Éon by P. Jean Baptiste Bradel, etching, 18th century

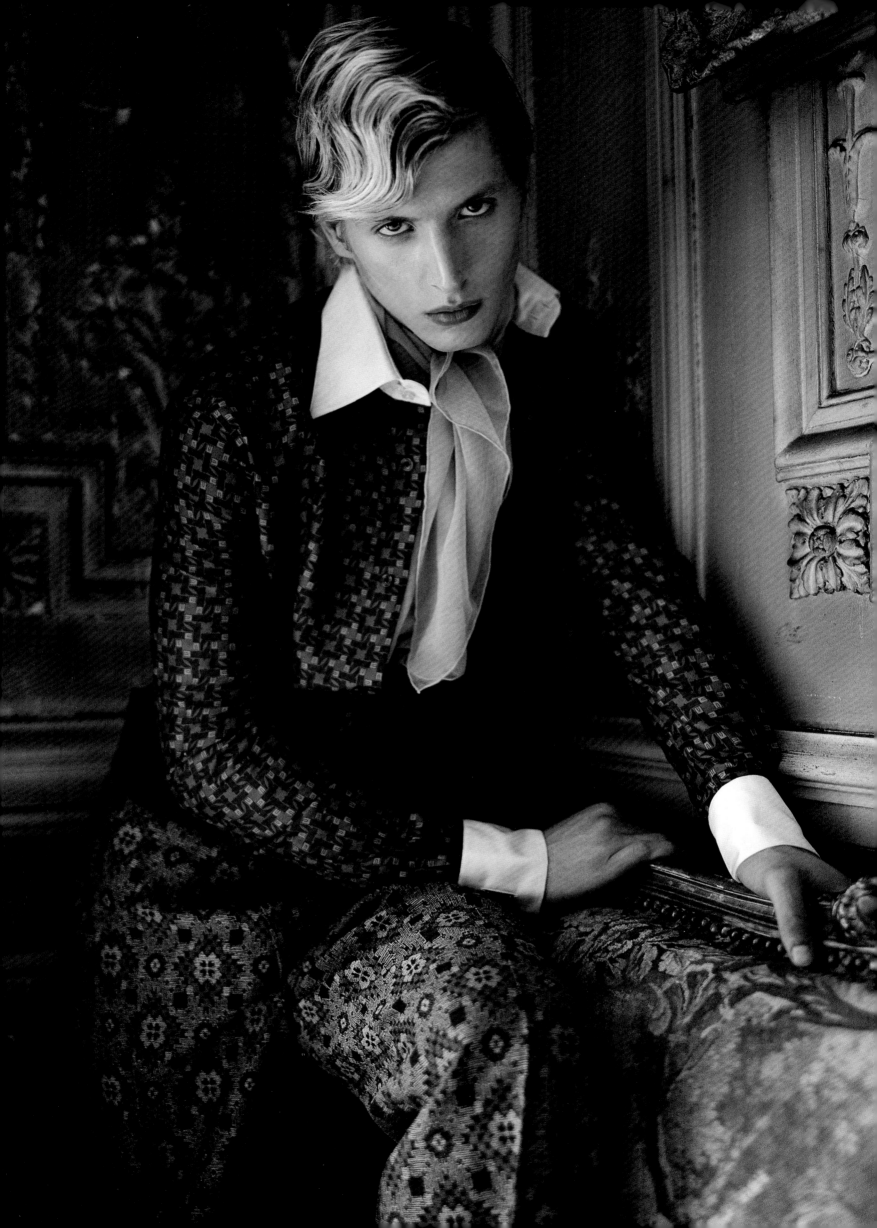

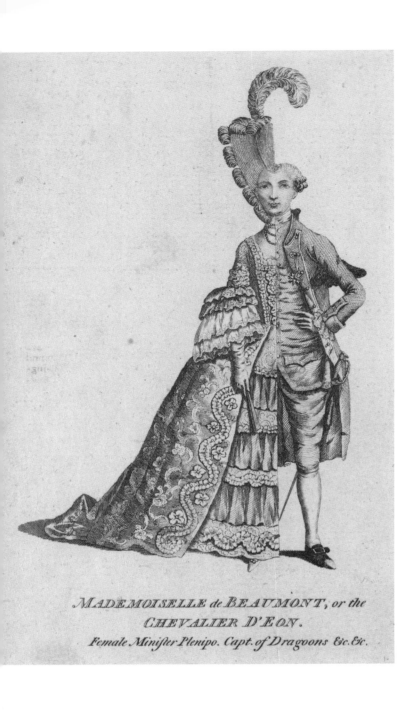

MADEMOISELLE de BEAUMONT, or the
CHEVALIER D'EON.
Female Minister Plenipo. Capt. of Dragoons &c.&c.

Above: *Mademoiselle de Beaumont, or the Chevalier d'Éon*, engraving, 1777
Opposite: Szandra Szilvassy, *Alef*. 2007. Photograph by Jamie Isaia

Elijah Tyedmers, *Men's Style*, 2013. Photograph by Steven Chee

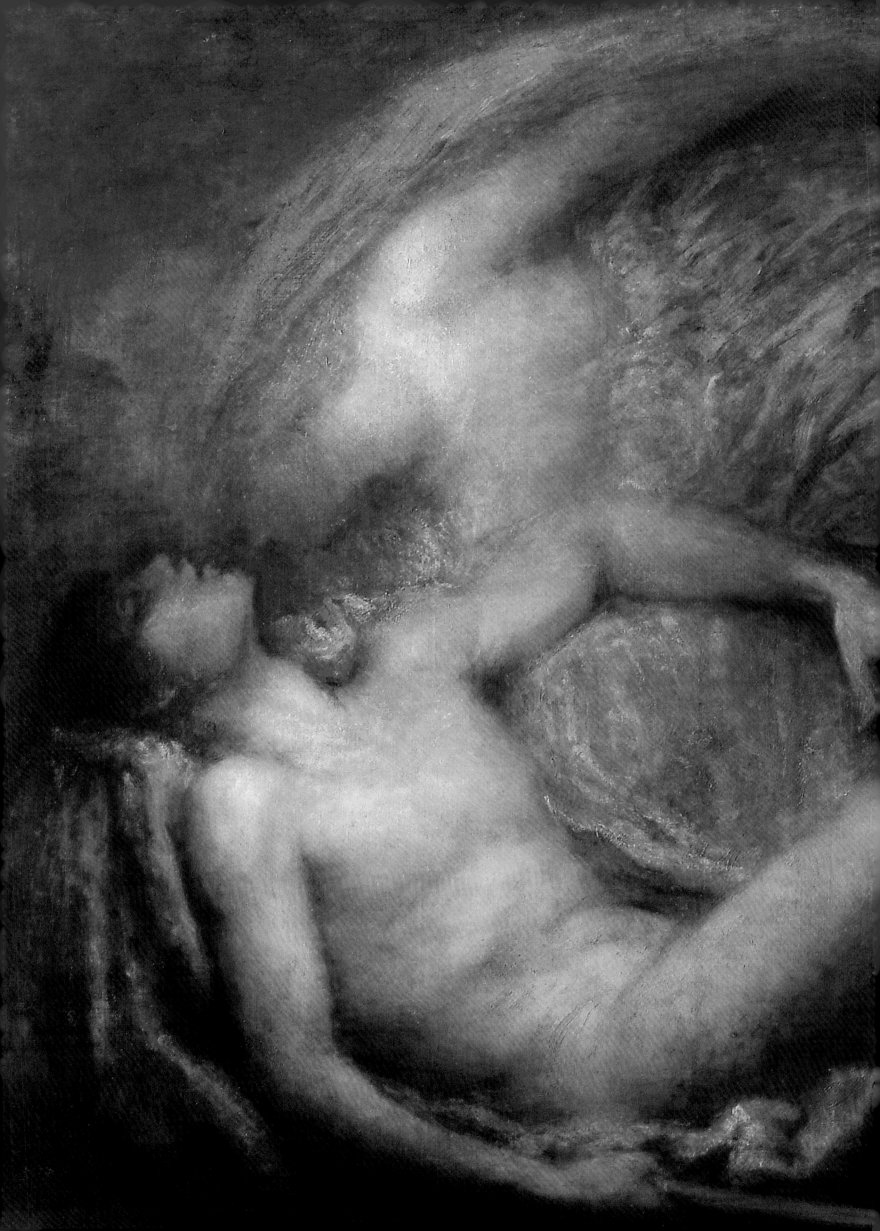

THE
'ANDROGYNO-
SPHINX'

If there was one person in the late nineteenth century whose life and works were magnetically drawn to the motif of androgyny it was the prolific and shadowy Joséphin Péladan, who defined his own century's attitudes to the subject against the archetypal 'delectable page boy' of the 1700s. A novelist, art critic and occultist, Péladan gained notoriety with the publication of *The Ultimate Vice* (1884), an ornate and mystical tale in which he championed the ideal, as opposed to the dominant naturalism of the 'pig Zola', and which received an enthusiastic reception from sophisticated literati. This became the first in a twenty-volume series collectively entitled *Latin Decadence*, which included among its exotic titles a slim volume dedicated to *The Androgyne* (1891). He followed this with a seven-volume cycle entitled *The Amphitheatre of Extinct Knowledge* (1891–1911) and dozens of plays and essays, including several devoted to his two heroes, Richard Wagner and Leonardo da Vinci. Convinced that the latter was his aesthetic forerunner, he made Leonardo the subject of a ponderous prosopopeia, *The Final Lesson of Leonardo da Vinci* (1904). He later published editions of the fourteen Leonardo manuscripts preserved in France, so playing a significant role in the artist's re-evaluation.

Carried away by his initial success, Péladan, who already styled himself a 'magus', now went one better: he adopted the title of 'Sâr' ('king' in Assyrian) and the name of 'Merodak' (a Babylonian ruler) – whereupon he was immediately lampooned with a shower of mocking nicknames, including the scathing 'Artaxerfesses', which played on the ancient Persian king Artaxerxes and a word for 'buttock' (*fesse*). With cascading curls and a lush beard clipped into twin points and anointed with cedar oil, the gloved and pomaded Sâr presented himself to his public in a tunic with Peter Pan collar and flowing sleeves and a bouquet of violets at his throat. Thus garbed, and after having founded and then left a variety of esoteric and cabbalistic orders, in 1892 Péladan organized the first of the six annual Salons de la Rose + Croix, which gave form to his artistic credo and also his obsession with androgyny. Although artists such as Gustave Moreau, Edward Burne-Jones and Pierre Puvis de Chavannes were scared off by Péladan's outrageous persona and failed to respond to his repeated entreaties to rally to the cause, they are nonetheless associated with his vision of 'subtlety as an ideal'. But a number of major figures in the Symbolist movement, including Fernand Khnopff, Ferdinand Hodler, Jean Delville and Henry de Groux, did regularly take part – to the accompaniment of Erik Satie's fanfares – in Rose + Croix events.

George Frederick Watts, *Endymion*, oil on canvas, 1903

'The beauty of a man', Péladan postulated, 'lies in his feminine attributes, the beauty of a woman lies in her male attributes, in proportions that are impossible to formulate but can nonetheless be conceived,' before going on to overload his metaphor: 'In reality, every man offers a series of broken lines without charm and every woman presents a series of curves without style. The formal issue, therefore, is how to round off the angles of the one and smooth out the curves of the other. The architecture of the male sex may be compared to the straight beam and of the female sex to the round arch; and we shall assume that the architecture of androgyny is related to the pointed arch.'

Historically, Péladan declared, 'Androgyny, a plastic synthesis, was to find its perfect form with the ancient Greeks, the most synthetic minds that ever existed.... The Minerva of Selinus is a handsome young man to whom a bosom has been added; the Minerva Albani, a copy of an ancient original, was posed by a man.' And this form of androgyny could only be perfectly represented, in a manner that would become familiar, in the intermediate and ambiguous state of adolescence. 'The virginal male', said Péladan, 'would be a good synonym for the androgyne, expressing the flower-like state of the body and the purity of the soul.... Androgyny is not so much a category as a transitory state, a glorious period that we observe in both young men and young women.'

Taking a swipe at the history of western art, Péladan saw the 'third state of the human body, blending strength and grace more than lasciviousness', as a theme shared by the twin pinnacles of aesthetic achievement: classical Greece and Renaissance Italy – and so, by implication, by their resurgence in Spiritualist, Pre-Raphaelite and Symbolist art, of which Péladan was the self-elected champion. 'The androgyne of Greek civilization will be reborn in the form of the angel of Christianity,' he proclaimed. From Fra Angelico through Benozzo Gozzoli and Raphael, 'all painters up to Guido Reni merged and multiplied the beauty of the sexes one with the other, in order to obtain an angelic form'. The absolute master of this miraculous synthesis, the artist who alone was able to 'give form to the invisible', was of course none other than Leonardo da Vinci, painter of the *Mona Lisa* and of that 'androgyne beyond compare, more enigmatic than the great Sphinx', *St John the Baptist*. When faced with these paintings, 'neither scholar nor neophyte differs in their reaction; they experience the same, almost *musical*, disturbance. Here, the painter's art has sought, and succeeded in portraying, the very nature of harmony: the *indefinite*.'

Given its abiding physical form in Leonardo's late works, 'the Androgynosphinx', says Péladan with an oracular flourish, 'represents a humanity that trusts in the resurrection manifested in every dawn'.

AMAZONS

'Impassive, intangible', Joséphin Péladan's androgyne eluded the grasp of sex and lust. This was a creature who was not only sublime but also embodied the sublimation of the passions; who recoiled in horror before the merest hint of homosexual effeminacy, denounced the 'sodomitical obscenities of Petronius and the filthiness of Martial'; and who was an early denizen of the Empyrean realm that would later be dubbed 'No Sex'. Péladan's androgyne thus seems to be the exact opposite of Rachilde's ambiguous characters, who were devoted wholly to the pursuit of the most sophisticated of pleasures and perversions.

Although Péladan and Rachilde might appear as decadent and dated as the figures in their writings, neither of them were solely products – or entirely representative – of their era's cult of the bizarre and the kitsch. Péladan's spiritualist vision found a way to survive beyond Symbolism in some of the theoretical positions adopted by modern art. After staging the final Salon de la Rose + Croix in 1897, he declared loftily: 'I lay down my weapons. The artistic expression that I have championed is now accepted everywhere, and once the river has been crossed, why should anyone remember the guide who led the way to the ford?' In this, at least, his prediction proved correct, for he was to die in total obscurity, having devoted the last twenty-two years of his life to his second wife. Rachilde, meanwhile, though indisputably a fully fledged eccentric, was at the same time not only a major figure in the French literature of the late nineteenth and first half of the twentieth century – tirelessly writing throughout her long life no fewer than sixty-five works in many genres – but also a true pioneer in gender issues.

Born in Périgueux on 11 February 1860, into a family that would nowadays be described as dysfunctional, Rachilde rejected the conventions of femininity at an early stage. On her arrival in Paris she adopted an ambivalent appearance, published work under a variety of male pseudonyms, and in 1885 – in the wake of the success of *Monsieur Vénus* – even obtained official permission from the City Council of Paris to wear men's clothes in public, as required under a law enacted in 1800 after the French Revolution. To give an idea of how unusual this dispensation was, in 1890 the press published a bizarre and incomplete inventory of those who had been granted the same licence: 'There are presently ten women in Paris and its environs who are authorized to wear male attire. They include the manageress of a printing house, who can most certainly pass as a man; a woman who works as a painter in the building trade; an artist; a bearded lady, who once appeared at the Éden Theatre; two people with deformities; and, finally, a woman who

displays every outward sign of being a man, and so would look ridiculous if she were to don the clothes of her own sex. What is more, a potato-seller in the suburbs has been granted permission to wear women's clothes all the time because of an infirmity that makes it impossible for him to wear men's clothes.' With her hair cut short – as she appears in the artist Félix Vallotton's portrait sketch of 1898 – and dressed in masculine attire, Rachilde anticipated the androgynous type that gave its name to Victor Margueritte's notorious novel *The Tomboy* (1922).

In 1889, she married Alfred Valette, editor of the *Mercure de France*, a Symbolist literary review, and soon began to host one of the most important literary salons of the age, where Paul Verlaine, Stéphane Mallarmé and Joris-Karl Huysmans rubbed shoulders with Oscar Wilde, André Gide and Guillaume Apollinaire. By championing figures like Apollinaire, Rachilde played a role in the move towards modernism, a role that has been overshadowed by her love of controversy and grand gestures.

Among the lesser known guests at Rachilde's salon was the young American writer Natalie Clifford Barney, whose career followed a path not dissimilar to her own. They shared the same desire to break away from their families; the same love of sexual ambiguity (although, unlike Rachilde, Barney was openly lesbian); the same remarkable longevity (they both lived to be almost a hundred); and the same indefatigable enthusiasm for salon life and networking. Despite her mercurial literary talents, Barney ended up making a spectacular entrance on the Parisian scene in fictionalized form, in the celebrated courtesan Liane de Pougy's *Sapphic Idyll* (1901). Reprinted seventy times in its first year of publication alone, this *roman à clef* offered a thinly veiled account of their passionate relationship which, inevitably, caused a scandal.

When her father died a few months later, Barney found herself in possession of a considerable fortune. This she dedicated to free living and a series of literary and amorous conquests, including the poet Renée Vivien, the prolific writer Lucie Delarue-Mardrus, the inscrutable novelist Colette and the aristocratic biographer Elisabeth, Duchesse de Clermont-Tonnerre, a relationship that lasted until the duchess's death in 1954. This affair did not prevent other liaisons; in 1914, Barney embarked on a long relationship with the American artist Romaine Brooks, who painted a series of elegant portraits of this close circle of women.

The title of the 1910 collection of aphorisms that sealed Barney's reputation, *Scatterings*, suited her perfectly. It also attracted the curiosity of the reclusive literary stylist Rémy de Gourmont, who fell madly in love and immortalized her in two hundred and twenty-two *Letters to the Amazon* (1914), so endowing her with a lasting nickname. 'Miss Natalie Clifford Barney exerted an almost hypnotic, not to say supernatural, power over Rémy de Gourmont,' wrote Maurice Martin du Gard in his classic memoir of the era's intellectual milieu; while, in his usual scathing fashion, the theatre critic Paul Léautaud wondered in his diary how 'this penetrating, challenging, sarcastic, disdainful mind' could have 'written all this sentimental claptrap'.

Many others attested to the 'hypnotic power' exerted by 'the Amazon' over those who had dealings with her, and which perhaps lay behind her most substantial success: the salon at which she presided every Friday for over half a century in her 'Temple of Friendship'. This charming pavilion, set in the grounds of 20 rue Jacob in Paris, attracted a galaxy of prominent twentieth-century writers, from James Joyce, Rainer Maria Rilke, Jean Cocteau and T. S. Eliot to Françoise Sagan, Marguerite Yourcenar, Truman Capote and Scott and Zelda Fitzgerald. Another guest was Radclyffe Hall, self-described 'congenital invert' and author of the infamous and overtly lesbian novel *The Well of Loneliness* (1928).

Barney's charisma and social skills assured Hall a place of honour in the international community of lesbians that developed in Europe from the 1920s onwards, and which was captured in the seductive portraits of Romaine Brooks, with their restrained palette of deep mauves and silver-greys, and of the English painter Gluck (Hannah Gluckstein),

which were cooler and sharper in mood. Both artists depicted an entirely new form of androgyny, one that replaced the feminized male with the masculinized female. The two most noticeable signifiers of this transmutation were cropped or bobbed hair, sacrificing the long and luxuriant tresses that were the traditional sign of femininity in western society, and the wearing of men's suits – to which one might add not wearing make-up. One of the most memorable representations of the first two features at least is the portrait painted by Romaine Brooks in 1924 of Radclyffe Hall's companion Una Troubridge, in which the sitter resembles an idealized version of Countess Geschwitz, the despairing lover of Lulu – the heroine of the German dramatist Frank Wedekind's *fin-de-siècle* plays immortalized by Louise Brooks, another icon of androgyny, in G. W. Pabst's film adaptation *Pandora's Box* (1929).

These 'Amazons', along with the 'tomboys' or *garçonnes* and their somewhat different priorities, helped to pave the way for the integration of men's clothes into women's fashion. From 1915 onwards, it was a leitmotif in the designs of Gabrielle 'Coco' Chanel (the fact that she was friendly with several of these pioneering women is no coincidence), and found its ultimate expression in Yves Saint Laurent's iconic 'Le Smoking' suit of 1966. By appropriating the trappings of masculinity for themselves, these women not only offended social mores – in France, for example, although the law forbidding women to wear men's clothes was partially repealed in 1892 and 1909, it was only abolished outright in 1946 – but they also undermined the purely formal, conventional character of male dress, subverting its dual function of concealing the body and affirming power, and playing on the tension between the 'extravagance' of female fashion and the neutrality and invisibility of the male 'uniform'. 'The female wardrobe', writes the English artist Grayson Perry, himself a heterosexual transvestite, 'is seen as one big extraneous addition, all artifice, hairdos, make-up, frills and heels, while men's clothes are entirely necessary for function and little more.' This vision is founded on a sense or conviction that is widespread but unsubstantiated: 'I grew up feeling somehow that men just are, while women have to work at it.'

Painters, poets, memoir writers and socialites, most of them with personal wealth that ensured their independence, the Amazons – like other similarly unconventional women throughout history – regarded themselves merely as singular, 'artistic' individuals. But they also benefited from the advances made by feminism in Europe from the mid-nineteenth century onwards, and from the very slow changes in attitude that followed. Increasingly, in the early decades of the twentieth century, the playing with, and assertion of, ways of being male was no longer restricted to a tiny coterie of the privileged few. It echoed the even greater freedoms embraced in the cabarets of Vienna and Berlin after the First World War that inspired writers such as W. H. Auden and Christopher Isherwood. And it found new forms of expression in the Hollywood films of the 1930s influenced by the European writers, directors and actors who took refuge in the United States from the advent of fascism. Marlene Dietrich, who played deliberately with ambiguity both on screen and in life, was perhaps the most magnificent example; while Lotte Lenya and Valeska Gert also challenged expectations, alongside Louise Brooks (who served as a link in the other direction between Hollywood and Berlin) and even Greta Garbo and Katharine Hepburn, as the cross-dressing heroines of Rouben Mamoulian's historical drama *Queen Christina* (1933) and George Cukor's romantic comedy *Sylvia Scarlett* (1935).

FLAMING

CREATURES

A love of cross-dressing, or at least a playful attitude to the expressive possibilities of clothes, were traits shared by the Amazons and her contemporary analogue or counterpart, the young, privileged and uniquely British 'aesthetes' who flourished in the 1920s. Distant heirs to the decadence of Oscar Wilde and Aubrey Beardsley – heirs also to the longstanding Oxbridge antagonism between aesthetes and 'hearties': rugged athletic types, more interested in beer than study – these delicate, artistic and bohemian young men who put on lavish and ostentatious displays of effeminacy were briefly to become influential arbiters of taste.

These 'Bright Young Things' – of whom perhaps the most prominent figure was the photographer Cecil Beaton, sometime lover of Greta Garbo – challenged the overwhelming conformity of British society at the time. Too young to have been involved in the Great War, provocative and wilfully arrogant, they flaunted a supreme insouciance and brazen immaturity while indulging in an endless round of cocktails, house parties and unabashed hedonism. They were often dilettantes of distinction, who ploughed their genius into their lives more than their work, like the society darlings Brian Howard and Gerald Tyrwhitt, Lord Berners, who by some oversight did contrive to leave behind them some musical, literary and artistic works. They mixed with artists and designers such as Rex Whistler and Oliver Messel, and writers and poets such as Harold Acton, Siegfried Sassoon, the Sitwell siblings – Edith, Osbert and Sacheverell – the future poet laureate John Betjeman and the dyspeptic Evelyn Waugh, who eventually lent a literary dignity to these lost souls in his caustic novel *Vile Bodies* (1930) and the nostalgic *Brideshead Revisited* (1945).

One of the targets of Waugh's spleen was Stephen Tennant, 'brightest of the Bright Young Things', who seemed to distil in his person all their faults and virtues. Born into the Scottish aristocracy in 1906, he was (according to Cecil Beaton) brought up by his mother, the redoubtable Lady Glenconner, 'to be a genius'. She also – reprising a now familiar motif – dressed him in girls' clothes, decking him out in frills and lace until he was eight. Subsequently, the young man's only goal in life (again according to Beaton) was 'to evade the more unpleasant aspects of reality'.

When Beaton, the product of less elevated social circles, first encountered Tennant, at a ball in 1926, he was dazzled by this languid young man's nonchalant self-assurance, brilliant conversation, flamboyant manners and ambiguous beauty. 'I don't know if that's a man or a woman,' a highly respectable admiral was heard to remark on one occasion, after passing Tennant on his way out of a restaurant, 'but it's the most beautiful creature I've ever seen'. More inclined to dream about things than do them, however, Tennant confined himself largely to coming up with ideas, to which Beaton was then eager to give form.

Edith Sitwell, an authority on such matters, wrote that only the sense of infallibility that was unique to the British could explain the tradition of eccentricity peculiar to them. Tennant was the very exemplar of this notion, his life offering a string of anecdotes that stretch credulity to the limits. In a period when this was fraught with risk, he made strenuous efforts to defy – with imperturbable insouciance – all the rules that applied to his sex. 'Stephen was extremely amiable,' observed the historian Lytton Strachey after meeting Tennant, 'though his lips were rather too magenta for my taste'. On a visit to London during the Blitz, it was reported, a bomb blast sent Tennant flying through the doors of the Ritz along with the hotel's page boy. He simply picked himself up, dusted himself down and compared the pair of them to Peter Pan and Wendy, before expressing concern for the welfare of the hotel's crystal chandeliers. According to Beaton, his bathroom was 'a great juxtaposition of face creams, scents, soaps, antiseptics, coal tar mouth wash, celluloid goldfish, and every sort of sponge and loofah', the purpose of which, he would say, was to protect him. 'But from what?' wondered a perplexed Rex Whistler.

On the pretext of delicate health, Tennant lived as a recluse in his damp if pretty ancestral home, Wilsford Manor in Wiltshire, amid a confusion of books and *objets*, draperies and hangings in pink silk (his colour), walls covered with silver foil decorated with sequins, shells and starfish, Baroque furniture, satin couches, and Victorian pouffes covered in leopardskin. 'A Miss Havisham gone berserk,' remarked an amazed Beaton, whose own tastes in decor were scarcely restrained. It was in this overblown but slightly shabby setting that Tennant reclined like an eighteenth-century salon hostess and devoted himself to not finishing his magnum opus, a novel set in the louche sailors' bars of Marseille, prophetically entitled *Lascar: A Story You Must Forget*.

Some have described this life spent in dedicated and intransigent idleness as nothing but a failure: 'He even failed to die young,' wrote one callous commentator. Much like the Chevalier d'Éon, Tennant did not expire at the peak of his glory, but lingered on as an elderly hypochondriac until his death at the age of eighty on 28 February 1987. Shut away in interiors untouched by any hand but time, the lissom androgyne metamorphosed into a plump, dishevelled and outrageously made-up figure, whom his waspish friend Beaton described as 'lying like a porpoise…fat & appallingly painted'.

An artist without a body of work, Tennant was nonetheless, in his own way, a harbinger of things to come. He belonged to a neo-Romantic shift in sensibility that is often neglected in terms of its significance to the history of art and fashion in the 1930s–50s, which championed eclecticism and a taste for the rococo, the dreamlike, the baroque and the bizarre in the face of the stripped-back austerity of modernism. Behind the flamboyant frivolity of the Bright Young Things lay an approach to life that was resolutely theatrical and playful, punctuated by a whirl of jamborees, costume balls and Arcadian garden parties, where Cecil Beaton was master of ceremonies, photographer and chronicler. At the same time, they cultivated a serene manner of displaying to the world morals and manners that were widely considered the height of scandal. Even today, going out in a football jersey with ostentatiously coordinated earrings – as Stephen Tennant did in 1928 – takes a little courage.

Romaine Brooks, *Una, Lady Troubridge*, oil on canvas, 1924

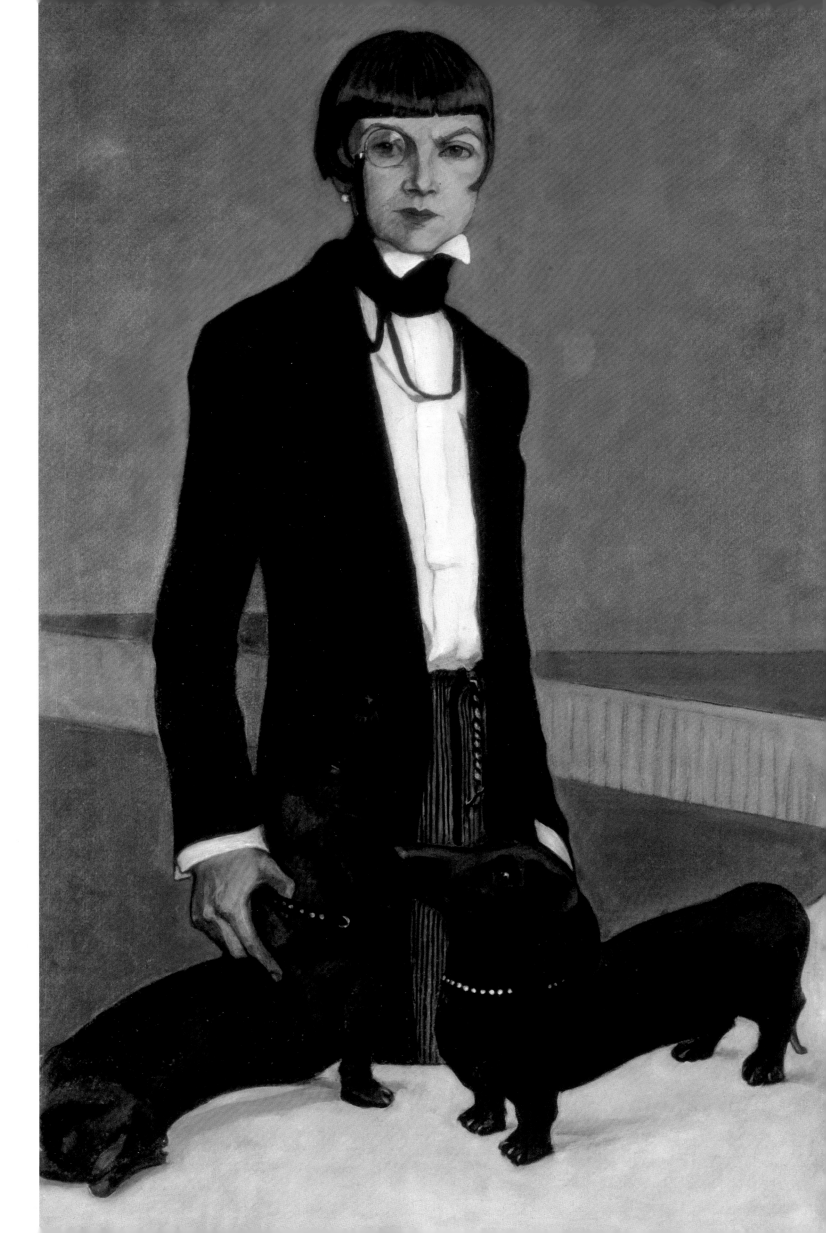

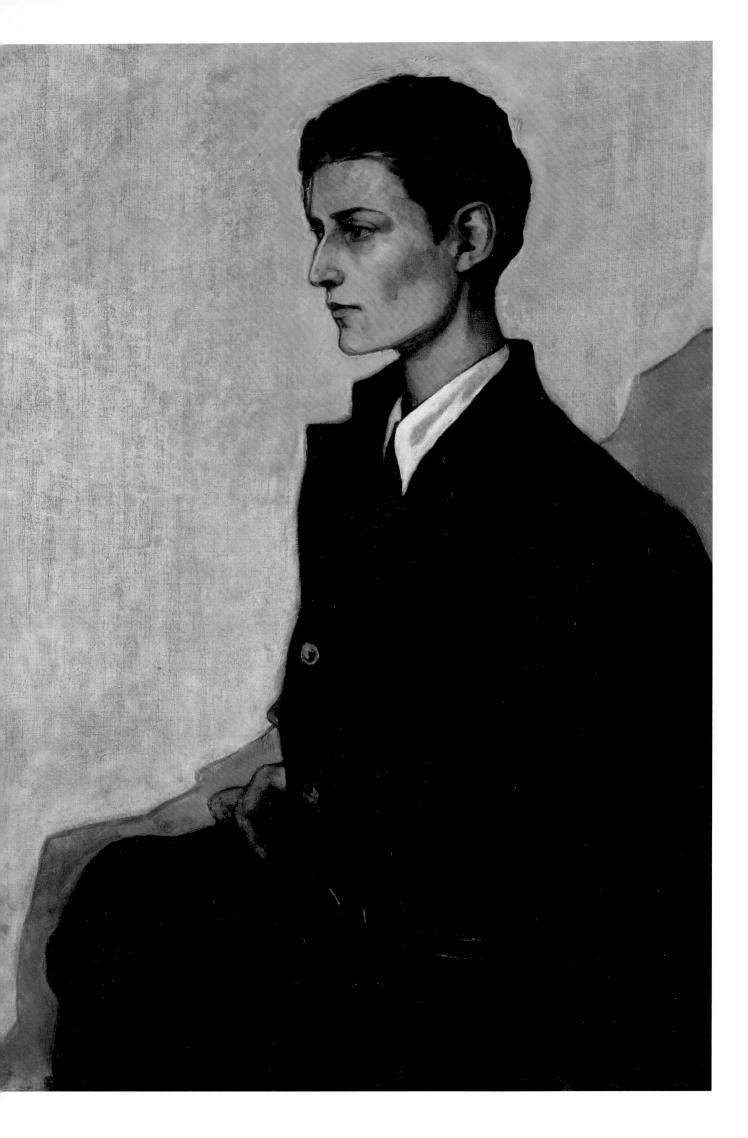

Above: Romaine Brooks, *Peter (A Young English Girl)*, oil on canvas, 1924
Opposite: Annemarie Schwarzenbach, Berlin, 1931. Photograph by Marianne Breslauer

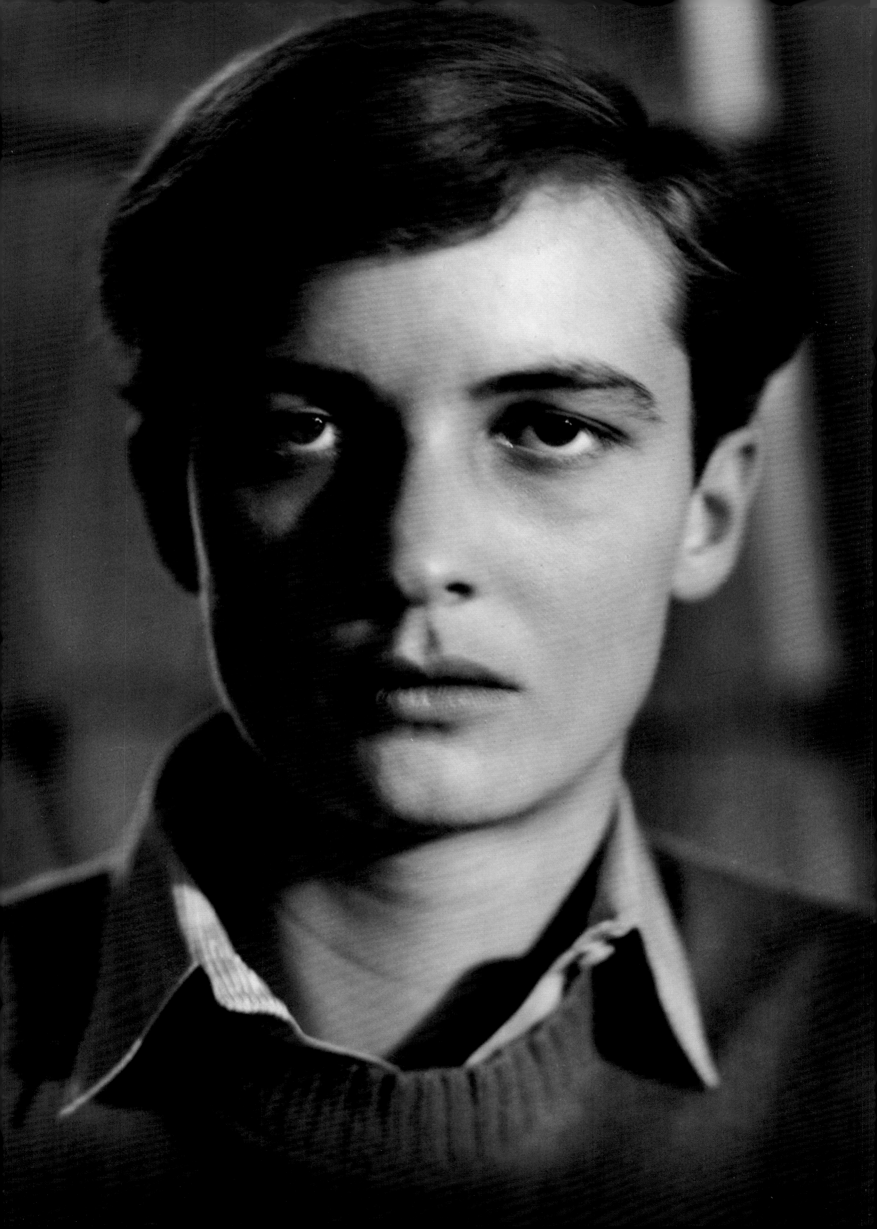

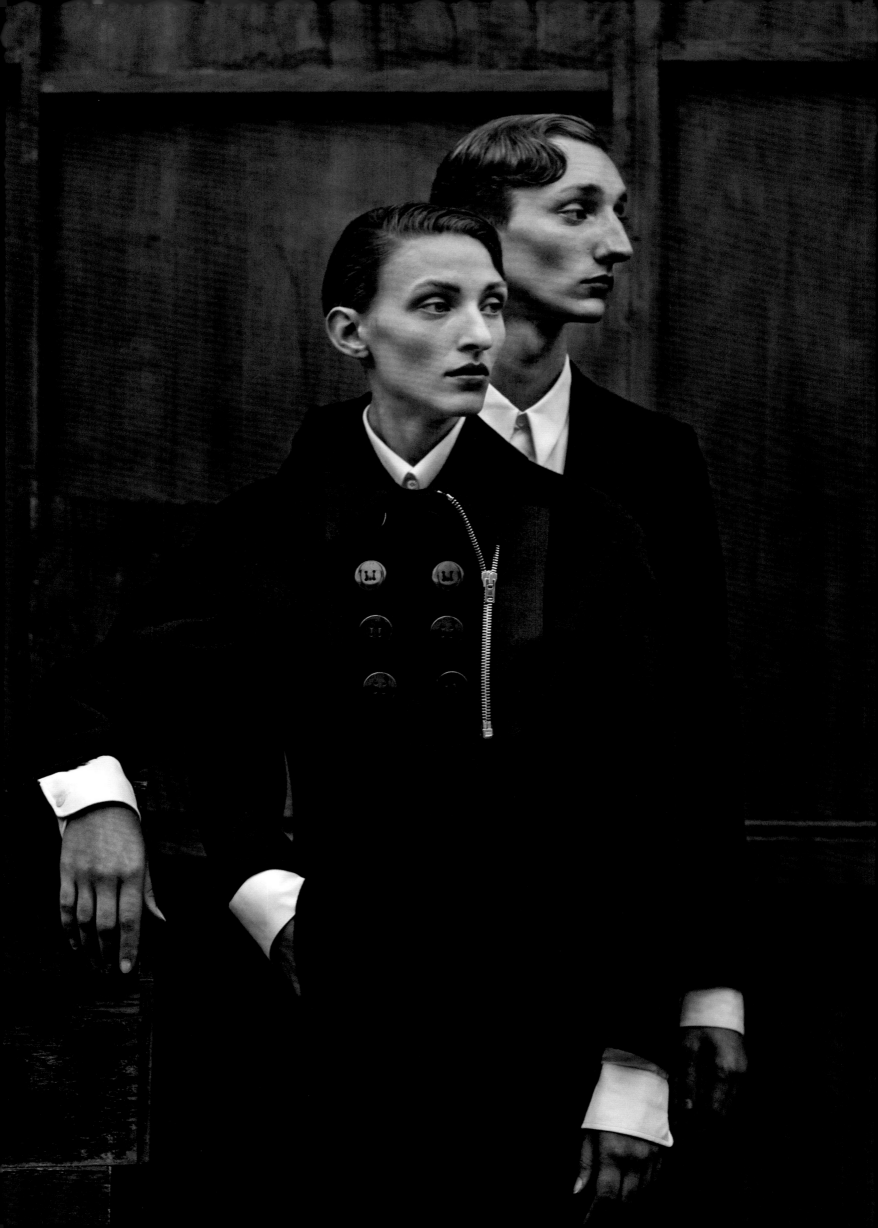

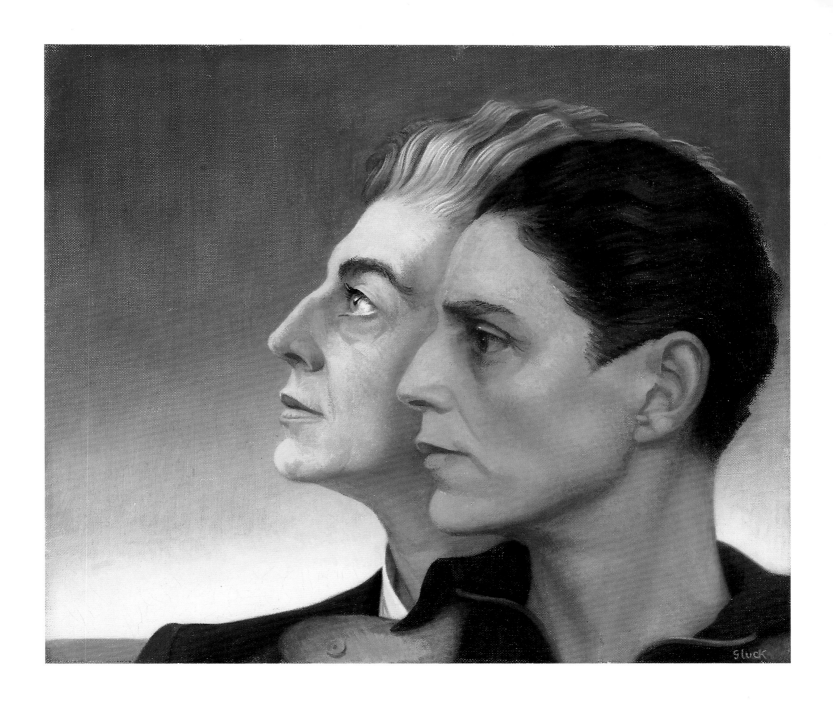

Above: Gluck, *Medallion (YouWe)*, oil on canvas, 1936
Opposite: Maggie Maurer and Tom Gaskin, *Numero*, 2013. Photograph by Julia Hetta

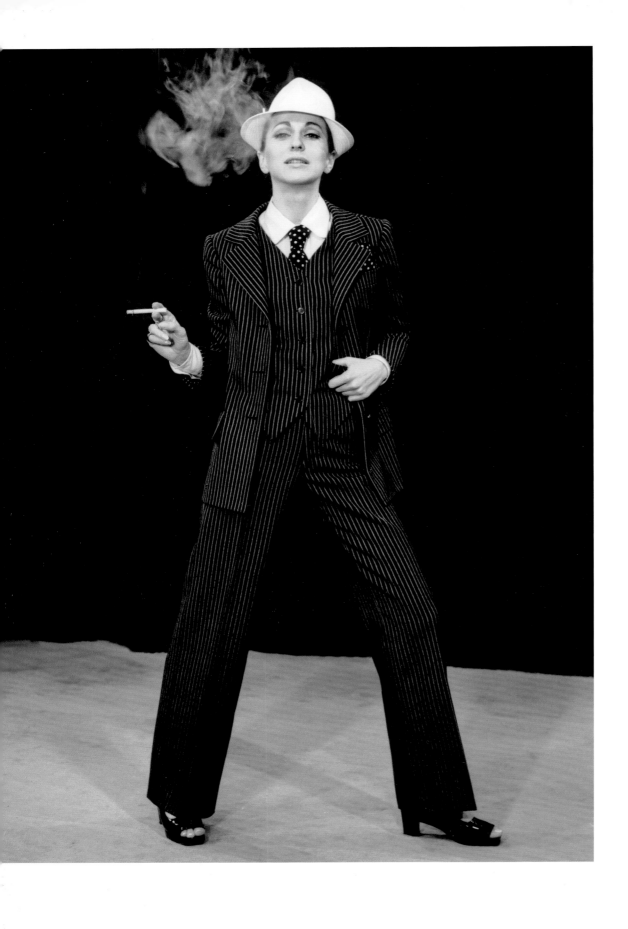

Above: Pinstripe trouser suit by Yves Saint Laurent, 1967. Photograph by Reg Lancaster
Opposite: Odette Pavlova, *Interview*, 2016. Photograph by Fabien Baron

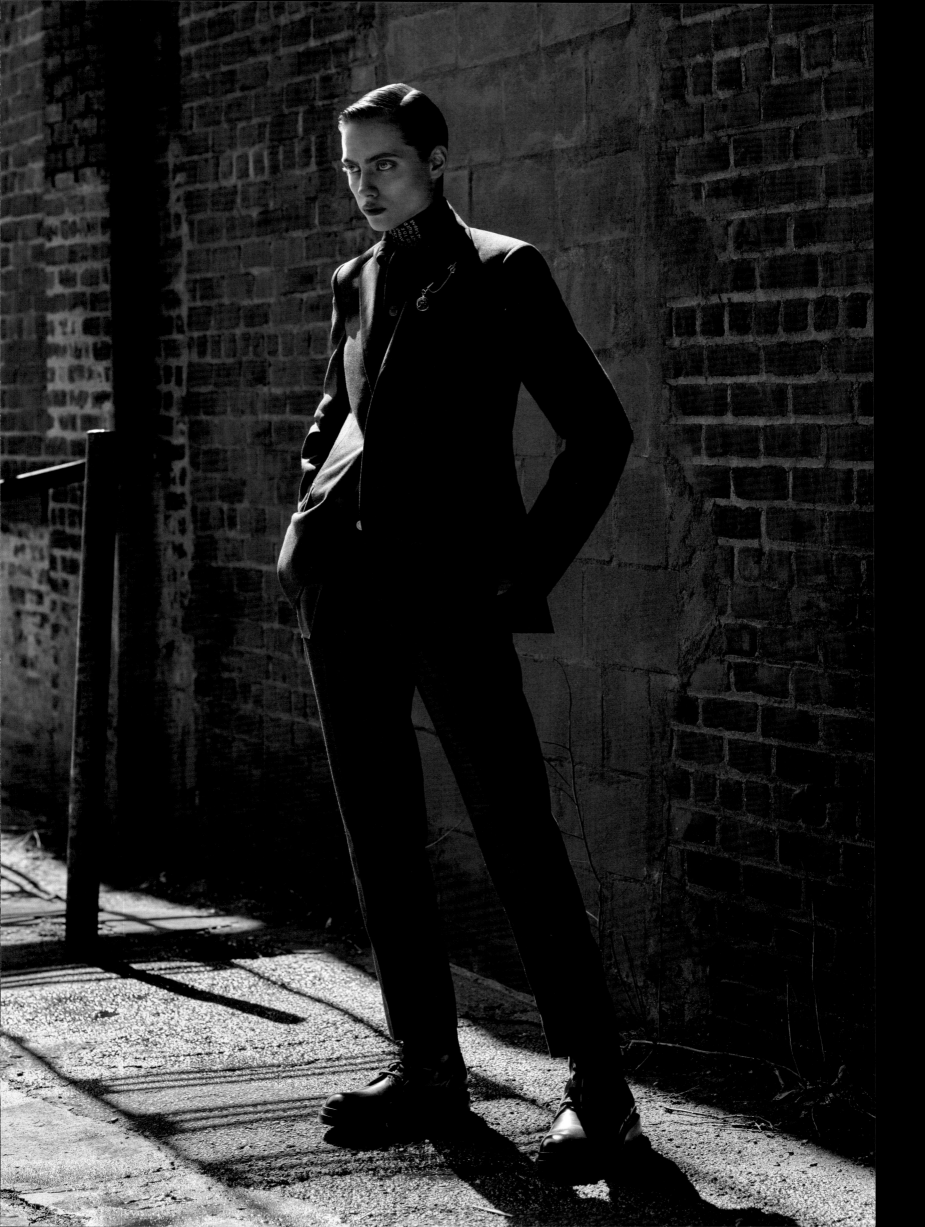

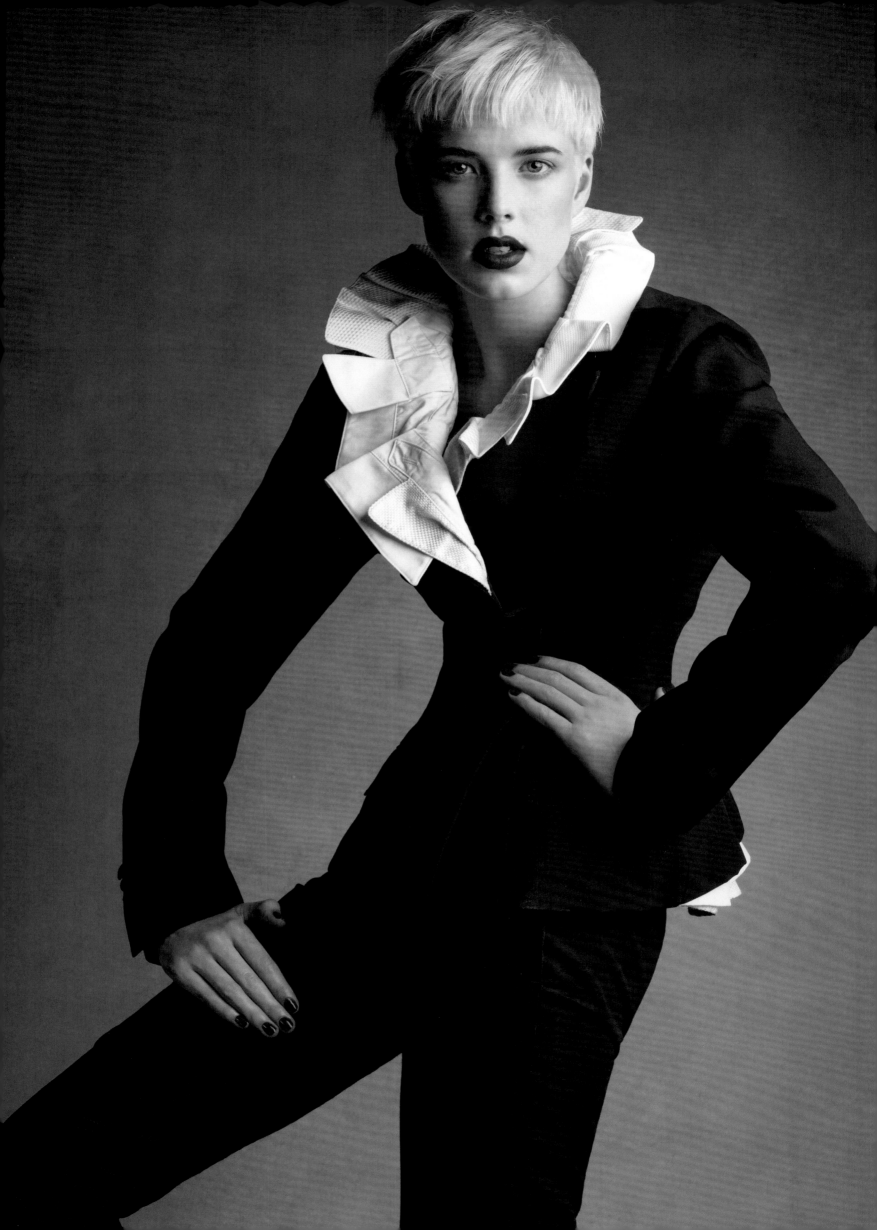

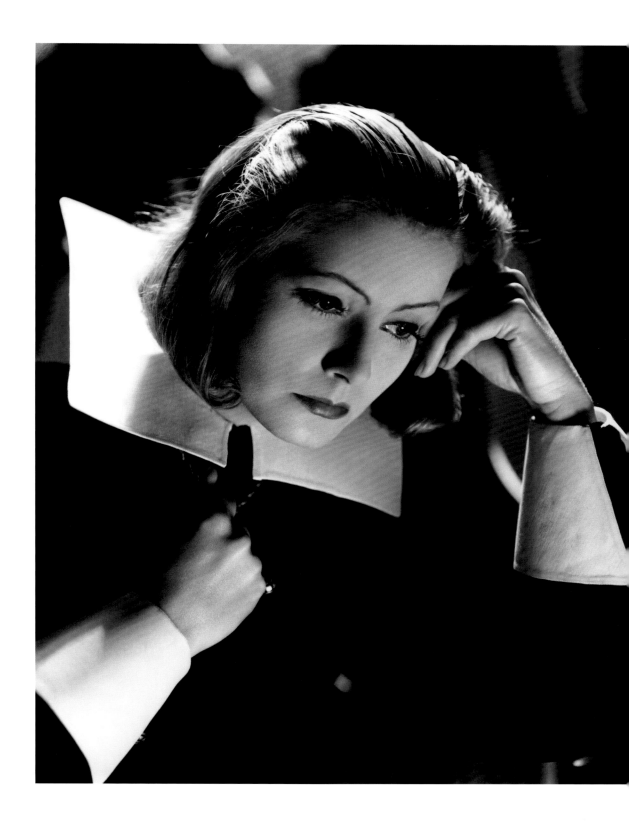

Above: Greta Garbo in *Queen Christina*, directed by Rouben Mamoulian, 1933
Opposite: Agyness Deyn, *Vogue*, 2007. Photograph by Patrick Demarchelier

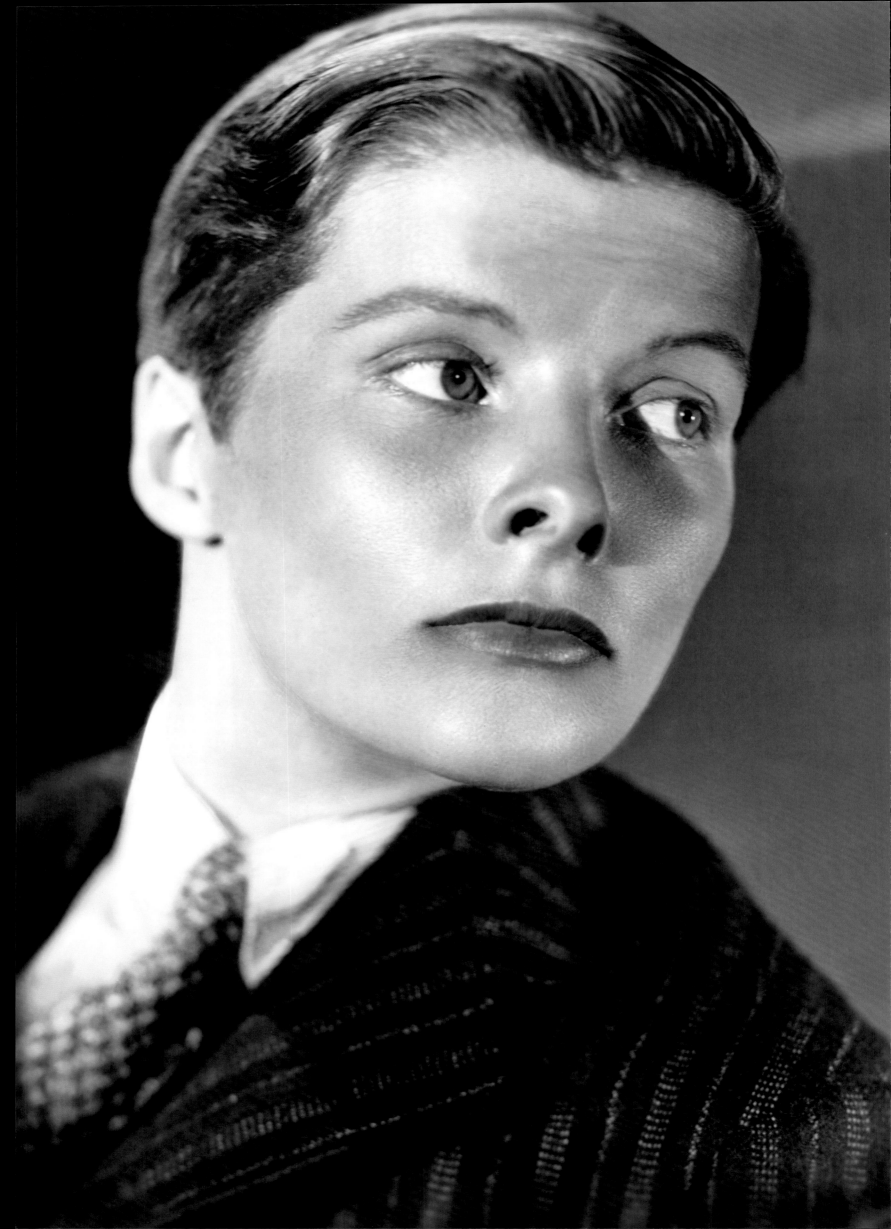

Opposite: Claude Cahun, *Self-portrait*, 1927

Overleaf: Erika Linder, 'On the LA Make', *Arena Homme +*, 2014. Photograph by Alice Hawkins

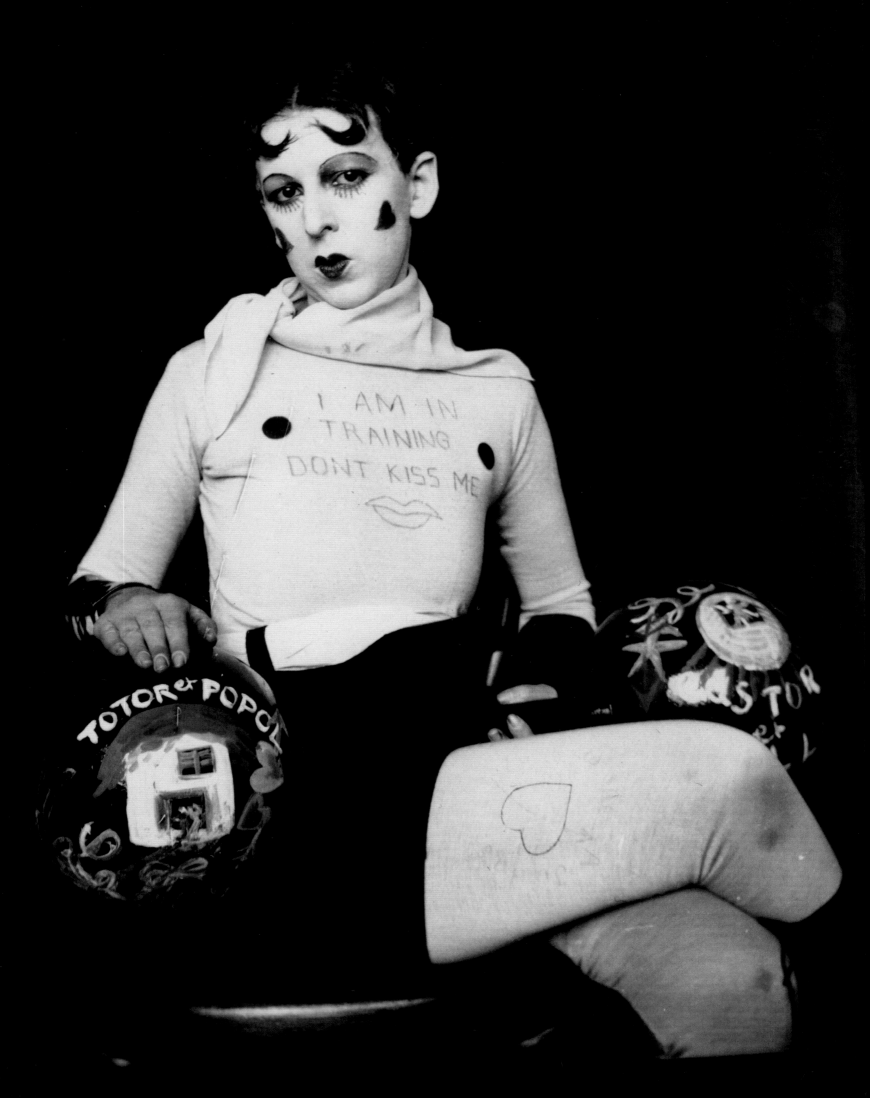

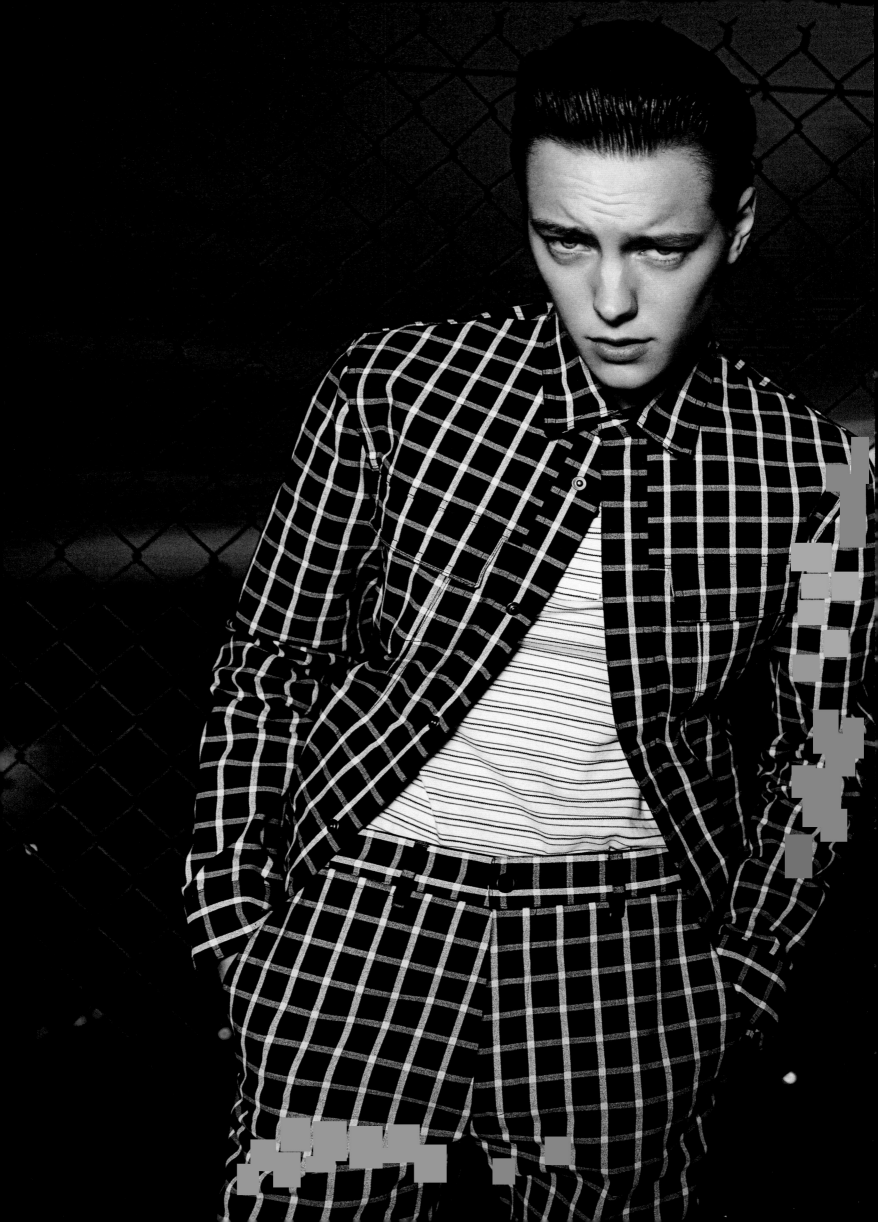

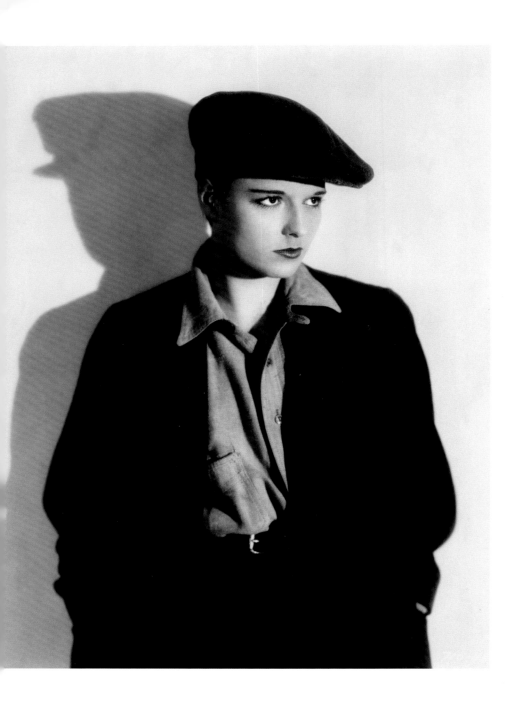

Above: Louise Brooks in *Beggars of Life*, directed by William Wellman, 1928

104 Opposite: Marlene Dietrich, Los Angeles, 1933

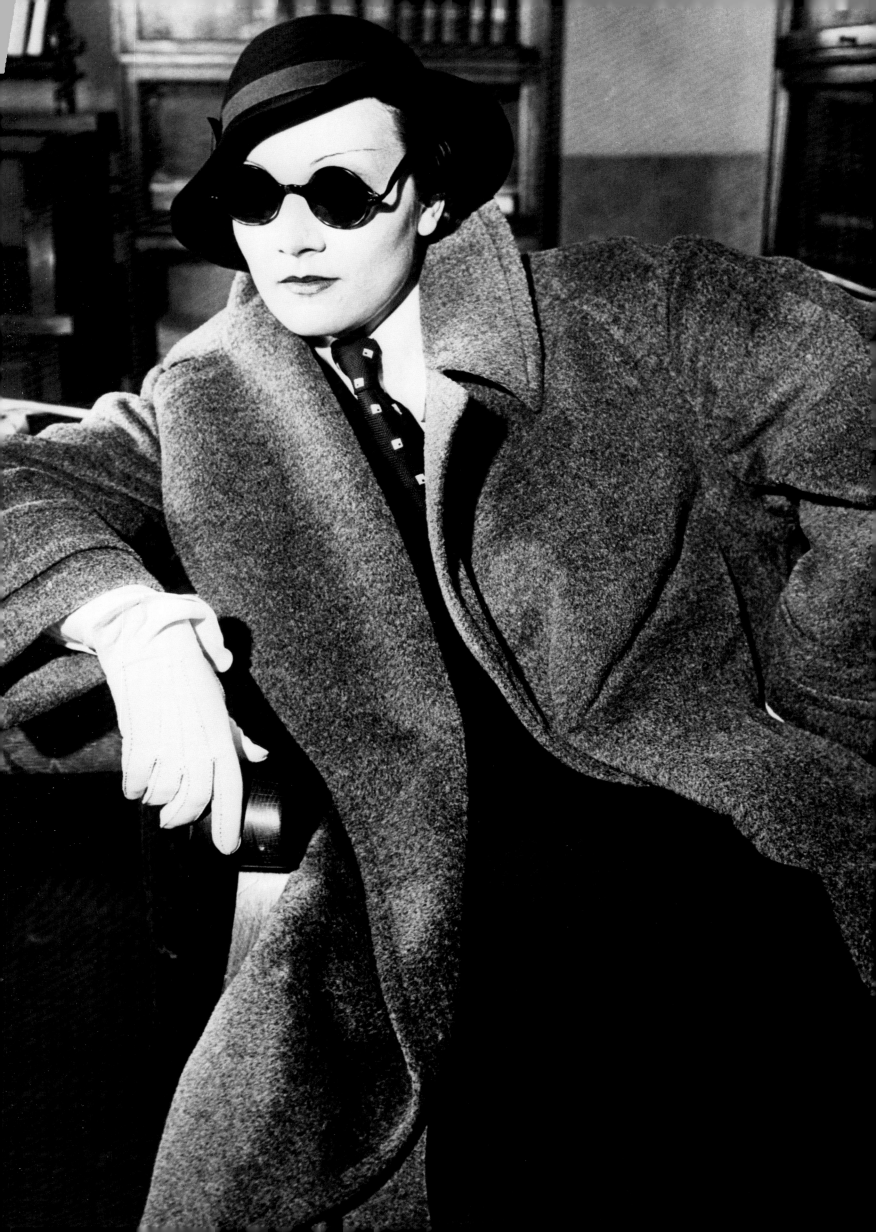

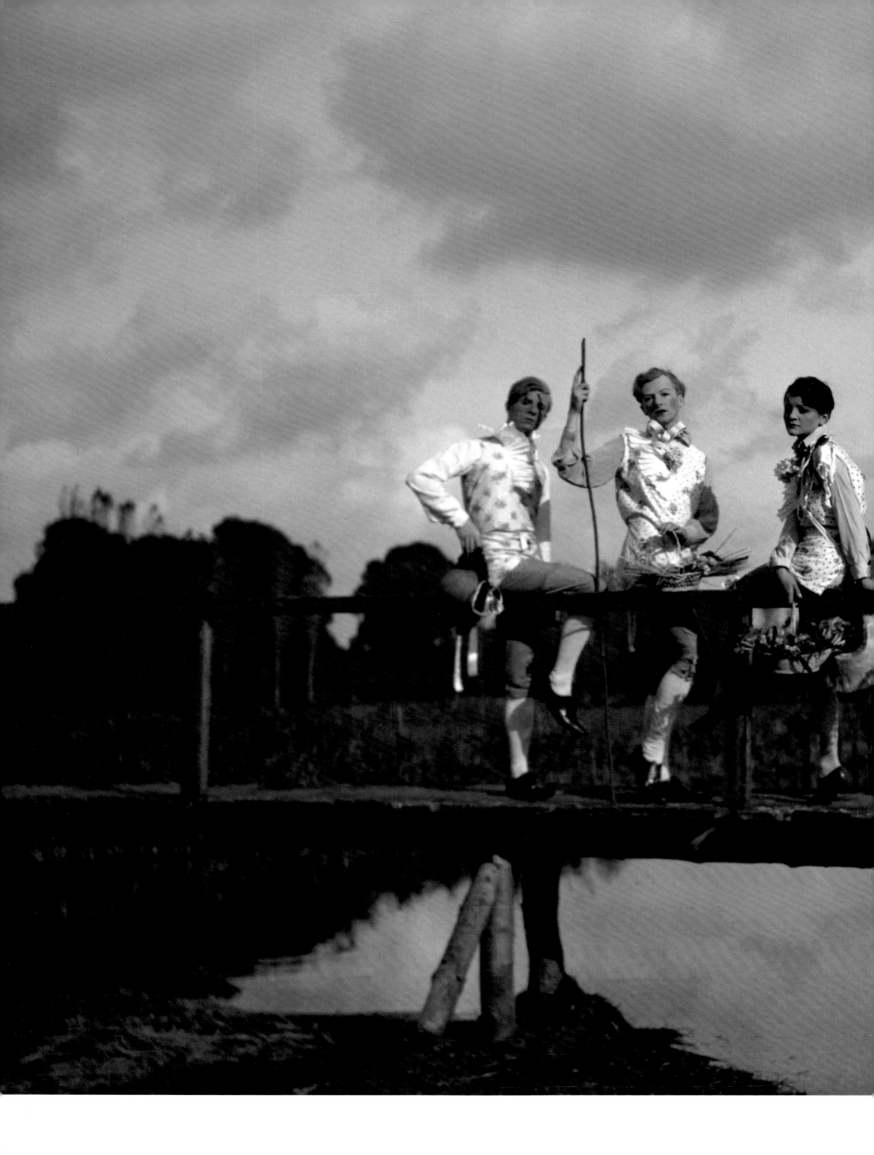

The Bright Young Things in Cecil Beaton's *On the Bridge, Wilsford*, England, 1927

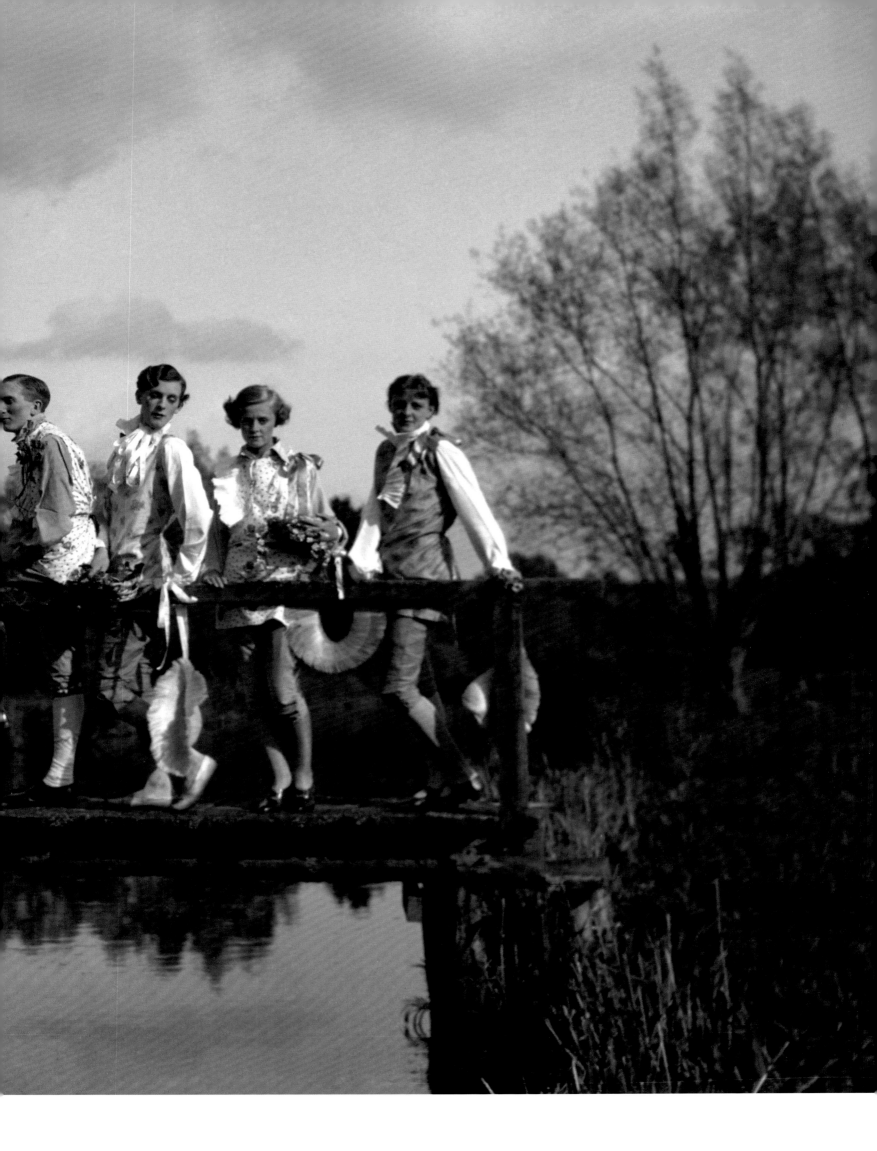

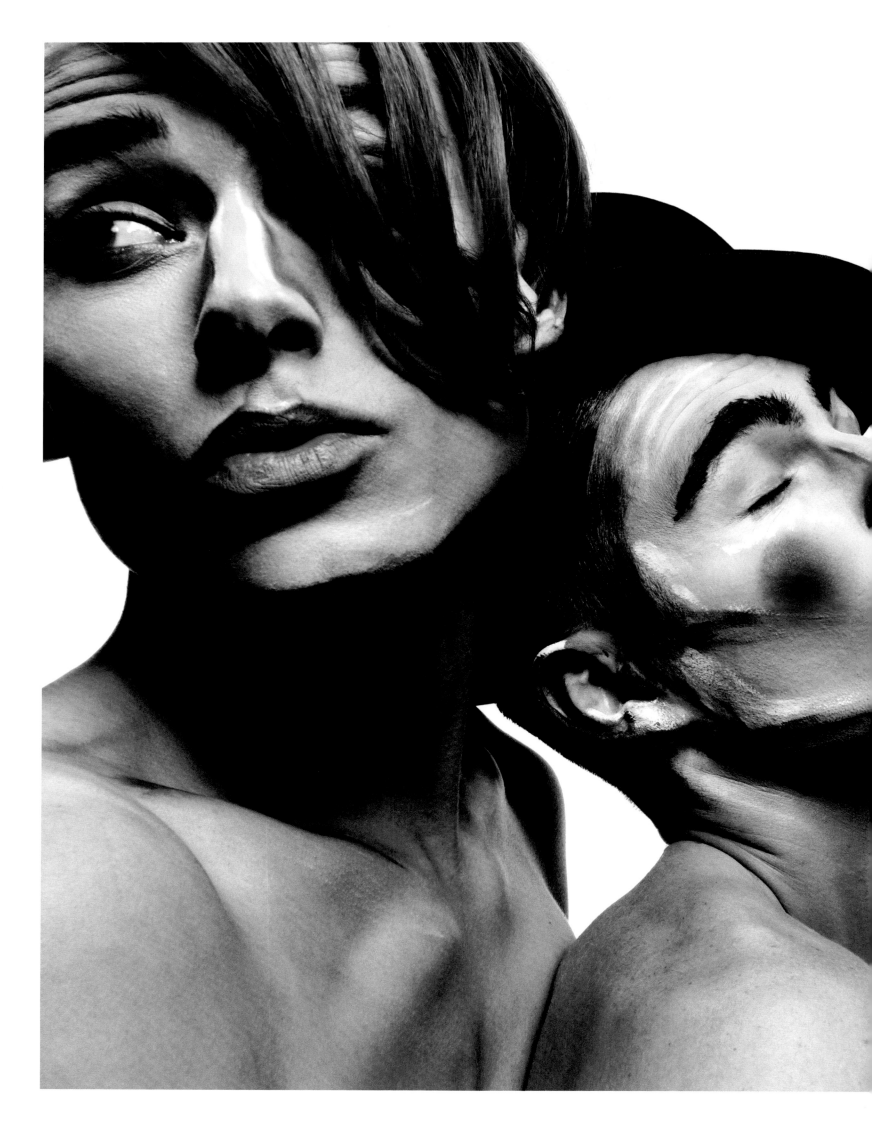

Arian Dalle Laste, Boris Kolesnikov, Lukasz Jakubowski and Shaun Haugh, *V*, 2005.

Photograph by David Sims

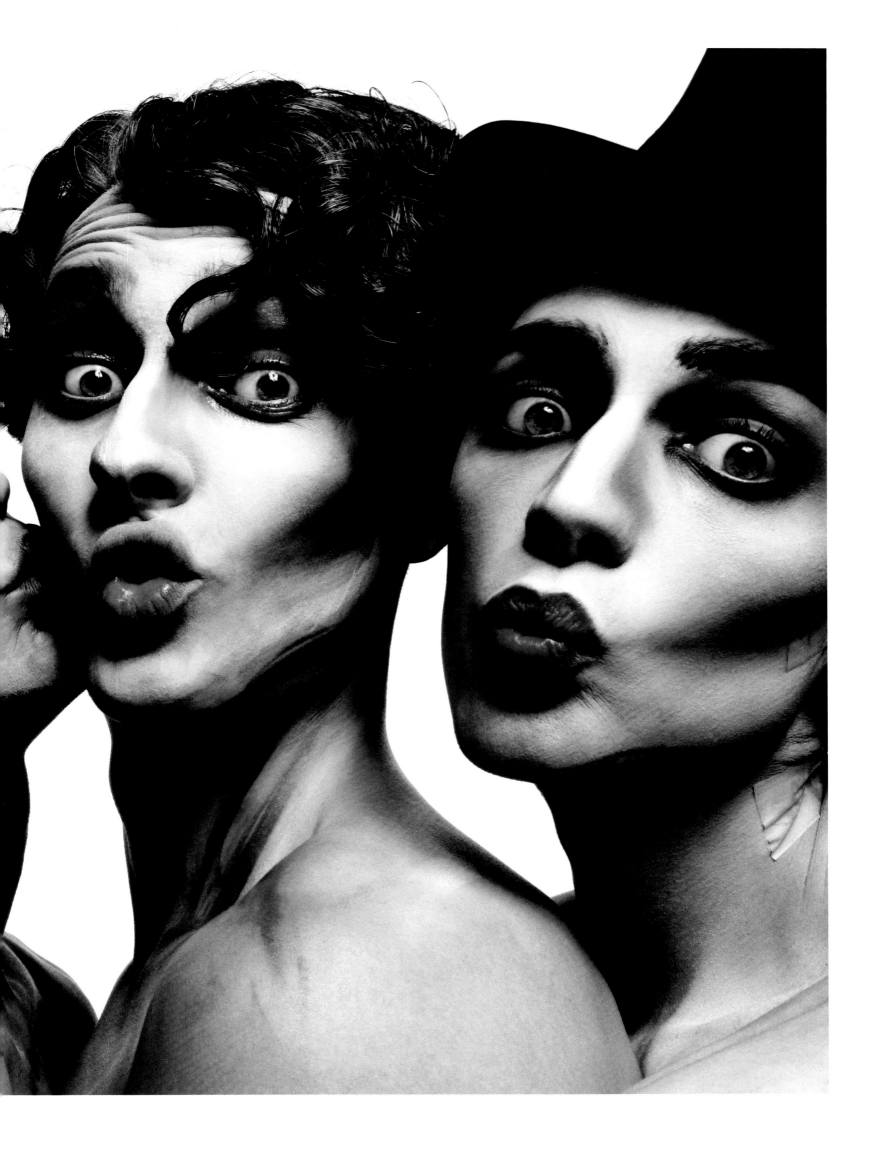

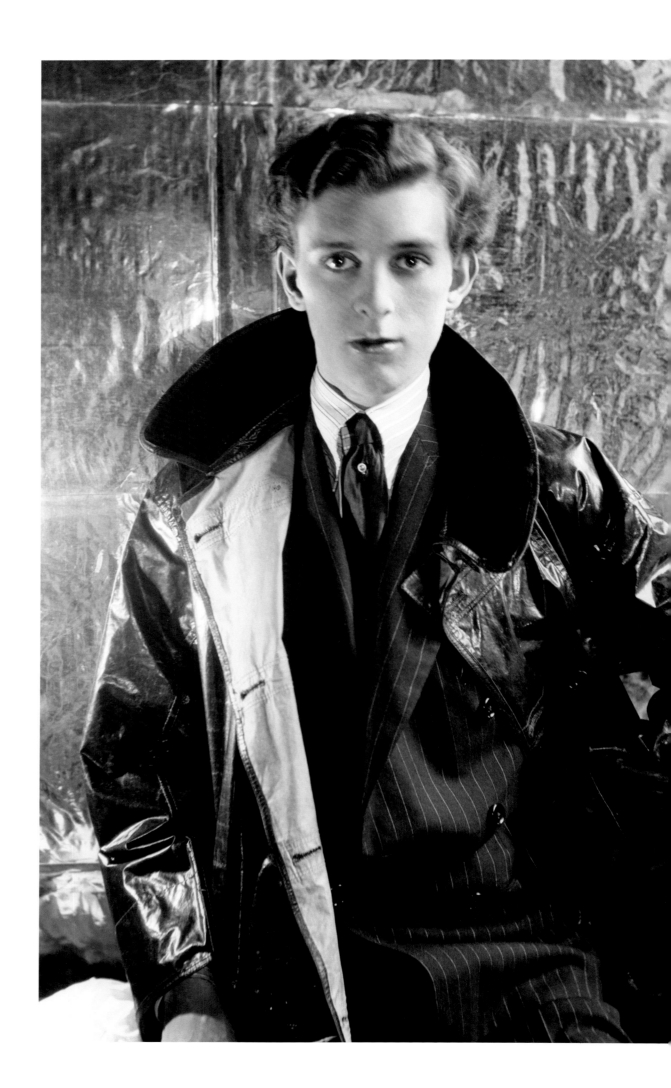

Above: Stephen Tennant by Cecil Beaton, 1927
Opposite: Stella Tennant, 'New Dandy', *Vogue* China, 2012. Photograph by Willy Vanderperre

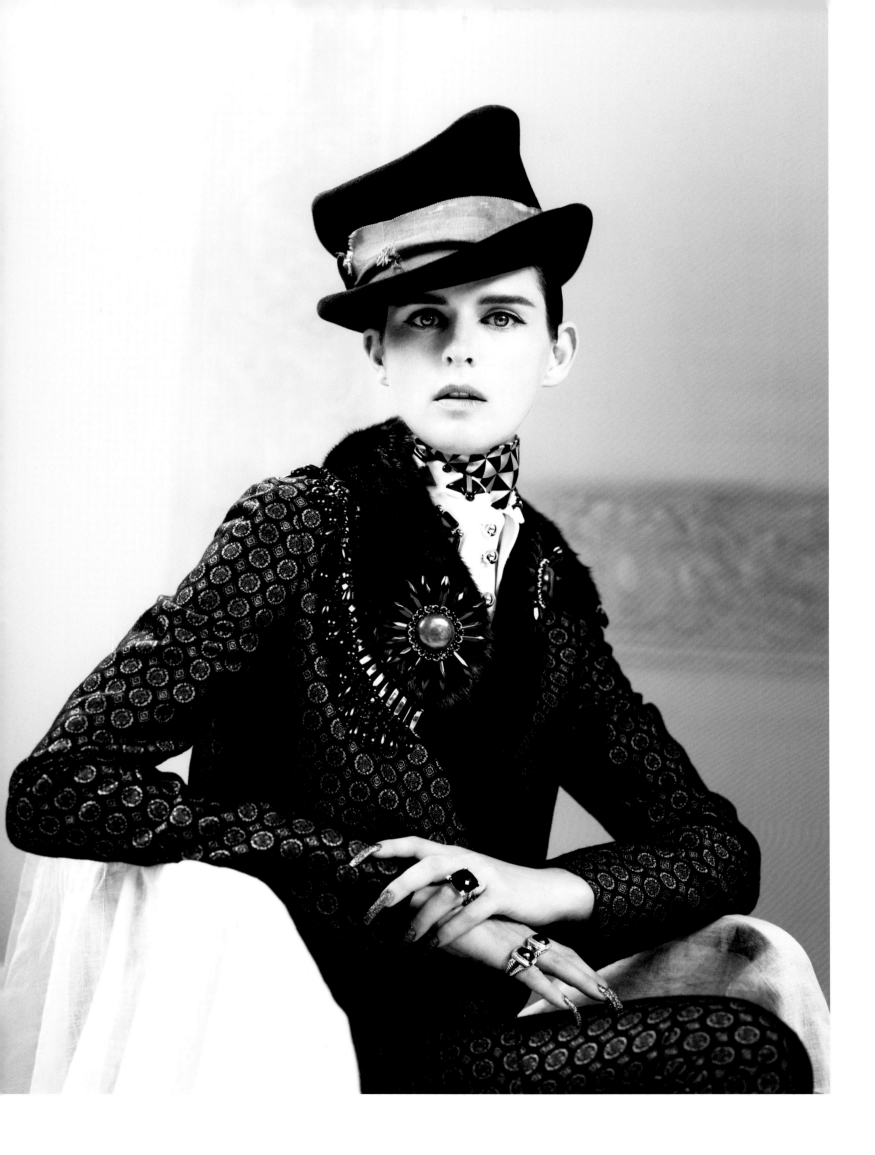

Cecil Beaton, *Self-portrait, All the Vogue*, 1925

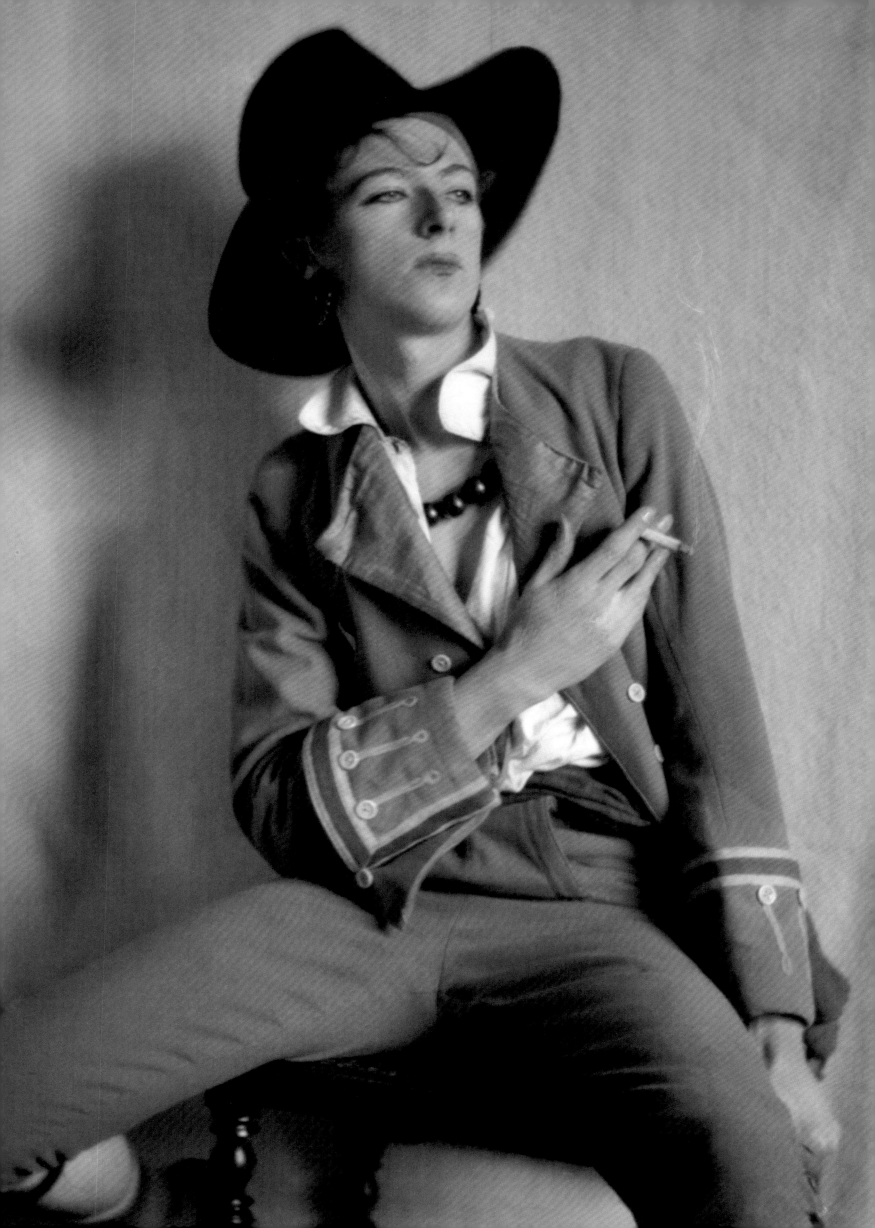

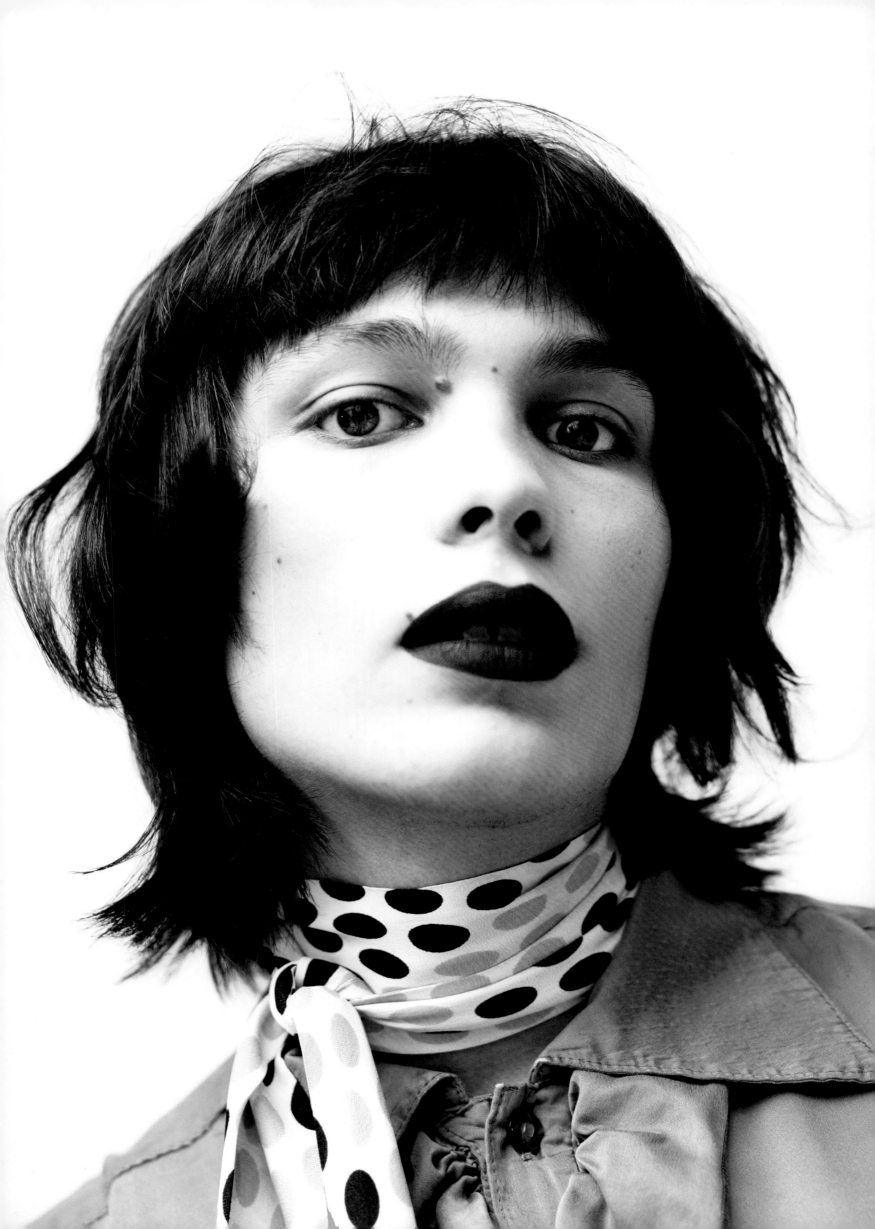

A CERTAIN

MR FISH

Both the Amazons who clustered around Natalie Clifford Barney and the Bright Young Things were never more than small circles of aristocratic, artistic, literary and urbane individuals. Nevertheless, both were cosmopolitan and distinguished enough to wield a degree of delicate influence in the cultured salons of Europe. Consequently, androgyny in the first half of the twentieth century (if true cases of hermaphroditism and transgender people are excepted) was largely a phenomenon dictated by class, if not by caste. We might, therefore, be forgiven for assuming that this rather superficial style of existence – of which Stephen Tennant was the most outrageous example – would come to a permanent end when the social order and way of life to which it belonged became obsolete. After the horrors of the Second World War and the strenuous task of reconstruction, the increase in prosperity that accompanied the technological advances of the 1950s and 60s gave birth to a blind faith in the idea of a future synonymous with progress and to a passion for modernity that culminated in a fashion for tasteful pseudo-futurism. There seemed to be little room left for the calligraphic flourishes, overwrought embellishments, languorous narcissism and sequin-and-papier-mâché decorations that were the natural habitat of the sylphlike aesthetes of earlier decades.

Yet, in the last quarter of the twentieth century, they made a comeback. The romanticism and utopianism of the social movements and student protests of the late 1960s, which challenged establishment values and rejected social conventions, also led to a re-evaluation of artistic movements, figures and ideas that, until then, had been dismissed as minor or of marginal interest. The great *fin-de-siècle* masters of androgynous imagery were gradually rescued from the disdain in which they had been held. In the USA, for example, the historian Stanley Weintraub published biographies of Aubrey Beardsley, James Abbott McNeill Whistler and Dante Gabriel Rossetti between 1967 and 1977; and, in the UK, the Hayward Gallery in London staged a major retrospective of the Pre-Raphaelite Edward Burne-Jones in 1975. Art Nouveau came back into vogue (in every sense) in the sinuous lines of psychedelia. A delight in mixing genres and registers; a return to the frenzied ornamentalism that seemed to have been permanently forced out of favour by ubiquitous modernism; a playful embracing of kitsch and camp; the elevation of incongruousness and irony to the level of formal principles – all of these things echoed the blithe effervescence of the Bright Young Things.

The most visible signs of this fundamental shift in taste – of what it expressed as well as its far-reaching implications – were found in the world of fashion, which was itself undergoing profound commercial changes at this time with the emergence of ready-to-wear. We have already seen the significance and power of clothes in the game of appearances, the inherent optical illusion of androgyny; but clothes as a unique form of individual expression are not the same thing as fashion. When the Chevalier d'Éon took pride in his wardrobe by the royal dressmaker, Rose Bertin; when Rachilde wore men's clothing; when Cecil Beaton and his friends dressed up as figures from Watteau's paintings – these were not choices that were intended to set an example or start a trend. Quite the reverse. In fact, it was only in the late 1960s that fashion was set on its present-day trajectory, on which it has grown to become simultaneously a trend, a template and a shared orientation – the expression of an era, of its confused desires, of a world of the imagination that it helped to construct, one facet of which forms the subject of this book.

History in general – and fashion history in particular – remembers only its heroes (real or assumed), while forgetting many of its true innovators. One such was John Stephen, who opened his first boutique on London's Carnaby Street in 1956, selling men's clothes that were a bold alternative to traditional smart menswear in their cut and their vivid prints and bright colours. Then there was Michael Fish, born in 1940 in Wood Green, north London, who started out designing shirts at Turnbull & Asser on Jermyn Street (much as Alexander McQueen began his career on Savile Row twenty years later). During his nine years at this bastion of traditional tailoring, Fish was credited with inventing the wide, often flamboyantly patterned, kipper tie, which was all the rage in Britain in the 1960s.

In 1966, Fish opened a boutique at 17 Clifford Street in Mayfair. With its scarlet paintwork, Mr Fish was to become the creative hub for a new kind of elegance – eclectic, nostalgic, effete and flamboyant – which is inextricably associated with rock icons including Mick Jagger, Brian Jones and David Bowie, as well as actors like Terence Stamp and James Fox. Standing collars, lace cravats, floppy neckties, puffed sleeves, brocade waistcoats, crushed velvet jackets, flounced tunics, multicoloured silk shirts and bold prints were its recurring motifs, amid a motley array of Renaissance doublets, Mandarin collars, seventeenth-century jabots and military frock coats. Their colours, fabrics, textures and spangles were diametrically opposed to the regulation blacks and neutrals of the traditional male 'uniform', clothes which in Grayson Perry's words 'imply a public role rather than an individual private identity. They distract from the individual body as object'.

Staying true to his approach, Mr Fish went even further and began designing frocks for men that lay somewhere between a Greek presidential guard's fustanella and Baroque court dress, including the famous white voile tunic worn by Mick Jagger at the Rolling Stones' Hyde Park concert in 1969, and the richly patterned gown modelled by a reclining

David Bowie on the cover of the UK release of his album *The Man Who Sold the World* in 1971. 'I tried to break down the frontiers for man,' explained Fish, nearly twenty years ahead of Jean Paul Gaultier, while the *Esquire* columnist George Frazier summed up an era when he dubbed this flamboyant parade of male finery 'the Peacock Revolution'.

The designer's perfectionism, the painstaking tailoring methods that were not far removed from haute couture, and the sumptuous and sophisticated range of fabrics all had their price, which meant that Mr Fish was reserved (once again) for a limited and wealthy clientele. Unlike the 1930s, however, the people who wore Mr Fish's designs were the icons of an increasingly influential pop culture, the most public and visible models a designer could wish for, with the result that images of his clothes reached a vast audience. 'Mr. Fish is a phenomenon of our age,' stated *The Times* in November 1969. 'He is a product of the 1960s sartorial revolution, as much as Carnaby Street. His shop in Clifford Street is probably the axle around which spins that particular, exclusive type of high fashion associated with swinging aristocracy – the suave velvet suits and incredible lace shirts.... The shop is, in fact, a way of life, an equivalent to a Pall Mall club where the assistants have names and the clients sign bills.'

The spark of success did not burn for long, however, as Fish fell victim to the lifestyle he embodied, to contracts that were never honoured and to orders that were dropped, so that he was forced to close his first boutique after only a few years. In 1974, he opened a second shop, on Mount Street (again in Mayfair), which soon followed the same fate, partly for financial reasons and partly because his designs were already somewhat passé. He subsequently left the world of fashion in 1978 to work as a host at the fashionable Embassy Club. In the mid-1980s, he returned to Turnbull & Asser; then, at the end of the decade, he opened a new boutique at 52 Pimlico Road in Belgravia. In 2004, sadly, he suffered a severe stroke, but his designs still retain an ardent cult following.

As well as embodying the zeitgeist, Mr Fish's style was also profoundly British, descending in a direct line from Beau Brummell and the original dandies of the Regency era, who had also been a major influence on the Bright Young Things. The androgynous tension that was one of its defining features formed part of a broader challenging of social and cultural roles; but it originated in the neo-Romantic imagination (later revived in Vivienne Westwood's 1981 'Pirate' collection) and reflected a distinctly English affinity with narrative and historical metaphor, whose importance was spelled out by the architectural historian Nikolaus Pevsner in *The Englishness of English Art* (1956). Stephen Tennant, as the hero of his own form of romanticism, anticipated the glitter of the 1980s in the lamé jackets and cravats he sported half a century earlier – creations belonging to the imaginary version of the eighteenth century that he yearned to bring into being. Mr Fish, however, heralded a much more contemporary approach to fashion, one observable today in the designs of Jonathan Anderson or Alessandro Michele for Gucci, which have revived the idea of going against type, and against gender, by using the most 'feminine' of fabrics – brocades, velvets, lace and prints – for menswear.

'LADIES AND GENTLEMEN

...AND OTHERS'

Mr Fish's two most prominent clients were both icons of the 'gender-bending' 1970s: Mick Jagger and David Bowie. Jagger accentuated his delicate features, sensual lips and lithe, catlike grace, flirting with ideas of seduction and male objectification in a way that had previously been exclusive to the female sex, and which was magnificently exploited by Donald Cammell and Nicolas Roeg in the 1970 film *Performance*. Bowie, however, took things a step further, questioning the basis of the idea of subjective identity. When he appeared on the BBC TV show *Top of the Pops* in 1972, with make-up, spiky red hair and a figure-hugging catsuit, he flung an androgynous protest at the world which was to have many repercussions. But instead of sticking with this image – no matter how unsettling and provocative – within a few months he began to shift identities, moving from the Man Who Sold the World to Ziggy Stardust and on to Aladdin Sane and the Thin White Duke until, in his later period, he started to wear more traditional-looking outfits, albeit sometimes accessorized with high heels.

By reducing identity to a form of role play, Bowie subverted the very notion of identity, particularly on a sexual level. His make-up and clothes became the markers of a sexual nonidentity, fluid and ever-changing. As a public figure and global celebrity, he positioned

himself from the outset on the fringes of both pop culture and the arts scene, which until then had been entirely discrete. He was a major source of inspiration for the pioneering exhibition *Transformer: Aspects of Travesty* curated by Jean-Christophe Ammann at the Kunstmuseum in Lucerne, in Switzerland, in 1974. In the way participants made themselves into their own artworks and metamorphosed from one exhibit (and sex) to another, the exhibition preyed both on representations of the body and on the concept of gender.

When presenting an award to Aretha Franklin at the Grammys ceremony in New York in 1975, Bowie famously began his speech with the words: 'Ladies and gentlemen... and others.' Over the course of his career, he declared himself gay, then bisexual and finally a 'closet heterosexual', thereby anticipating the label of 'non-binary'. In doing so, he drew upon all the resources of the semiotics of fashion at the command first of Mr Fish, and then of Kansai Yamamato, Freddie Burretti and many other designers. In turn, due to the cyclical nature of fashion, Bowie's various looks were to directly inspire leading couture collections forty years after his 1970s heyday.

Two months before Bowie's appearance at the 1975 Grammy Awards, Michael Fish closed his Clifford Street boutique, bestowing on it the brusque epitaph: 'Fashion doesn't exist any more. Only clothes.' In his own way, Fish was acknowledging the first stages of the radical transformation of the fashion business into its current form. At the same time as he was shutting up his first shop, London's other small boutiques were beginning to close down too, to be replaced by the 'designer' stores of the international high-street brands which were to remake the global fashion landscape over the next quarter of a century. The years prior to 1975 had been ones of cheerful improvisation. Money and management, as Fish's own career had shown, were merely tangential: what mattered most were dynamism, drive, experimentation and hedonism. Now, the abandonment of utopianism, a disenchantment with the world and growing pressure from consumers all led towards the celebration of power, money and rampant individualism that characterized the shameless materialism of the 1980s.

'What marks out the 1980s is the collapse of systems, the disappearance of ideals, the end of a belief in the grand explanatory systems that claim to encompass the whole of human life,' the French curator Christian Schlatter wrote grandiloquently in 1984. 'No more uniforms or formal trappings, no more slogans or trends, no more intellectual terrorism legitimizing the terrorism of appearance and ways of being.... The monochrome human of the 1970s is giving way to the variegated human of the 1980s. A person who finds himself alone, alone with himself, alone in a world that is no longer certain and can no longer be judged through the lens of theory. Stripped of illusions, he will say "I", he will no longer be able to say anything but "I": a necessary "I", the only way he can reclaim himself, since he can no longer rely on external assurances or proposals.'

In hindsight, 'flashy' might be a better description for the 'human of the 1980s', rather than the 'variegated' that Schlatter chose to contrast the zeitgeists of the two decades. In France in the 1980s, the previous decade was more closely associated with political turmoil, slogans, solidarity and theoretical polemic than with revolutions in fashion. And 'monochrome' seems a long way from how we now view the 1970s. Conversely, a period that worshipped at the altar of the individual, or the 'necessary "I"', would surely recognize a natural ally in the expression and exaltation of the self that is fashion (and also its handmaiden, advertising). 'Do advertising and fashion not reveal so much about the culture of the 1980s?' Schlatter asked rhetorically. 'When it comes down to it, who or what best captures the human of the 1980s? Is it not advertising and fashion that show us – with acute sensitivity – an aspect of ourselves?'

Leaving behind the lofty heights of haute couture, fashion in the 1980s now entered the province of ready-to-wear, ushering in the extraordinary boom that we are still witnessing today. The pioneering figures of the 1960s, such as Mary Quant in Britain and Christiane Bailly, Emmanuelle Khanh and Gérard Pipart in France, gave way to the cult

of the designer as media celebrity: Karl Lagerfeld (then at Chloé), Sonia Rykiel, Yves Saint Laurent (in his Rive Gauche incarnation), Thierry Mugler, Anne-Marie Beretta, Claude Montana, Jean Paul Gaultier and later Christian Lacroix were the iconic figures of this new era. A new body image also emerged, particularly for women. This was the age of power dressing, of the affirmation of women as strong, masculine, athletic and ambiguous; in other words, the exact opposite of the androgynous figures of the age of flower power. The power suit for women was a triumph of sharp tailoring and huge shoulder pads: 'The waist and the length are of no importance,' declared Claude Montana, 'what matters is the shoulders. The garment hangs from them. Everything starts from there.' Thierry Mugler, another champion of this dramatic, masculine image, added: 'Every collection has its heroine, in a way. There is one constant, and it is a victorious woman. She triumphs either through her femininity, softness and voluptuousness, or on the contrary through her toughness. These women are never sad or weak. They are fighters.'

The muse and model Grace Jones provided one of the defining images of this streamlined androgyny. With her severely square-cut cropped hair, broad shoulders and tiny waist, dangling cigarette, and vertiginous heels that emphasized her imposing height, she presented a caricature of uninhibited femininity that was slightly menacing but also played with and undermined gender stereotypes. In endless variations on the same theme, the photographer, illustrator and arch-manipulator of images Jean-Paul Goude explored the graphic qualities of Jones's angular, narrow-hipped physique, simultaneously reducing it to a sign (always his primary method of interpreting the world) and cunningly making it the instrument of an off-kilter and ironic vision that questioned the idea of normality and the traditional values associated with it. Goude's images of Jones transcended the female stereotype of the time and gave it a new clarity by setting it within a private realm of the imagination, one in which this ambiguous physique became an interface for exploring race, sex and gender. This obsessive theme in the work of Goude attained its finest expression in his almost artless photograph of the 'real' Grace Jones standing face to face with her twin brother.

The same love of irony and distancing, and the same obsession with ambiguity and role reversal, constantly recur in the work of another major figure in the fashion world of this period, John Paul Gaultier. Seven years after he featured a biker jacket worn with a tutu in his first collection (to mixed reviews), in 1983 Gaultier launched a men's ready-to-wear collection that offered a series of striking variations on the theme of the objectified male. Continuing on the same course, he hit the media jackpot in 1984 with his significantly named collection 'And God Created Man', in which his male models wore skirts and behaved and walked like their female counterparts. His 'One Wardrobe for Two' collection in 1985 took the idea further, with men's outfits featuring elements that had formerly been considered female: backless tops, plunging necklines, figure-hugging fabrics, the use of voile and lace, and suggestive cutouts.

If one were to choose a rhetorical device to describe Gaultier's work in the 1980s, it would be chiasmus, or repetition in reverse order. By transposing the sexes, Gaultier was not seeking to fuse them into a single, non-sexual ideal; on the contrary, he accentuated their customary characteristics before he transferred them. In this respect, the 'empowered' woman of the 1980s fitted his vision perfectly. He laced her into corsets that crossed the line between lingerie and fetish wear; he transformed the curves of her breasts into pointed and aggressive cones, as sported by Madonna on her 'Blond Ambition' tour in 1990; and, following in the footsteps of Coco Chanel, he created a women's version of the striped sailor's jersey and turned it into an icon of his brand. At the same time, he went out of his way to strip the male image of its conventional attributes, and to reshape it in an erotically charged way, accentuating the male's seductiveness at the expense of the neutrality that traditionally signified his power. It was no coincidence that he called his first men's ready-to-wear show in 1983 'Boy Toy'. 'I like to reverse roles, to smash

established codes that are meaningless today,' he declared in May 2015, at a retrospective of his work held at the Grand Palais in Paris. 'I don't believe that fabrics have a sex, any more than some garments do.'

Over thirty years, Gaultier has stayed true to what has been both an article of faith and an expression – within the rarefied realm of haute couture – of social change and of identity politics. However, both his approach towards the merging of the sexes and his vision of it have indeed changed. In doing so, they were mirroring the trajectory of androgyny in wider popular culture. The androgynous icons of pop from the 1970s and 1980s – the New York Dolls, Boy George, the inspirations for the character Brian Slade in Todd Haynes's movie *Velvet Goldmine* (1998) – positioned themselves strategically as feminized men; but they nevertheless remained trapped between the poles of 'male' and 'female'. At or around the beginning of the twenty-first century, however, the nature of androgyny itself began to change, to evolve into a higher state. The contemporary androgyne claims to have escaped from the idea of polarity altogether.

Mick Jagger, Amsterdam, 1973

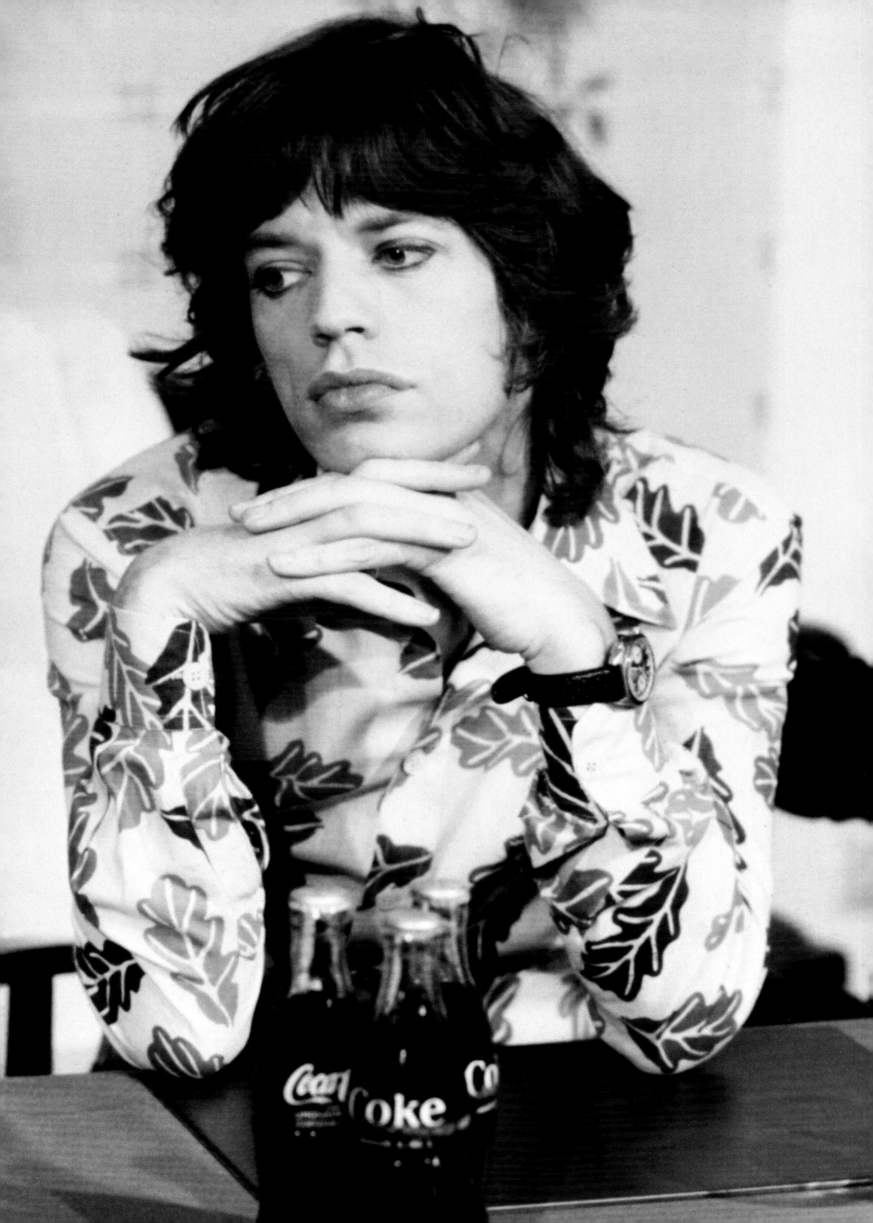

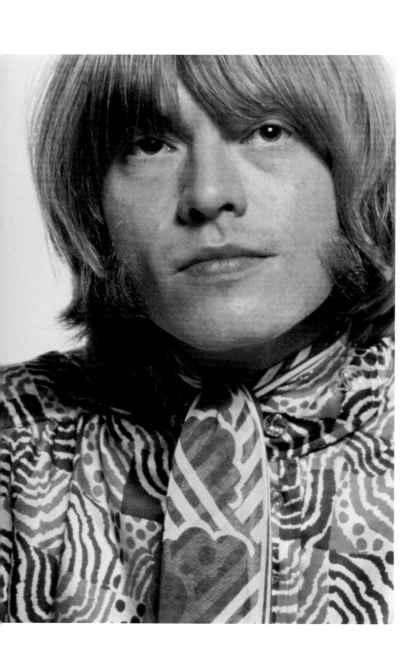

Above: Brian Jones, 1968. Photograph by Mark and Colleen Hayward
Opposite: Philip Kesselev, *Another Man*, 2012. Photograph by Alasdair McLellan

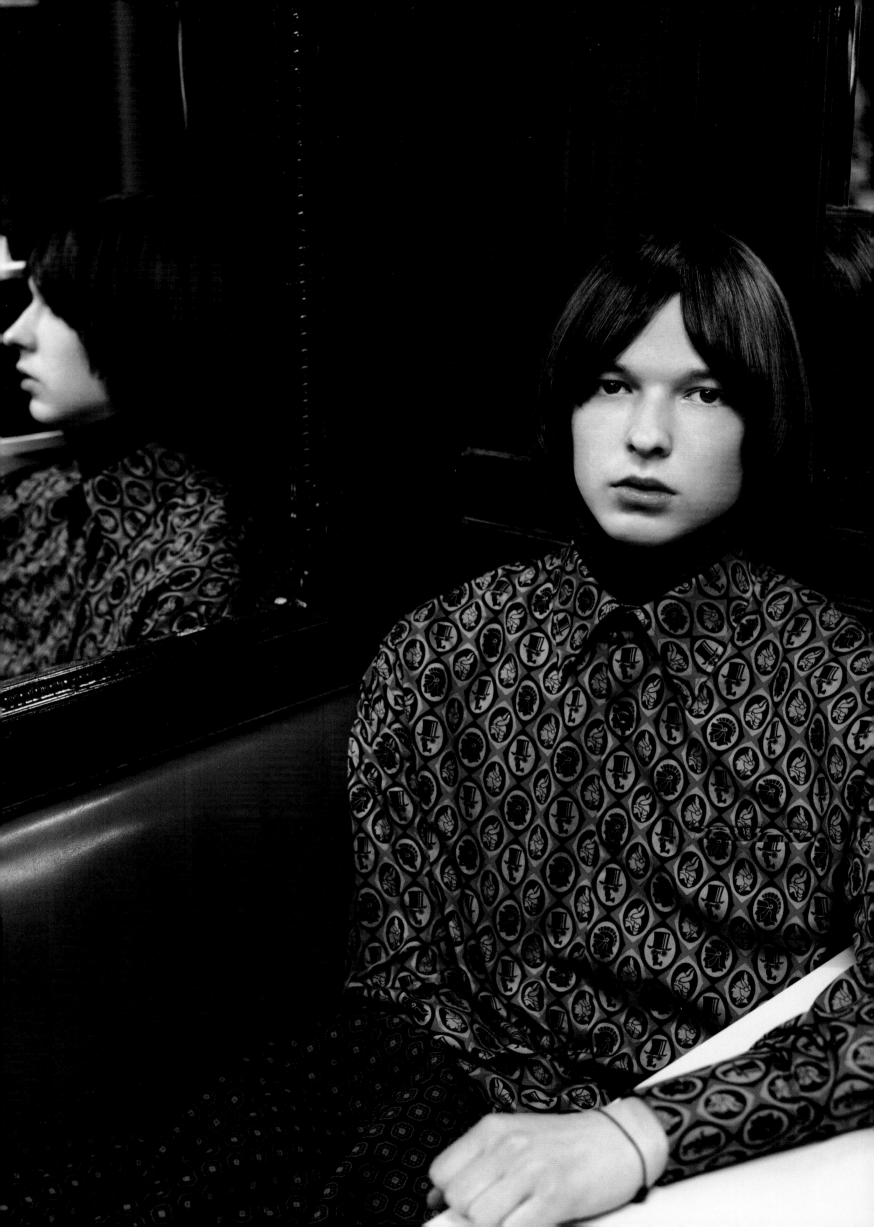

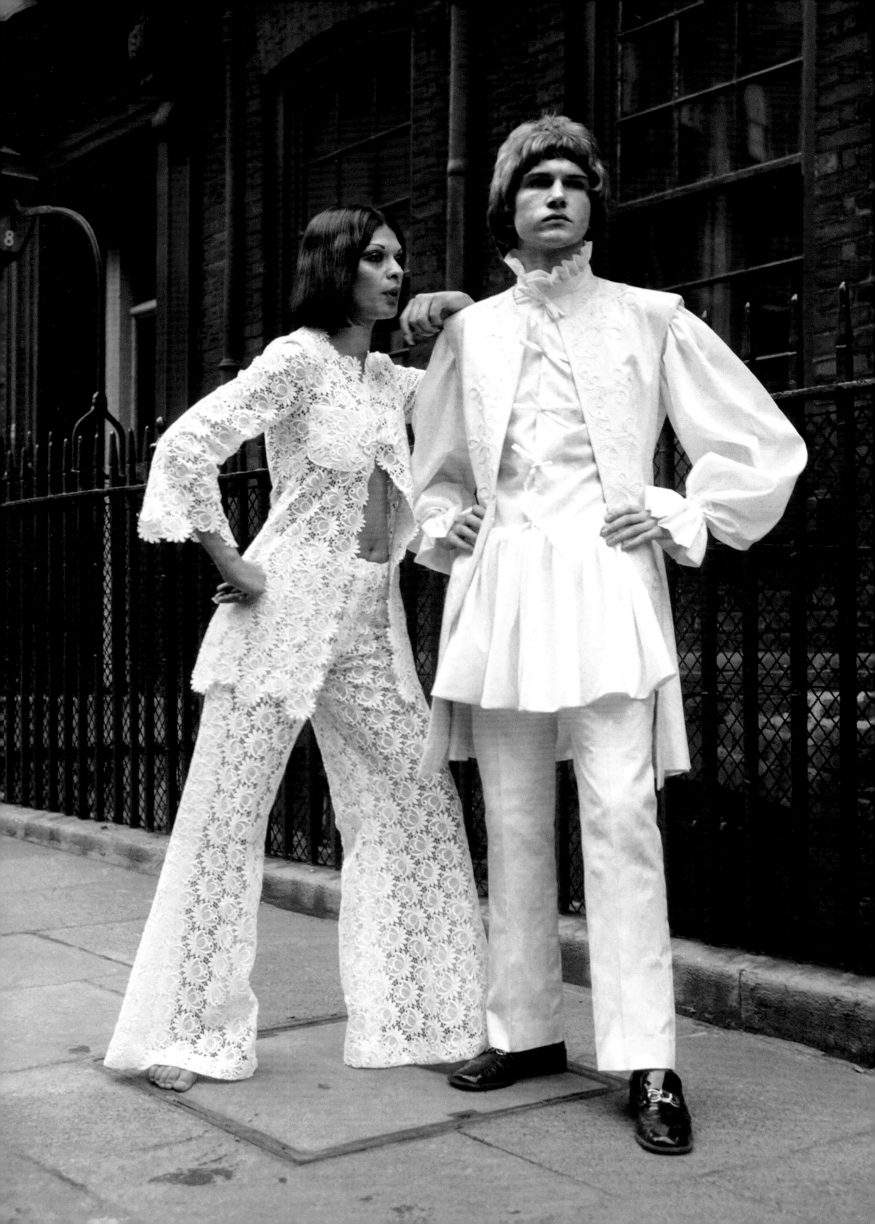

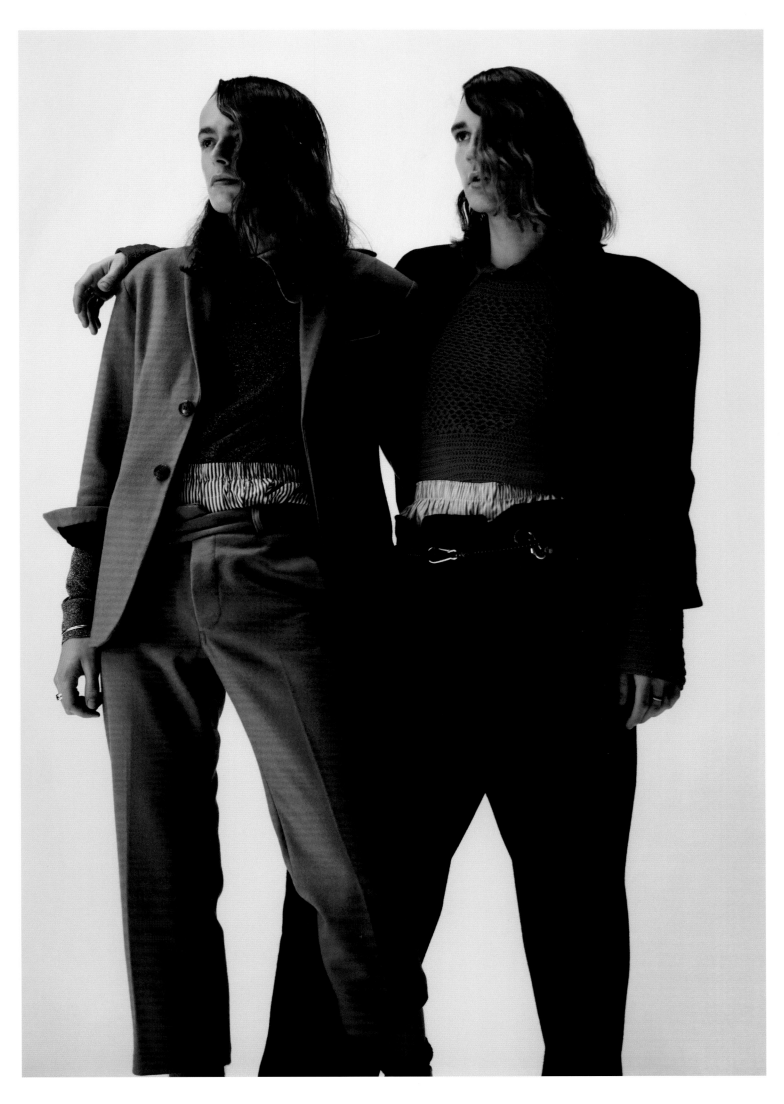

Above: Pip Paz-Howlett and Lachlan Mackie, *Man About Town*, 2016.
Photograph by Max von Gumppenberg and Patrick Bienert
Opposite: Janet Lyle and Michael Fish, London, 1969

Patrice Calmettes and Miguel Bosé, London, 1973. Photograph by Anthony Crickmay

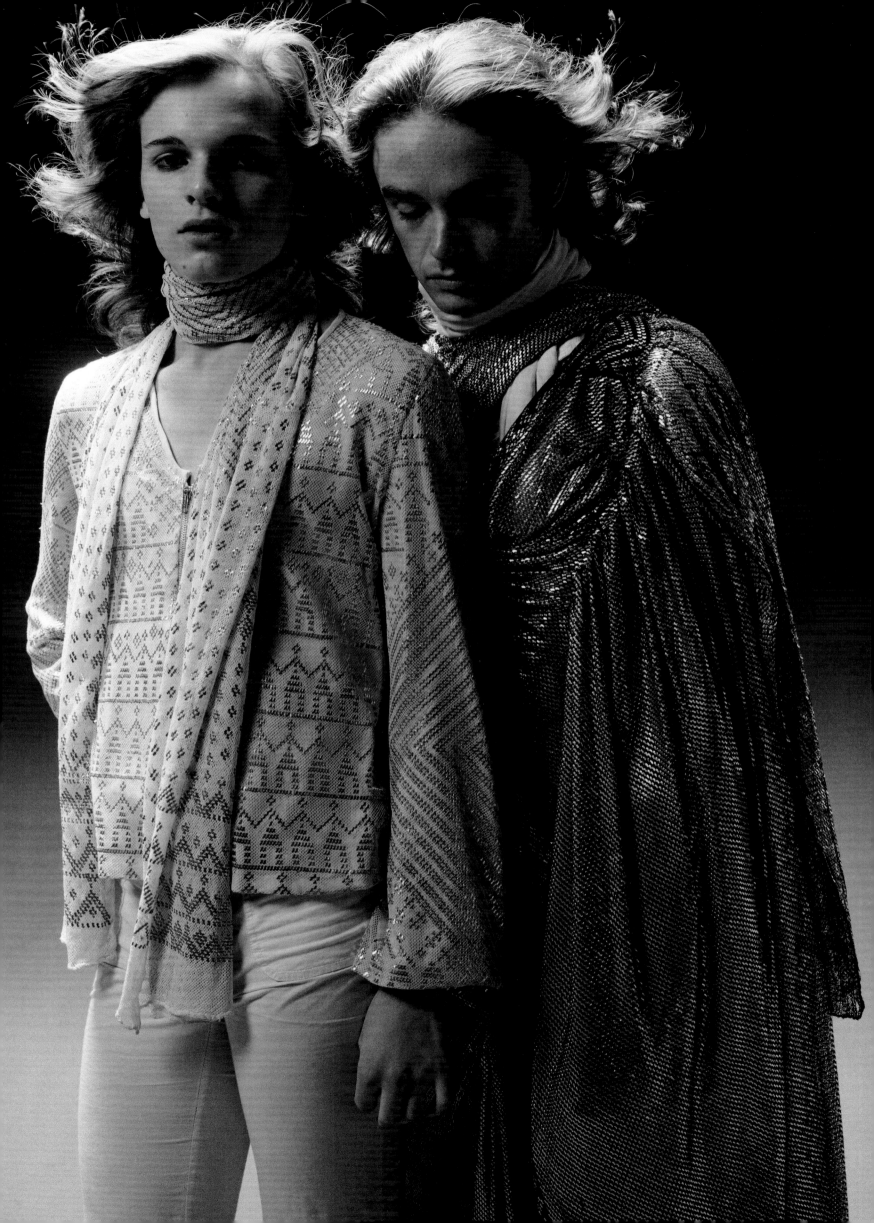

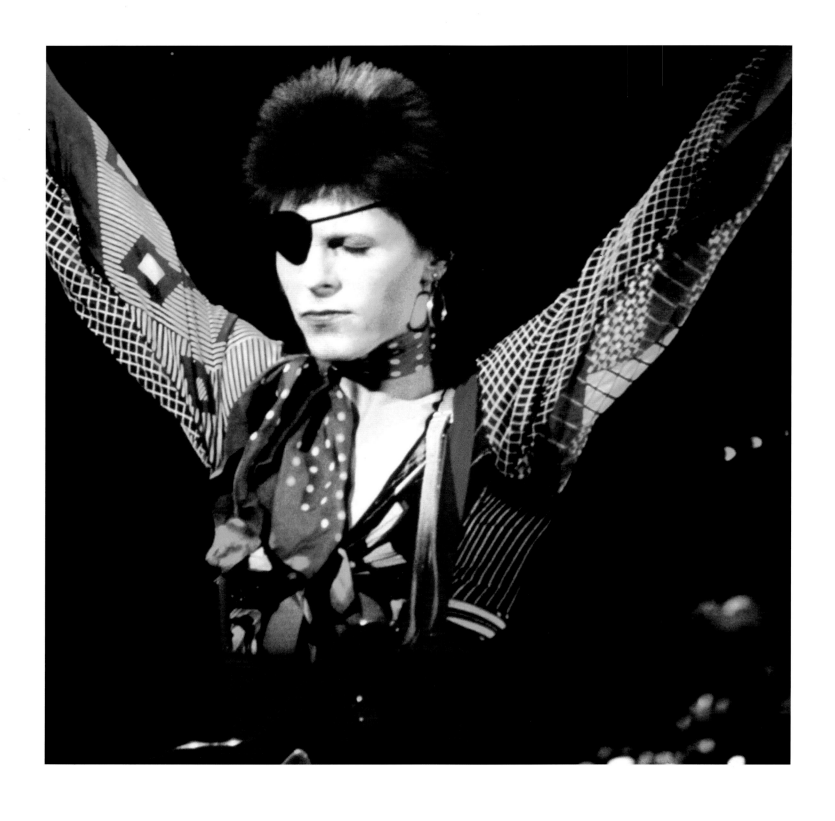

Above: David Bowie, 1973. Photograph by Roger Bamber
Opposite: Oliver Pallister, *Arena Homme +*, 2015. Photograph by Alasdair McLellan

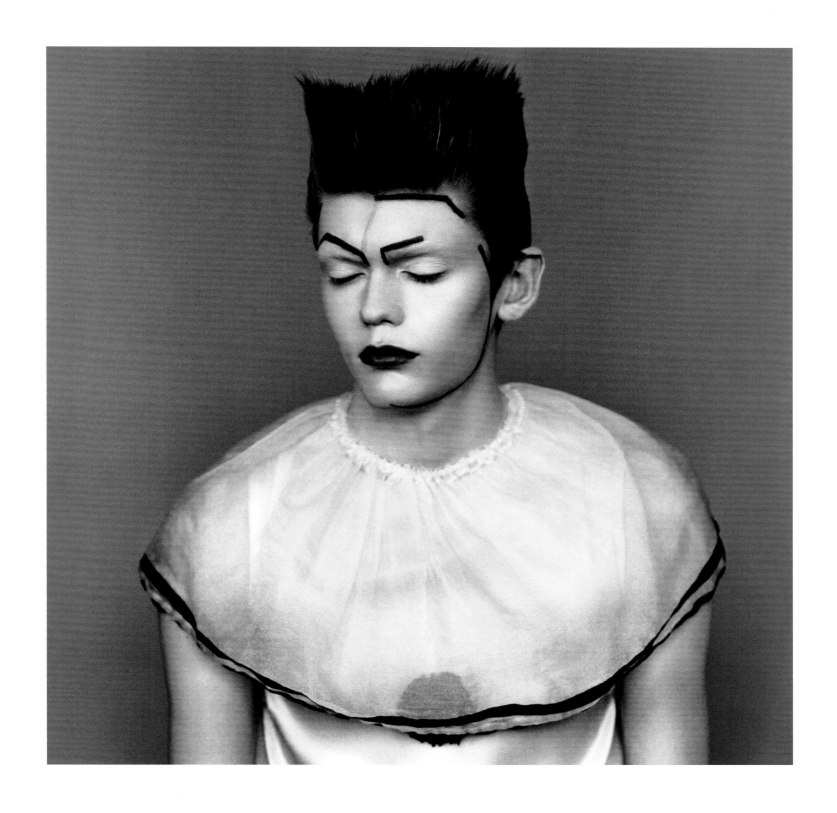

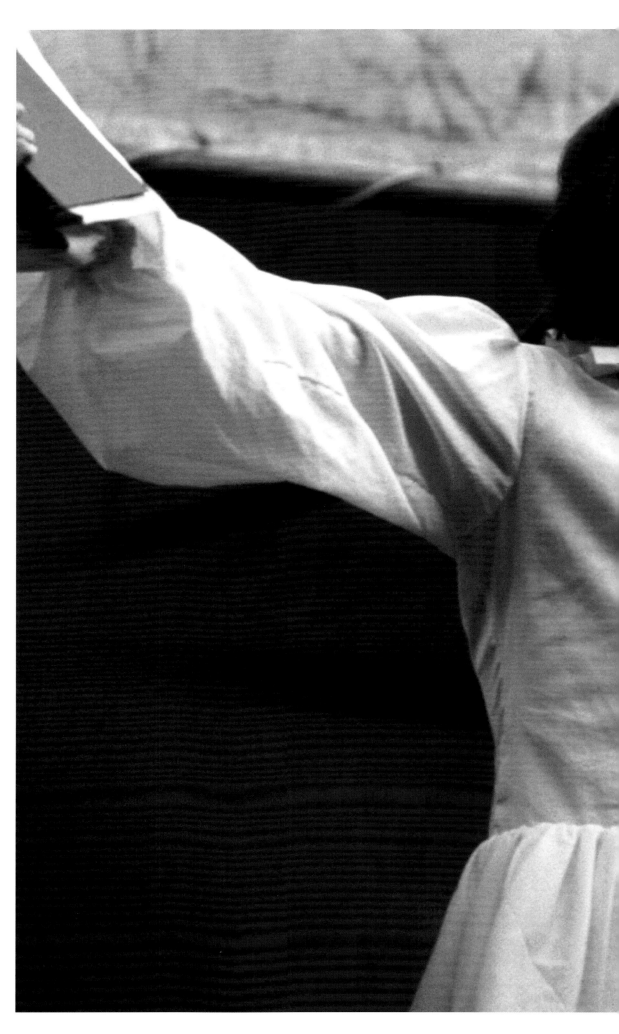

Above: Mick Jagger, Hyde Park, London, 1969
Overleaf: Mica Arganaraz as Steven Tyler, *CR Men's Book*, March 2016.
Photograph by Sebastian Faena

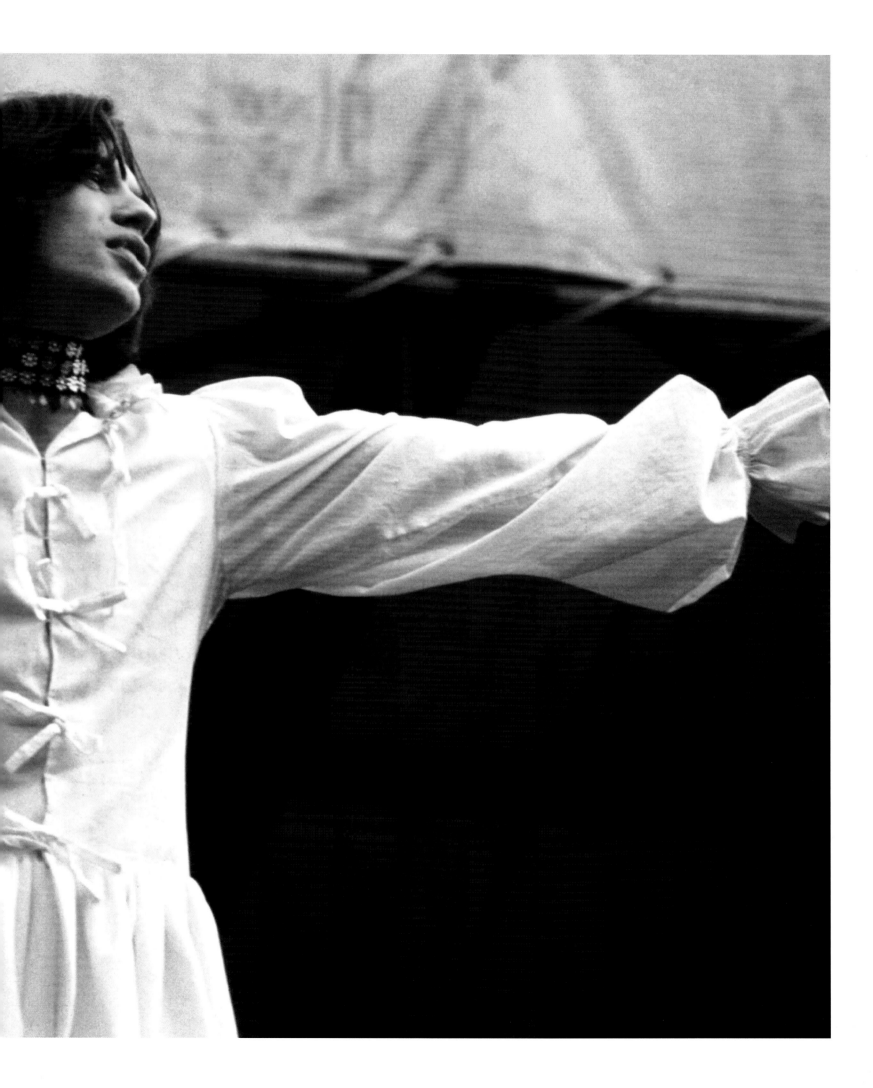

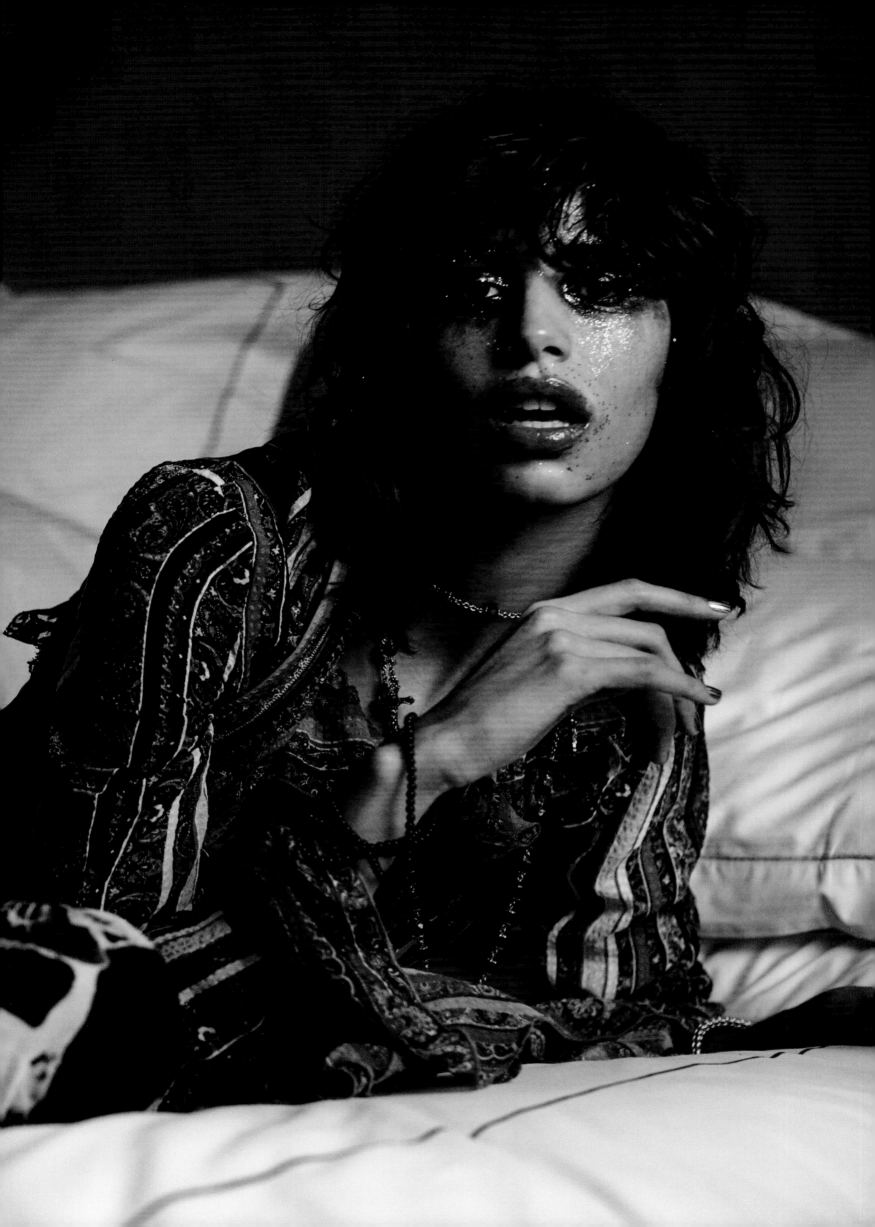

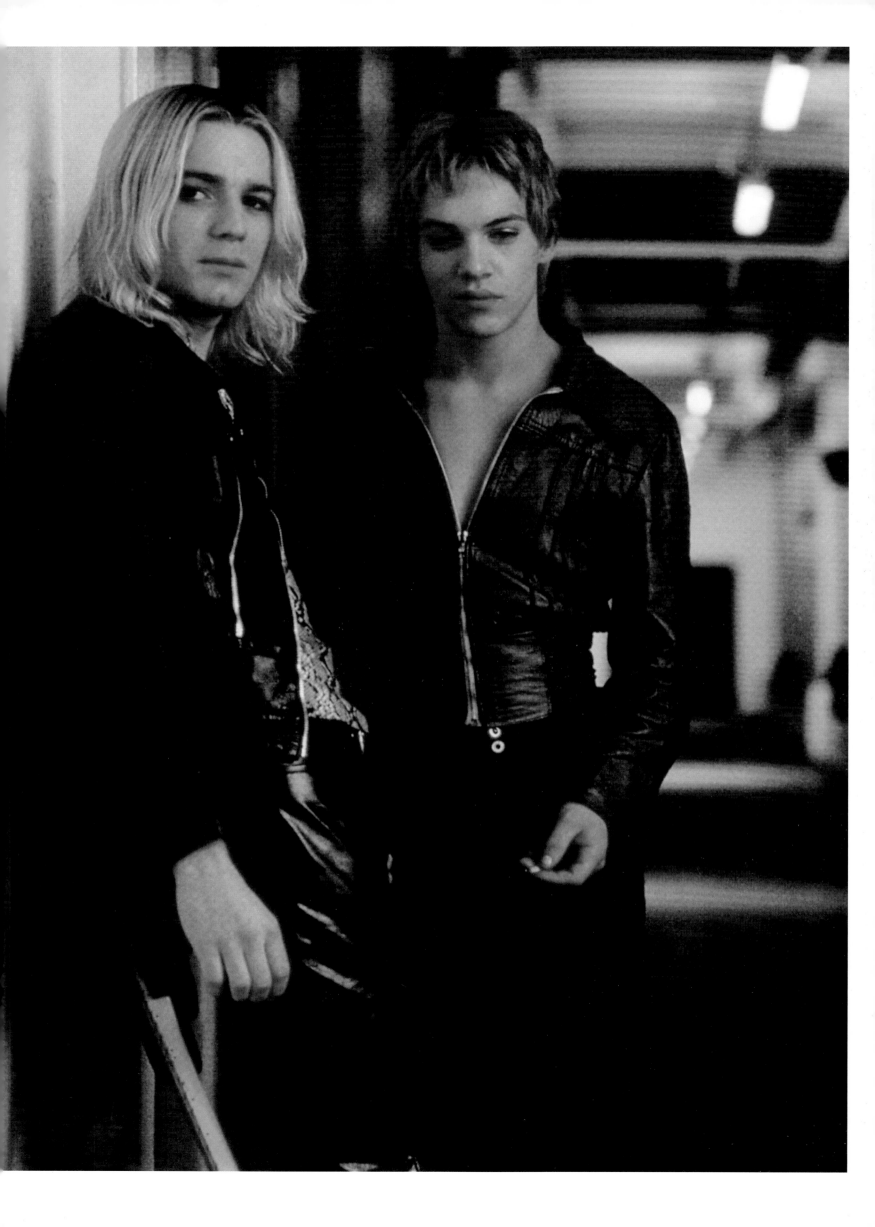

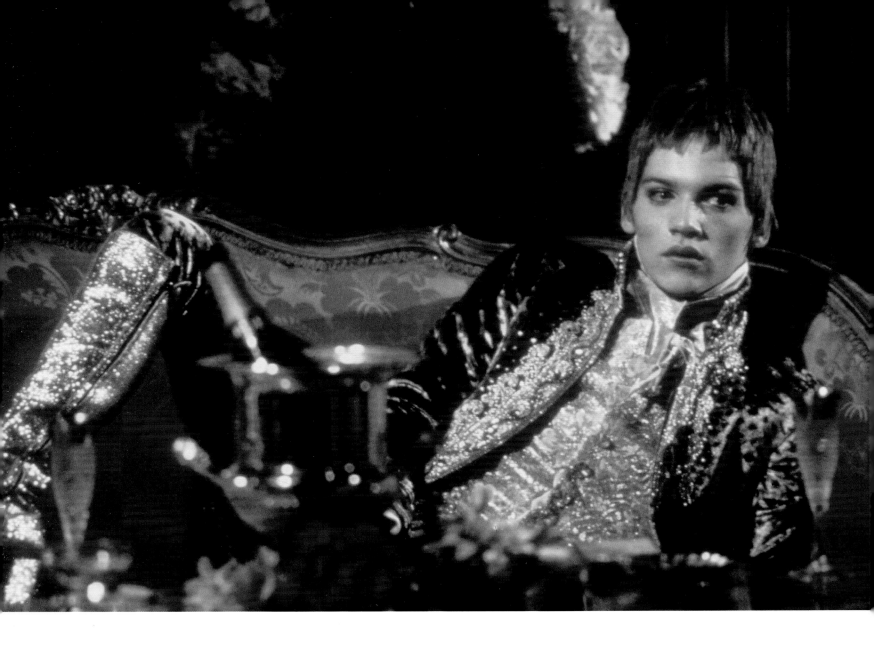

Ewan McGregor and Jonathan Rhys Meyers in *Velvet Goldmine*,
directed by Todd Haynes, 1998

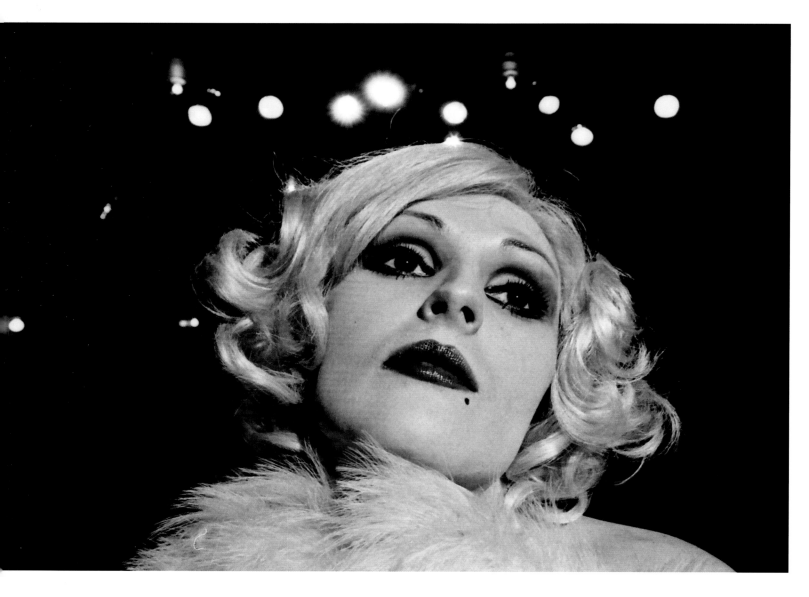

Above: Candy Darling in Tom Eyen's *The White Whore and the Bit Player*, New York, 1973.
Photograph by Jack Mitchell

Opposite: Andreja Pejić, *DuJour*, 2012. Photograph by Tony Kim

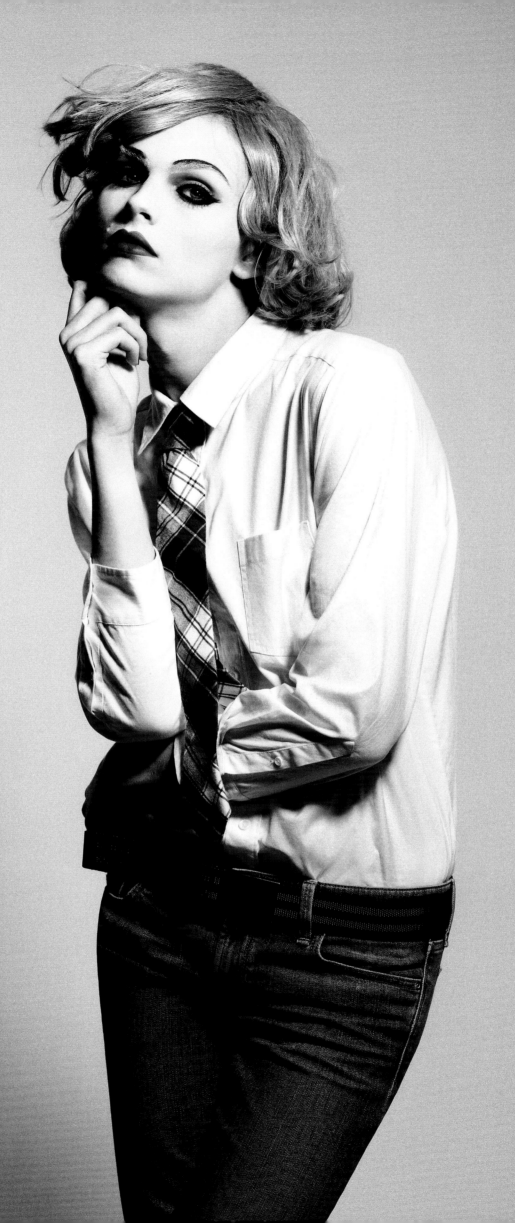

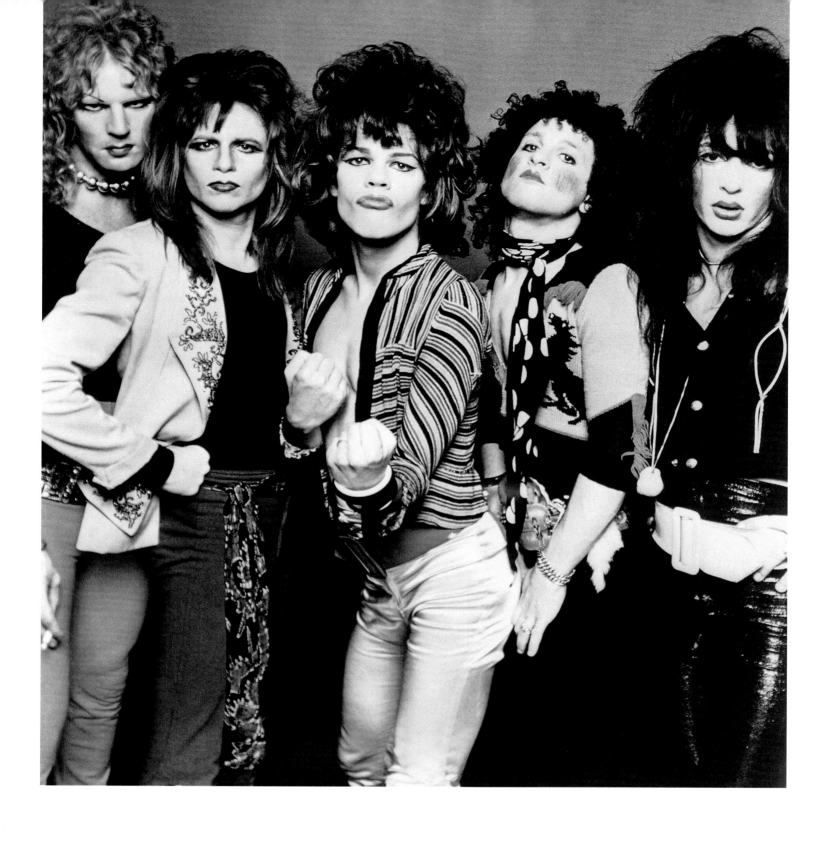

Above: The New York Dolls (Arthur Kane, Jerry Nolan, David Johansen, Sylvain Sylvain and Johnny Thunders), New York, 1973. Photograph by Bob Gruen

Opposite: Jenna Earle, *Flare*, 2012. Photograph by Andrew Soule

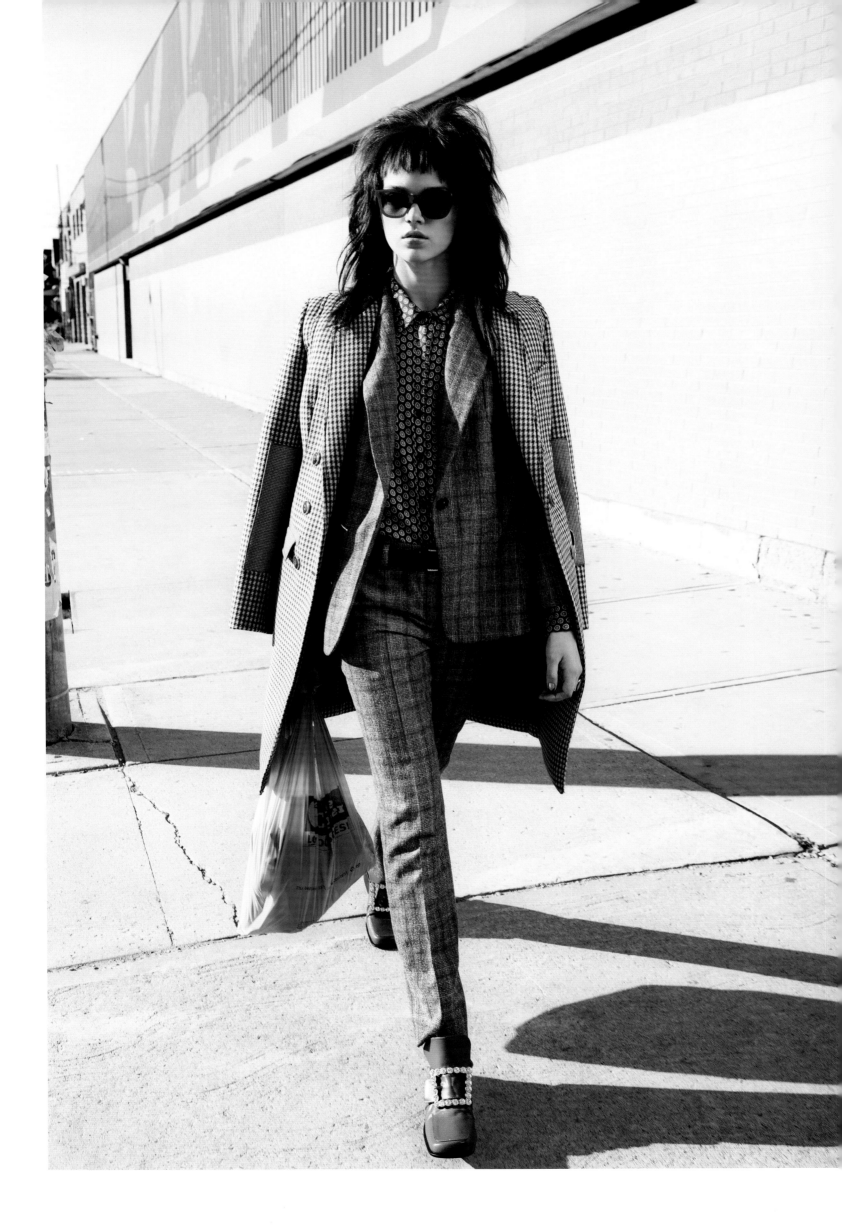

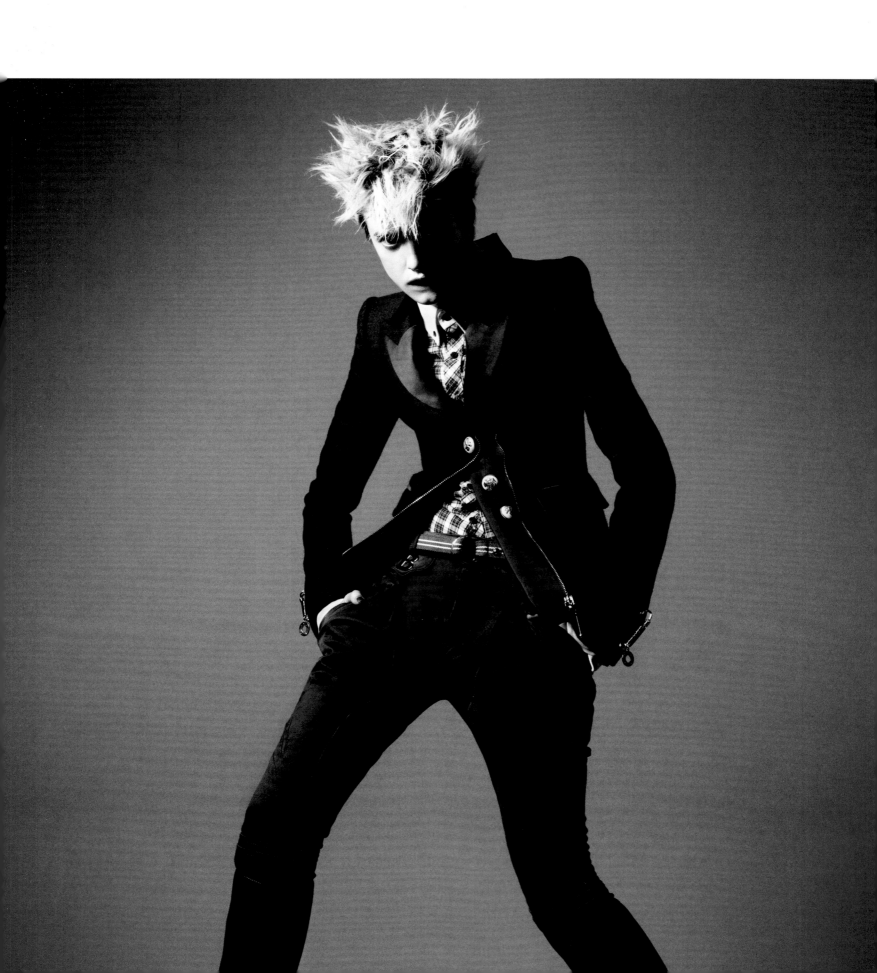

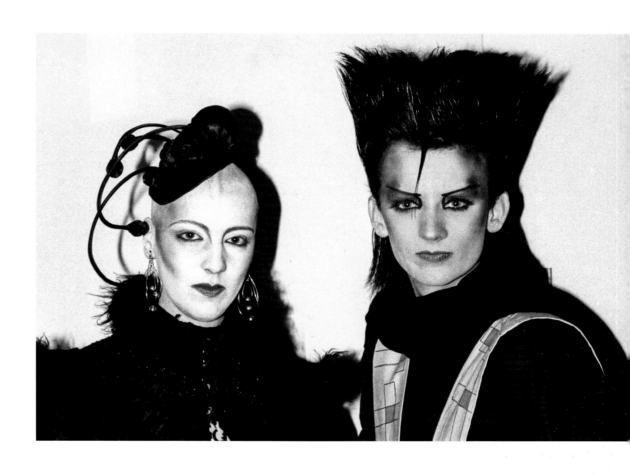

Above: Michele Clapton and Boy George, London, 1980. Photograph by Graham Smith
Opposite: Agyness Deyn, *V* USA, 2007. Photograph by David Sims

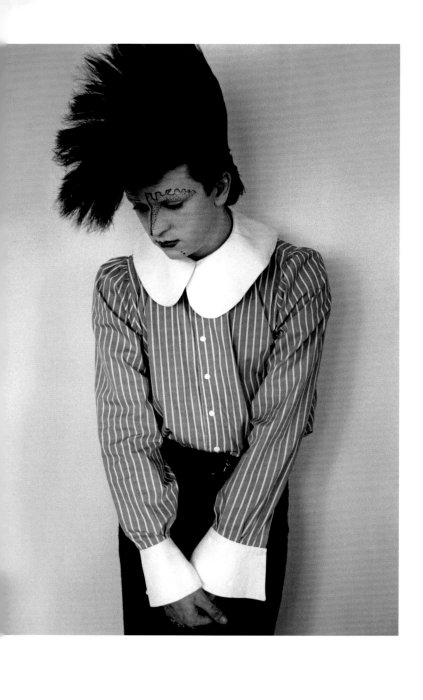

Above: Steve Strange, London, 1981. Photograph by Janette Beckman
Opposite: Stella Tennant and Guinevere Van Seenus, *Vogue* UK, 2013.
Photograph by Paolo Roversi

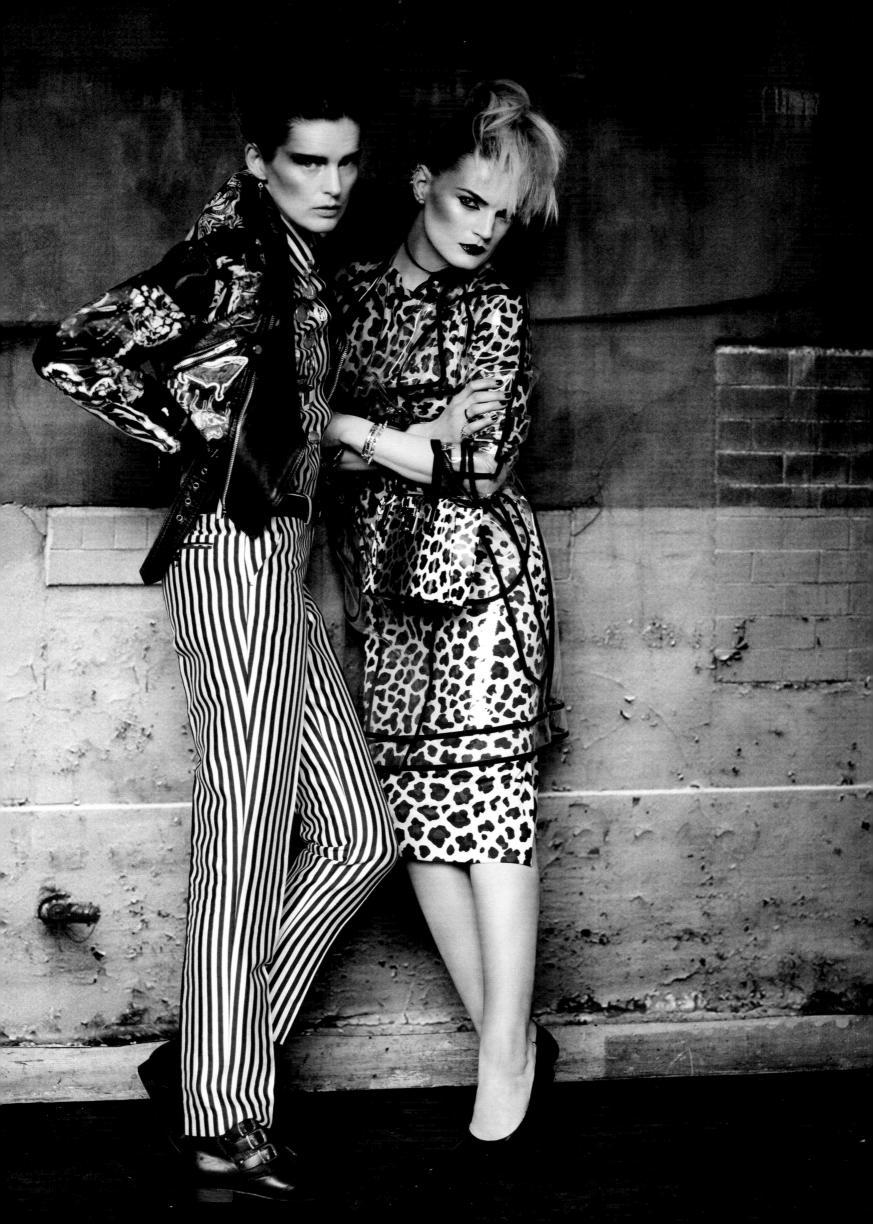

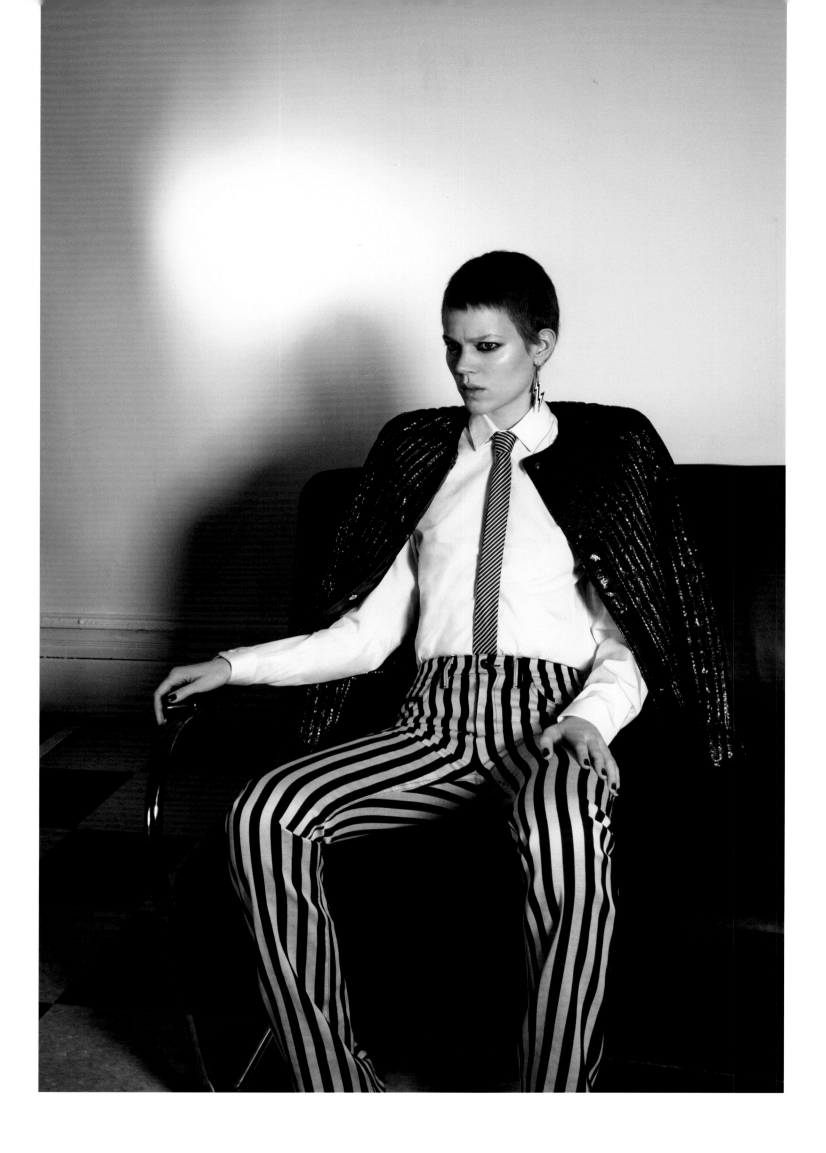

Freja Beha Erichsen, *Vogue* Paris, 2015. Photograph by Glen Luchford

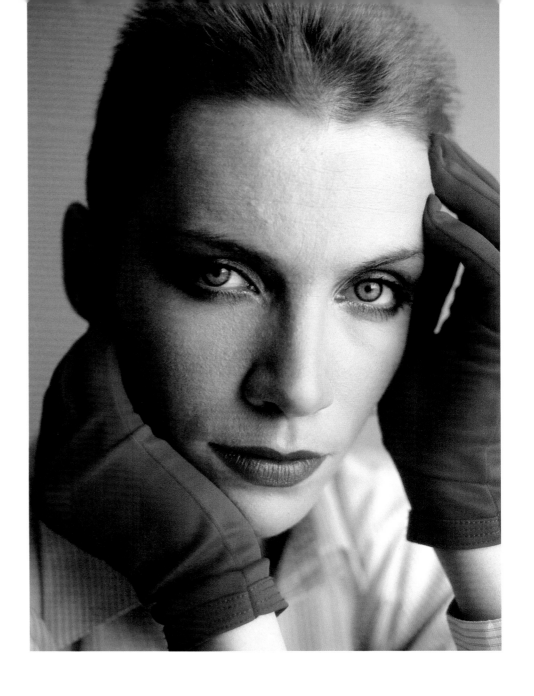

Annie Lennox, 1983. Photograph by Deborah Feingold

Grace Jones and her Double by Jean-Paul Goude,
New York, 1979

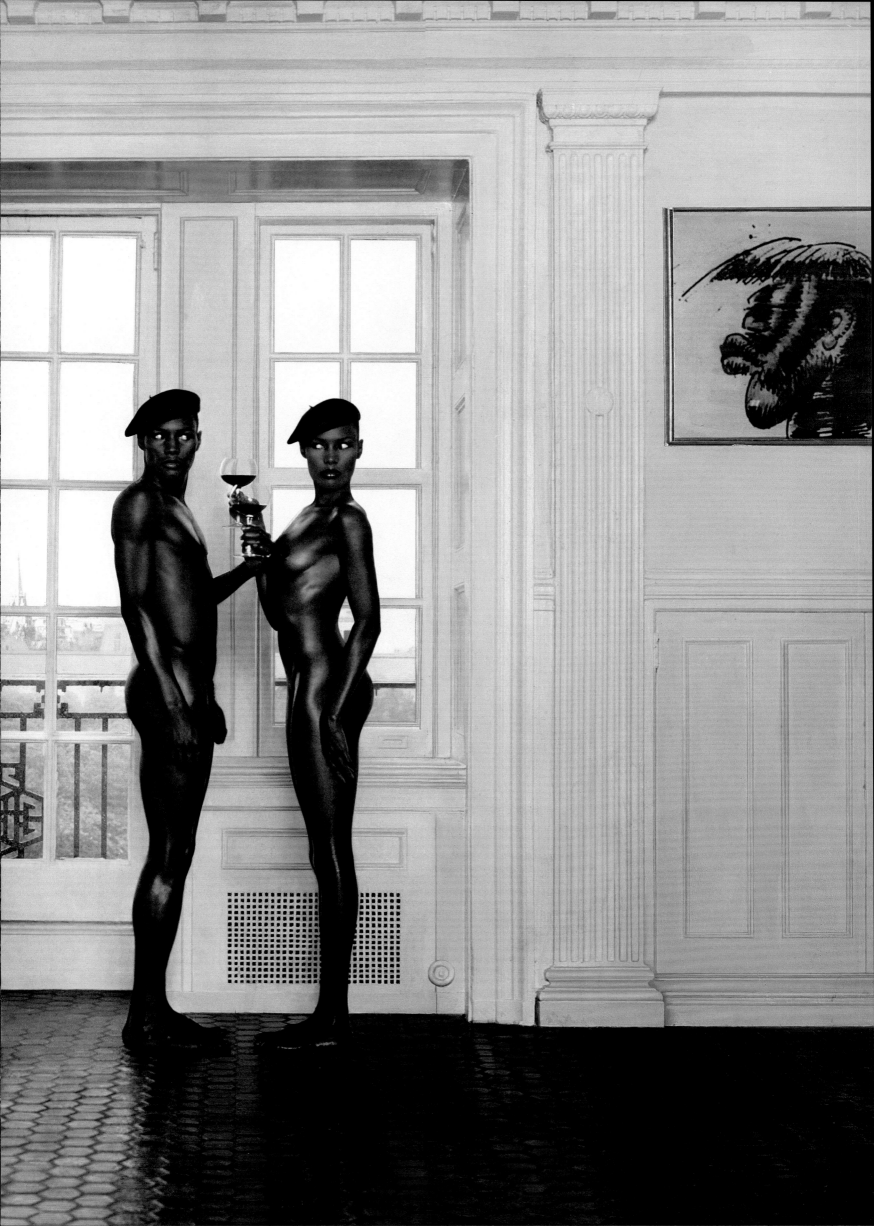

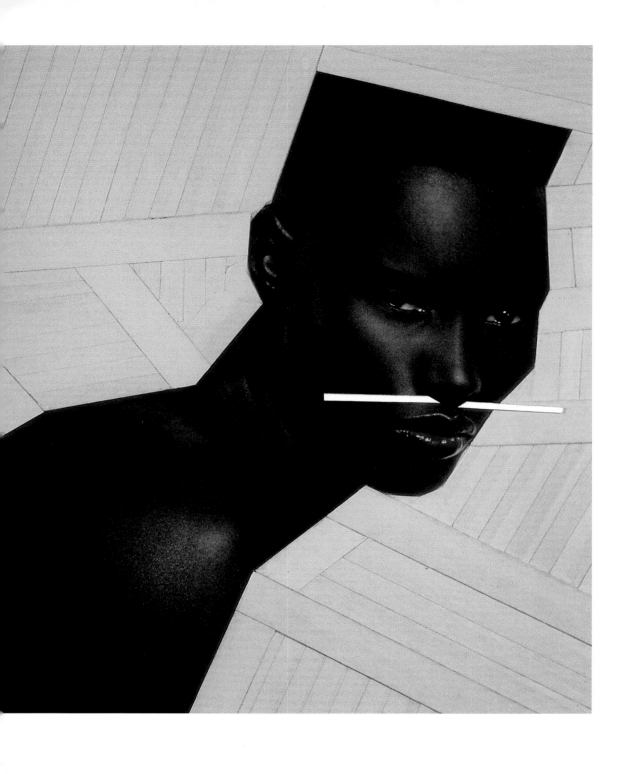

Above: Grace Jones by Jean-Paul Goude, 1983.
Opposite: Andrew Ruffin as Grace Jones, *Vogue Hommes* Japan, 2009.

Photograph by Josh Olins

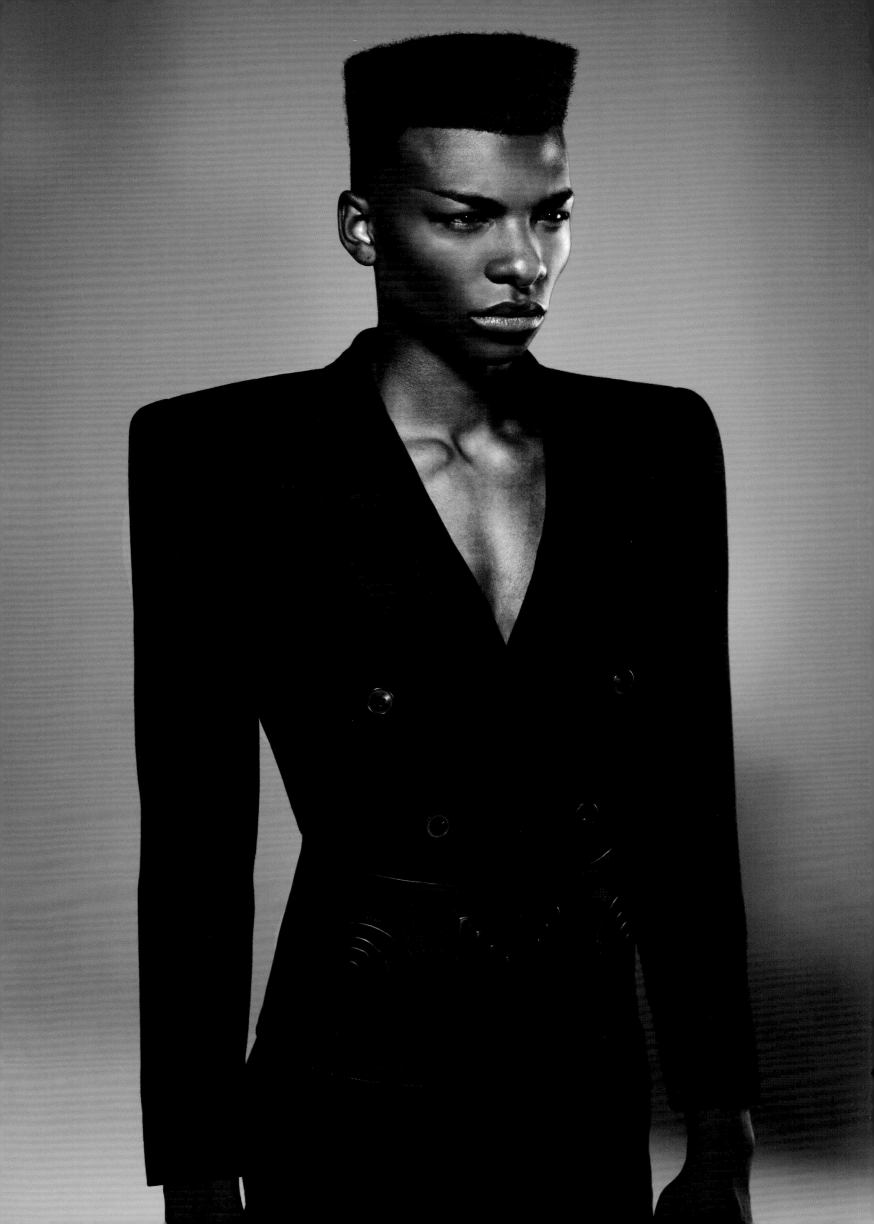

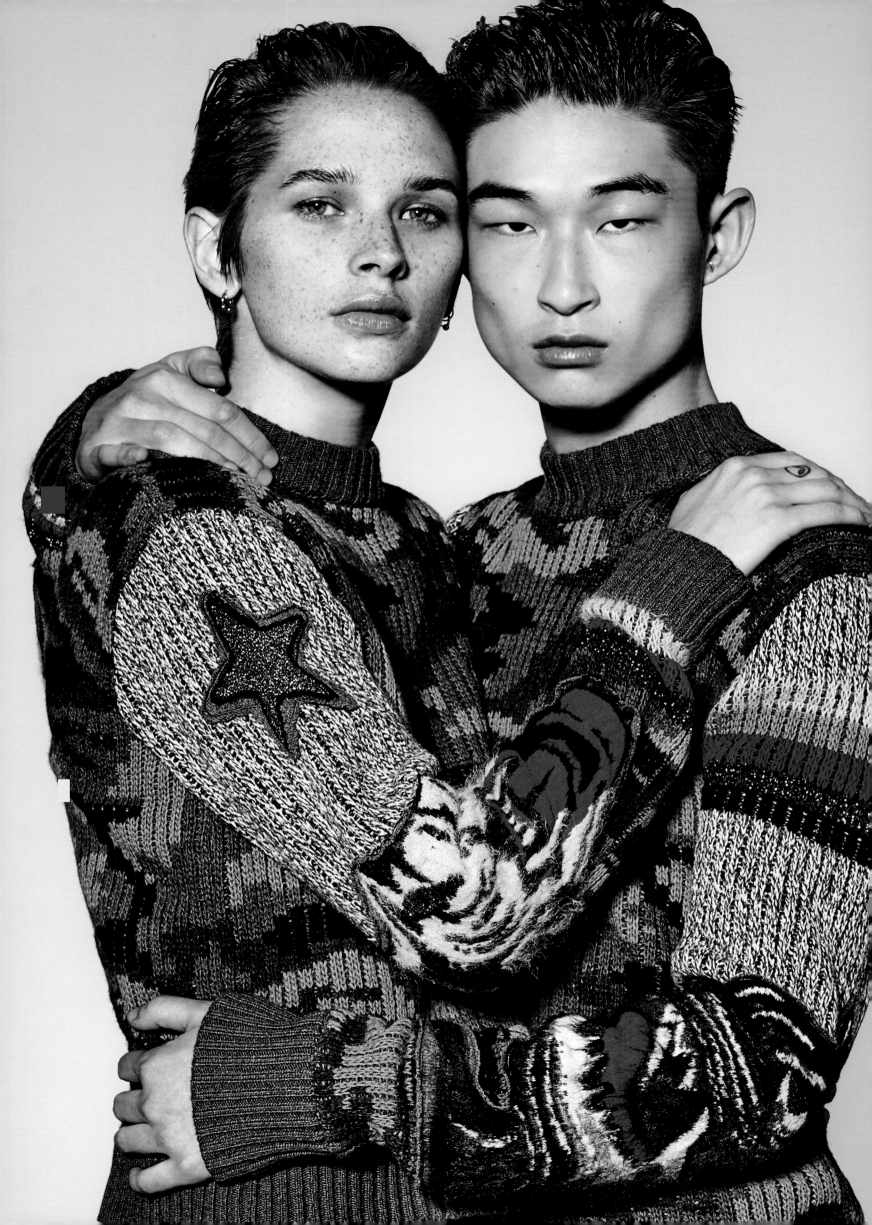

THE
LATEST
MODE

Following Baudelaire's credo that 'the beautiful is always bizarre' – or, as Gaultier himself might say, 'diverse' – the couturier has continued his onslaught on convention. He hit the headlines again with his autumn-winter 2010 collection, when the runway muse he chose to wear outfits ranging from the extremes of feminine glamour to severe suits was a nineteen-year-old model, Andrej Pejić, whose exquisitely fine features, long blond tresses and slender silhouette flew in the face of masculinity in all its traditional forms. For the following spring-summer collection in 2011, Gaultier went a step further, choosing Pejić to model the bridal gown that traditionally closes the runway show, a long, figure-hugging sheath with horizontal bands of white fur and topped with a towering plumed headdress. He also chose Pejić and the Russian model Karolina Kurkova as the poster couple for the provocative ad campaign to promote the collection, where they appear embracing each other like the reflections of the same ethereally ambivalent creature.

In place of the paradoxically sexualized androgyny that had brought him such attention in his early career, Gaultier now substituted the more disconcerting and hazy androgyny of a physique and features that were perfect yet unspecific, recalling the androgynes of classical mythology. Highlighting the centrality of this motif in his work, and as an in-joke about his own career, he themed his spring-summer 2016 show around a legendary Paris nightclub of the 1980s, Le Palace. In this setting, he cast beautiful gender-fluid young men of the moment, such as the French model Alex Wetter, in the roles of the tomboyishly gorgeous girls who had first inspired him. Prominent among those well-known figures from 1980s Paris's nightlife was the blonde Edwige Belmore, who had been one of his muses and was like an earlier incarnation of Casey Legler, the French former swimmer with an athletic build and delicate features who became the first woman to sign exclusively with a male model agency and model menswear.

The recent arrival of Pejić and other sexually ambiguous models, such as Allen Roth and Alex Wetter, has marked a genuine turning point in the history of contemporary fashion and has had a symbolic significance far beyond this particular domain. The issue of gender, now so topical, has played a key role in fashion design in the early twenty-first century, and is common to approaches and styles that are otherwise very different. When Hedi Slimane moved to Saint Laurent from Dior in 2012, he continued in the vein he had made his own. Taking inspiration from the lanky silhouette of Betty Catroux – Yves Saint Laurent's androgynous muse of the 1960s and 70s – and from Saint Laurent's 'Le Smoking' of 1966, he was able to assert his own vision of an ever youthful and gender-neutral look. At Givenchy in 2010, Riccardo Tisci featured the transgender model Lea T as the figurehead of a campaign based around the blurring of genders. The following year, he chose the Dutch model Saskia de Brauw, who has described herself as 'an androgynous face with a female body', to walk in his January menswear show. And Karl Lagerfeld, in March 2016, took Coco Chanel's iconic tweed suit – borrowed from menswear nearly a century earlier and turned into a timeless staple of female elegance – and placed it back on to a male body, thus bringing matters full circle and transforming the venerable atelier into a proponent of non-binary fashion.

Two designers regularly cited as the leaders of contemporary 'androgynous fashion' are Jonathan Anderson and Alessandro Michele. Since Anderson started his career as a designer in 2008, he has deliberately refused to make his looks gender-specific, paying tribute to the trailblazing work of Jean Paul Gaultier and referring back to the gender-neutral fashion of Japan and the Far East: 'I design a shared wardrobe,' he explained in 2014. 'I have never liked to label clothes by gender. These classifications have had their time. Nowadays, women help themselves from the men's department and vice versa. It breaks down barriers. I hope that in five years this will be the norm.' Michele's strategy at Gucci is totally different, and recalls the spirit of designers such as Mr Fish in his playful use of prints, combinations and colours. According to the fashion journalist Yari Fiocca in 2015: 'Since Alessandro Michele has called the shots at Gucci, the sexy panache man's body was imbued with is no longer a big deal. Michele keeps through the thrills of bending sexes, creating a more flamboyant halo with a 70s style throwback. His off-gender brave new world confuses, winks. Male or female is just a hangover of the past. The machismo show-off era draws to an end and – as it turns out – a subtle eroticism gets into high gear. Decadent straight ruffle-collar silk blouses, the delicacy of lace mixed with knitwear, the sporty allure of some outerwear pieces soften the classy lavalliere bows, art déco prints and astrakhan overcoats….'

So many examples – and all of them applications of the truism that the deepest ideas can be expressed by the most superficial things, that clothes can be the means of communicating identity or, at the least, affirming it to the wearer. The diverse offerings of contemporary fashion have come a long way from the frills and furbelows of the Abbé de Choisy, the studied starchiness of the Amazons, the many faces of David Bowie or even

the early designs of Jean Paul Gaultier. But now, the assertion of diverse and nonconformist identities seems to be established as a regular feature of couture shows. 'If 2015 was the year unisex became a trend in fashion, 2016 may be the year the question of gender and dress enters an entirely new dimension,' stated *The International New York Times* in the first week of 2016. 'It is obvious that gender neutrality is dominating the runways,' confirmed *CR Fashion Book* a few weeks later.

The manifestations in contemporary fashion are the most striking and evolved sign of the disruption of the supposedly natural order and opposition of the sexes, as well as of the social changes occurring in its wake. But they are also – and this point cannot be over-stressed – the belated expression, post facto, of the philosophical, psychological and sociological questioning of the 1970s. Agender, genderless, cisgender, transgender, intersex, non-binary, gender fluid, genderqueer, third gender, transmasculine, transfeminine – the idea of gender, and even more the idea of an identity that is stable, fixed and unchanging, has dissolved in a fluid tide of acronyms and individualities. Formerly self-evident qualities like 'feminine' or 'masculine' have now become simply questions of recognition and acceptance on the spectrum between AFAB and AMAB (assigned female/male at birth). The opposition between biological sex and social gender, the subject of so much controversy over the last thirty years or so, has gradually entered the mainstream. Commenting in 2013 on Anne Fausto-Sterling's influential essay 'The Five Sexes: Why Male and Female Are Not Enough', written two decades earlier, the psychologist Pascale Molinier observed that 'bodies are part of an indivisible process of nature/culture or sex/gender'; that 'no state of nature exists that can be understood outside the context of society'; that '"biological reality" has no meaning unless interpreted within the system of representation unique to each society'; and finally that 'gender comes before sex'. When Fausto-Sterling revisited 'The Five Sexes' in 2000, she insisted that 'absolute dimorphism disintegrates even at the level of basic biology'.

Historically, science and scholarship in general have responded to the uncertainty and difficulty of perceiving the androgynous body – and hence of describing and classifying it – with a desire to pin it to one pole or the other, creating, in Molinier's words, 'a parody of a gendered body, a "so-so" body': but any approach is no more accurate than all the rest. In order to restore the body's freedom, Fausto-Sterling wants to cast off any notion that the fluid reality of intersexuality should be veiled or straitjacketed: 'Hermaphrodites have unruly bodies. They do not fall naturally into a binary classification'. Unique and irreducible, the androgynous figure reveals the imaginative world that lies outside science.

Suzanne Kessler, however, argued that Fausto-Sterling's remarkably open-ended approach had one significant limitation: it 'still gives genitals…primary signifying status and ignores the fact that in the everyday world gender attributions are made without access to genital inspection…what has primacy in everyday life is the gender that is performed, regardless of the flesh's configuration under the clothes'. Kessler went on to suggest a concept of 'cultural genitals' that would better suit the diversity of sexual identities, leading Fausto-Sterling to admit: 'One should acknowledge that people come in an even wider assortment of sexual identities and characteristics than mere genitals can distinguish.'

This is what fashion today is constantly saying beneath its apparent frivolity. Before eventually transitioning and becoming Andreja, Pejić modelled for years while refusing to be defined by gender, moving easily from one end of the spectrum to the other, according to mood or couture show. When looking for someone to represent 'a generation that has assimilated the codes of true freedom, one that is free of manifestoes and questions about gender', Nicolas Ghesquière, artistic director at Louis Vuitton, used Jaden Smith, son of Hollywood star Will Smith, as a model for his summer 2016 womenswear campaign. 'Wearing a skirt comes as naturally to him as it would to a woman who, long ago, granted herself permission to wear a man's trench or a tuxedo.' Casey Legler, meanwhile, has set her sights on wider horizons, beyond the limits imposed by gender: 'It is certainly not

about gender. It is about being fierce…. This is about making space, making room and making things better.'

At the same time, Japan has seen the rise of the 'genderless danshi [young men]', the most prominent of whom is Toman Sasaki, a musician and model who wears long, heavy-fringed hair, make-up and high heels, shrugging off the codes of masculinity in favour of total ambiguity. As if to blur the issue further, like many genderless danshi he is straight. Another member of the group explained that, as a teenager, he disliked the attention he attracted from gay men. 'But now that I began wearing this genderless fashion, I think I shed my prejudice…. Before, I didn't like boys or men who love each other, but I have started to accept them. Beautiful people are just beautiful.'

Accustomed to codes of dress and to theatrical and artistic traditions that often lessen the gap between the sexes, the Japanese gaze views differently what the West has often regarded as a disorder. In the 'Empire of Signs' – as Barthes famously called Japan – it is easier, so fashion historians say, to discern ways of presenting one's 'deeper' or sexual identity through clothes. The opposition between 'appearance' and 'truth' – and the 'blurring' this implies – that is common to the various forms of androgyny we have discussed is eradicated here. Western fashion, in making the affirmation of gender a simple matter of semiotics – an array of signs from which each individual is free to choose without the obligation to conform to any codes – is now discovering the spirit of cultures that have always had much greater freedom in this respect. Doubtless it will take many years before the 'semiological chaos' of the early twenty-first century fully settles. We need only consider the commotion created in the early 1900s by the 'appropriation' of men's suits, trousers and sportswear by Coco Chanel and Jean Patou – now a complete non-issue – to imagine the same process occurring around the adoption by men of traditionally female garments.

In taking a sly pleasure in blurring the issue, the androgynous trend in contemporary fashion seems to be fulfilling Anne Fausto-Sterling's hope: 'Imagine a world in which the same knowledge that has enabled medicine to intervene in the management of intersexual patients has been placed at the service of multiple sexualities. Imagine that the sexes have multiplied beyond currently imaginable limits. It would have to be a world of shared powers. Patient and physician, parent and child, male and female, heterosexual and homosexual – all those oppositions and others would have to be dissolved as sources of division. A new ethic of medical treatment would arise, one that would permit ambiguity in a culture that had overcome sexual division.'

When these lines were written over twenty years ago, they seemed to express wishful thinking, a lyrical flight of fancy or a utopian ideal. Any challenging of the difference between the sexes – the fundamental division of human society for both science and religion – resembled a straightforward act of denial, inevitably destined to break down when it hit the wall of reality. This statement's power to provoke, whether deliberate or not, can be measured by the resistance that its sentiments encountered, and still encounter today, in many social and cultural circles – and, in particular, by the violent reactionary response they receive from supporters of the 'traditional' family model, with its allegedly 'natural' roots that are supposed to exist outside historical contingencies but are actually fundamentally dependent on the Judeo-Christian tradition. The same ideas, albeit in a different guise, can also be found behind the intrinsically French opposition between universalists and communitarians: between those who believe in secular citizenship, stripped of markers, and reflecting some golden mean or hypothetical entity; and those who accept expressions of group identity, idiosyncrasies and petty divisions without wishing to plaster over them. The former believe that the latter pose a threat to the integrity of traditions or culture, yet they do not see that these, like languages, are no other than the aggregate of countless differences, distinctions and peculiarities.

In January 2017, the highly respectable *National Geographic* magazine devoted an entire issue to the sociological phenomenon of the 'gender revolution'. 'People today – especially

young people – are questioning not just the gender they were assigned at birth,' it declared, 'but also the gender binary itself.... A recent survey of a thousand millennials ages 18 to 34 found that half of them think "gender is a spectrum, and some people fall outside conventional categories."' Only time will reveal the full scale and scope of this new form of the 'right not to choose' – the new and dogged quest for gender neutrality, which was once thought illusory, impossible or pathological, but is now gaining a strength and importance like never before. Fashion, in its role as a harbinger of change, now literally embodies this quest.

'This ad is gender neutral' proclaimed a 2015 promotional shot for Diesel in which the two models, Sara Cummings and Sang Woo Kim, are identically dressed. Gender free, gender neutral or androgynous images like this one also represent youth suspended in time. In so doing, they are revisiting a leitmotif of androgyny that we have already seen, one that resonates with our fears of growing old, and of the ever lengthening dotage now promised to us by advances in science, and with the rejection of the ageing body that is characteristic of modern societies. Many of the photographs included in this book contain immaculate bodies bathed in soft light, recalling the motif of the 'body of ivory' that we have seen in the works of Ovid, Balzac and Rachilde: a body free from the marks of time or gender, whose youth makes it the very embodiment of the Neuter – a human being in its most perfect form. These images stand on what the cosmopolitan Polish novelist Witold Gombrowicz called the 'fatal boundary, dividing two not just separate but opposing phases of life', those of 'development and decline, man after thirty who is beginning to end and man before thirty who is still developing. This is fire and water, here something in man's very essence changes. What does a young man have in common with an aging man if each is written in a different key? It would seem that there should be two separate languages: one for those who have more and more life and another for those who have less and less. Yet this contrast has been passed over in silence.' To Gombrowicz, this was both a code of ethics and a sensual and tragic vision of existence: 'it is important, even very important, that we never break within ourselves with the period of the human lifetime in which beauty becomes accessible – this is youth. For whatever beauty is gained in old age, it will always be incomplete beauty, marred by a lack of youth.'

While overcoming the basic antithesis of male and female, these images of eternal adolescence remain caught in another fundamental opposition between two states of the body: that between youth and age, between the 'blossoming life' that Gombrowicz found so fascinating ('the only life that deserves the name') and its eventual decline ('that which doesn't blossom, withers'). By ignoring one in favour of the other (as so many fashion images do), they reflect a reality that still seems unlikely or artificial, but which scientific, psychological, social and cultural changes are bringing ever closer and rendering ever more plausible. After all, the androgynes of the early decades of the twenty-first century are now flourishing in myriad incarnations, many of which did not even have a name only a few years ago.

In their dynamic desire to shake off reductive definitions and categorizations, to pass freely from one state to another, and to use the power of ambiguity in a playful way, these contemporary androgynes are the exact opposite of the Platonic beings who were sliced in half with a length of horsehair twine and left haunted by the absence of their other halves – creatures of desire hollowed out by loss and the eternal wretched quest for a satisfaction that can never be found. In their self-affirmation, their diversity and their desire to be different, the modern androgynes are much closer to the ones imagined two centuries ago by the utopian philosopher Charles Fourier, who made these epicene, composite creatures the emblems of his *New World of Love* (1816), where 'pivotal' passions, the appreciation of fundamental interconnectedness and a respect for all forms of desire, however unusual, would lead humanity from the tainted state of civilization towards

harmony. It is no surprise that Fourier became a tutelary figure of the 1970s, a decade that sought to liberate desire and move towards the recognition of otherness.

The overturning of ideologies, the exploring of philosophical extremes and the stressing of a naive longing for freedom have all paved the way for a present marked by disillusionment, by a return (supposedly) to realism, by a cynical view of the struggle for power, by the belief that might is right and that the winner takes all, and by the elevation of success to an objective measure of virtue. We have rarely been so resistant to the power of dreams, and to the imagination that fuelled the art of most of the twentieth century, as we have in the last two decades, when poverty (if not complete lack) of style has been perceived as a virtue, when knowing naturalism with a sociological gloss has become the last word in literature, and when art – at least the kind most often showcased – has been judged quite shamelessly for its investment value.

History is littered with shattered utopias and unfulfilled hopes. Perhaps the rejection of gender divisions, the quiet ambiguity conveyed by images like those featured in this book, and the values they embody, will remain nothing more than the fleeting expressions of a brief moment. Or perhaps, on the contrary, they herald a radical transformation of what has long been regarded as an immutable aspect of human nature, but which is now being challenged by these unwitting Fourierists, the modern androgynes. After all, the utopia of one age may also become the reality of the next.

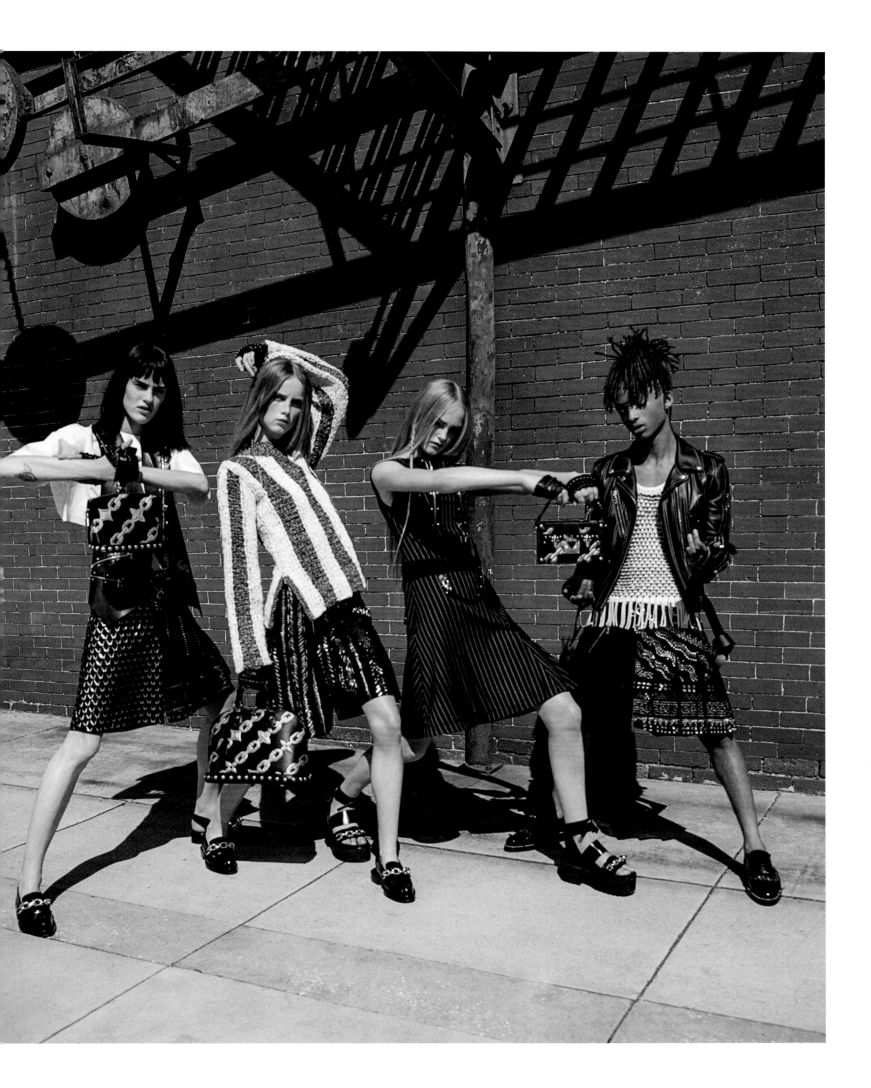

Sarah Brannon, Rianne Van Rompaey, Jean Campbell and Jaden Smith
for Louis Vuitton, 2016. Photograph by Bruce Weber

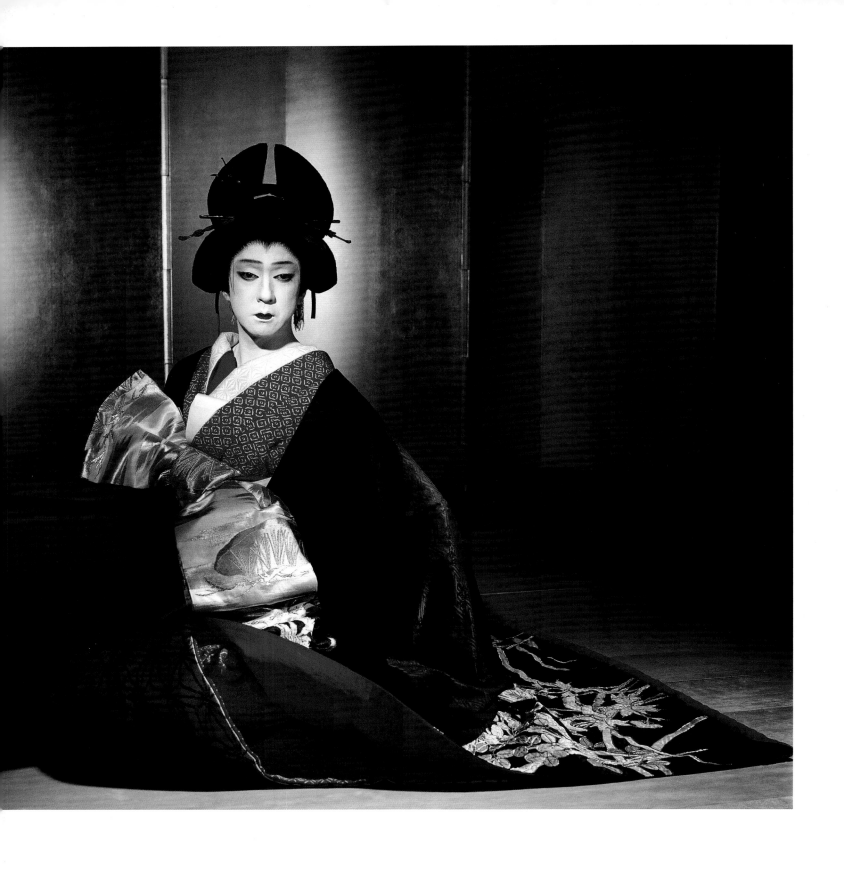

Above: Onnagata actor Bando Tamasaburo V, kabuki theatre production, Uchiko, Japan, 1996.
Photograph by Hervé Bruhat

Opposite: Show Luo, *Vogue* Taiwan, 2012. Photograph by Mika Ninagawa

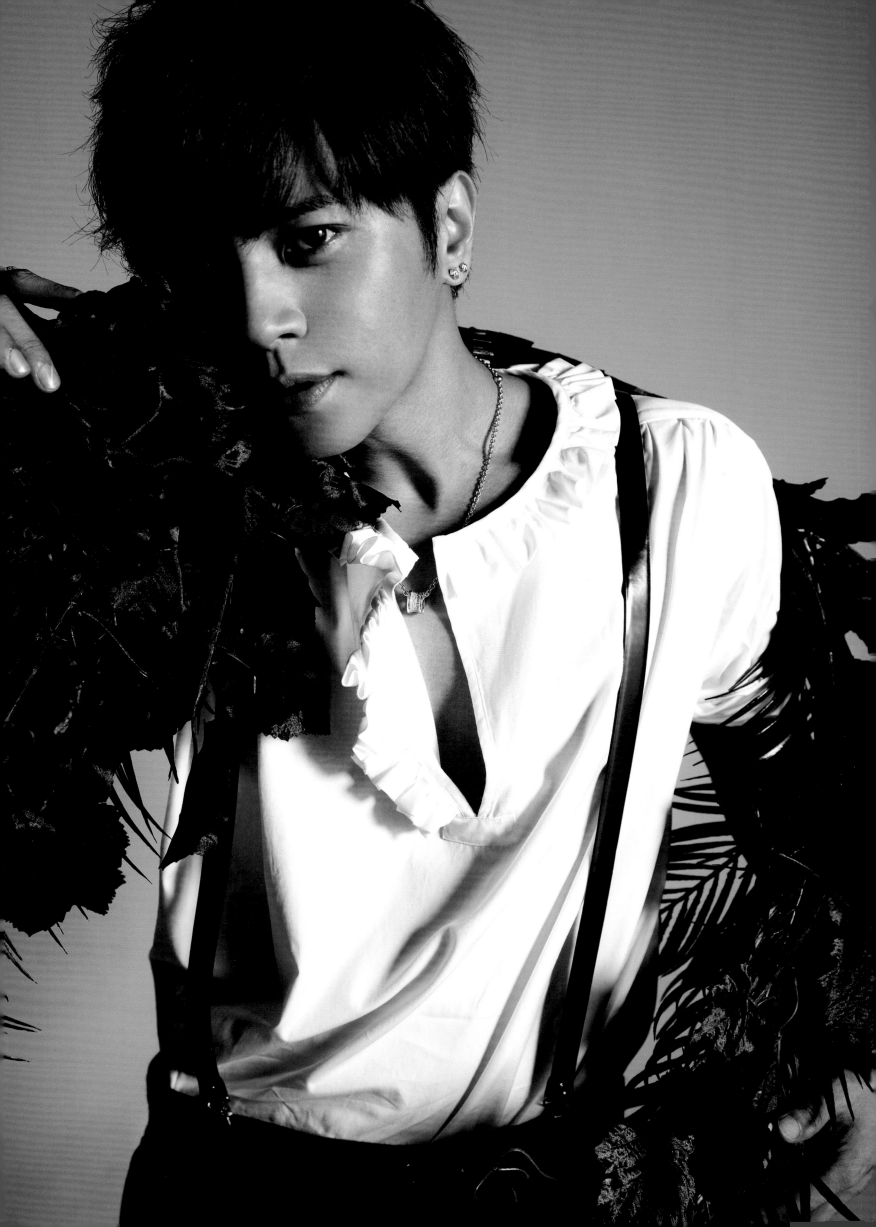

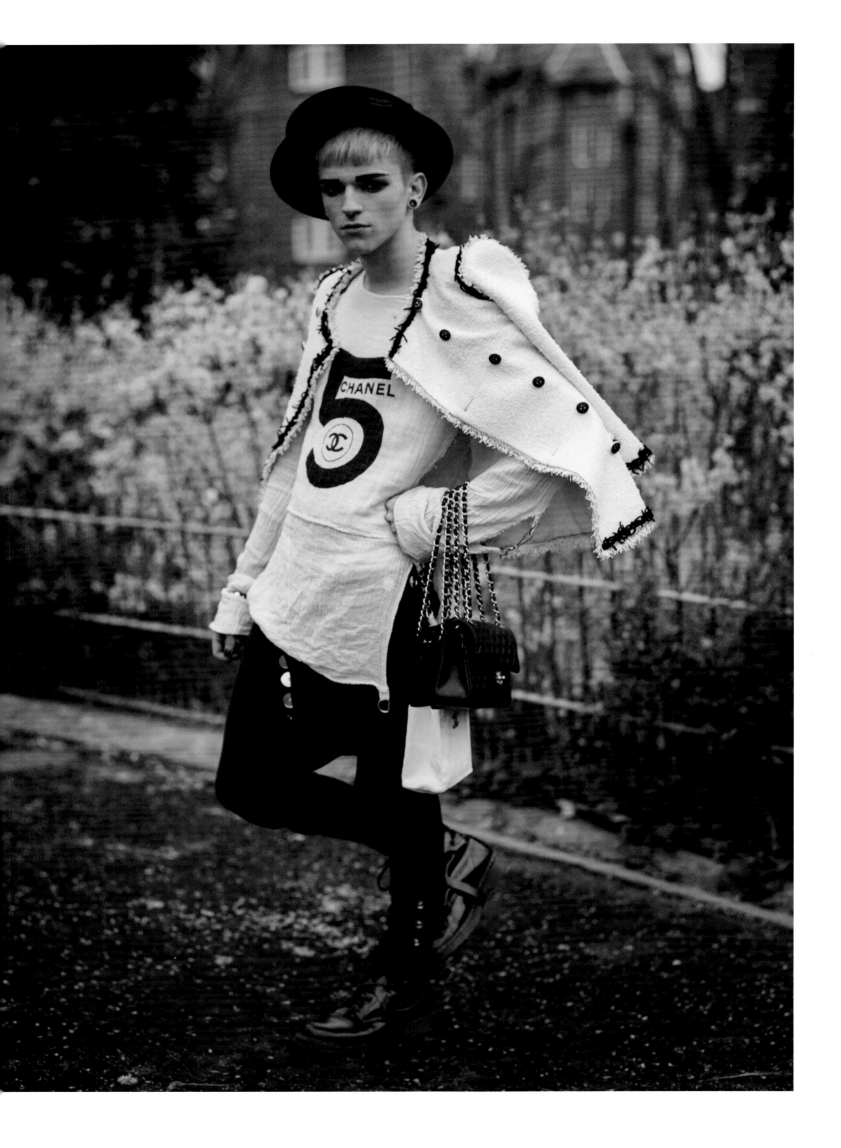

Little 'Coco' Jordan, *i-D*, 2009. Photograph by Tim Walker

Gabrielle 'Coco' Chanel and Gigot, Villa La Pausa, Roquebrune-Cap-Martin, France, *c.* 1930 163

Ruth Bell, *Another Man*, 2016. Photograph by Collier Schorr

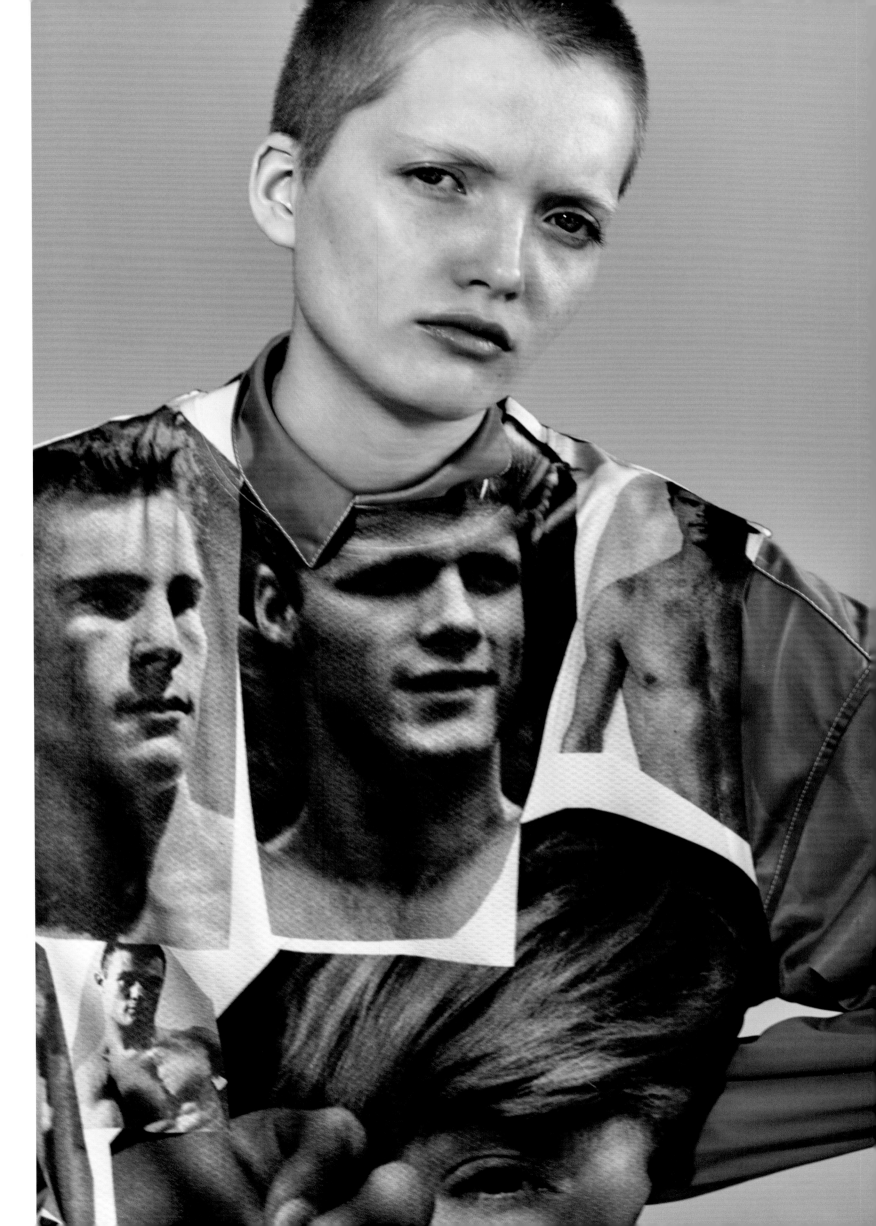

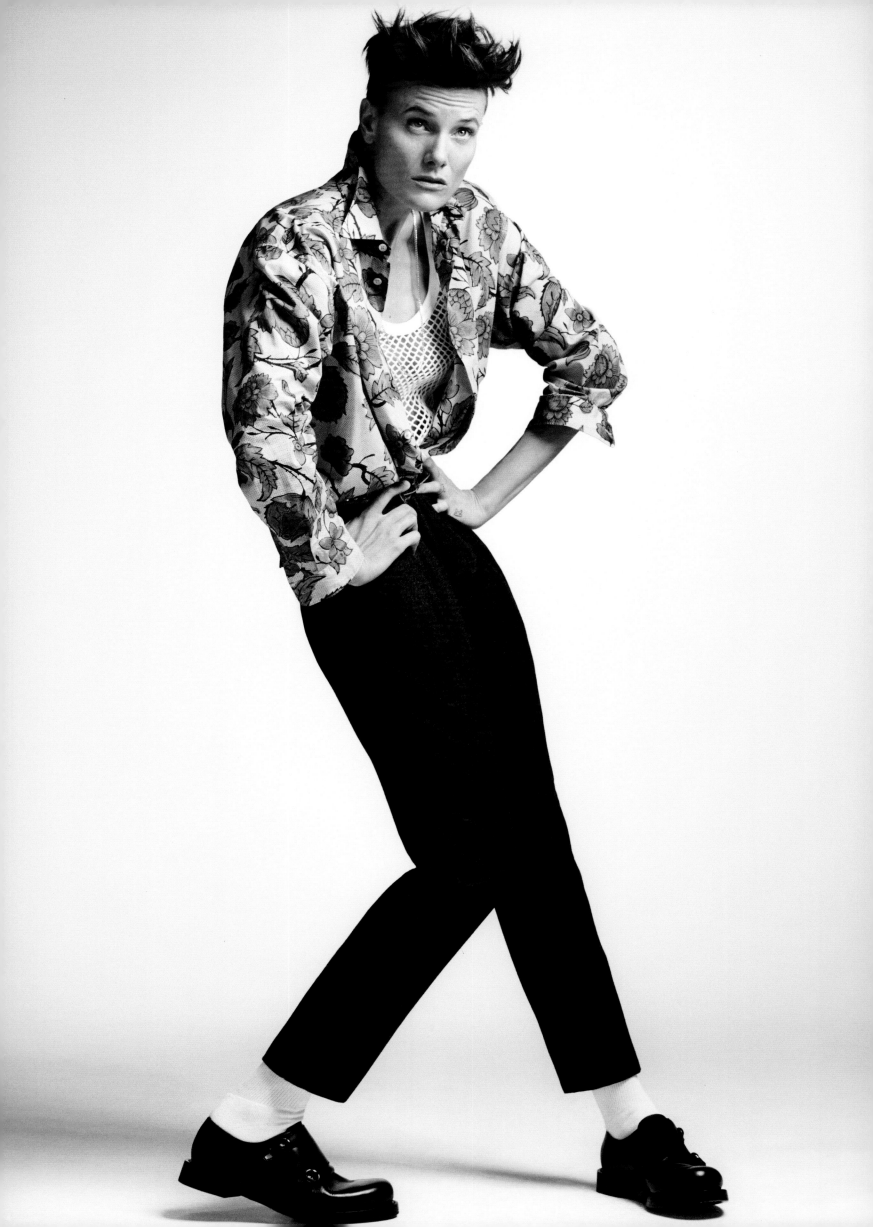

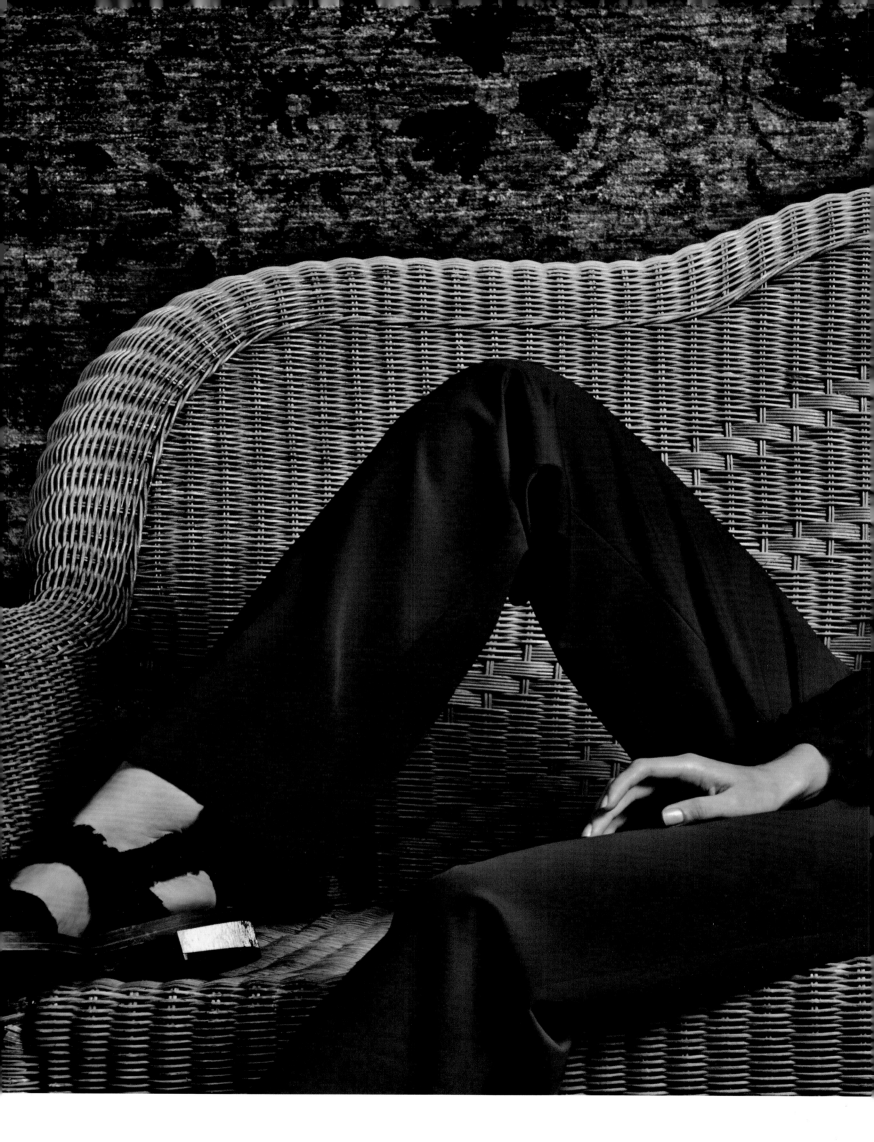

Irina Kravchenko, *Vogue* Russia, 2015. Photograph by Jason Kibbler

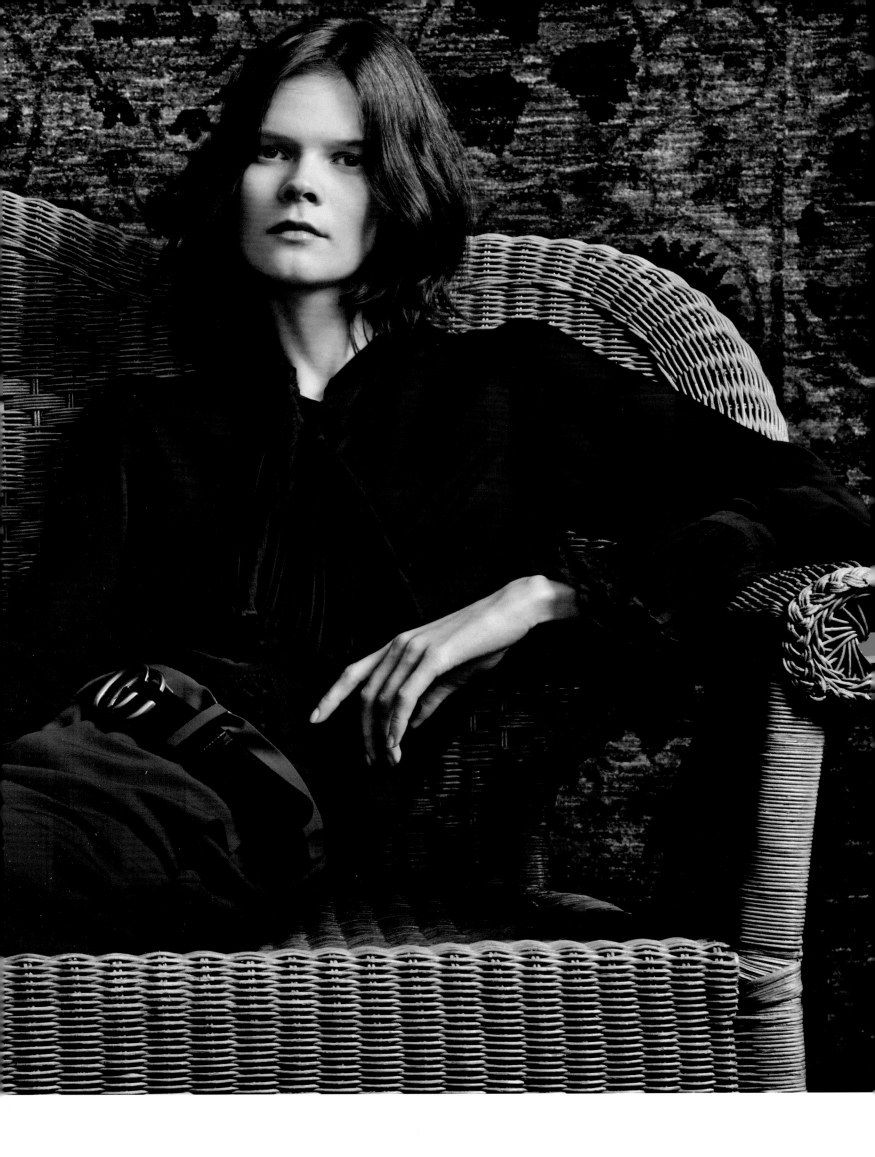

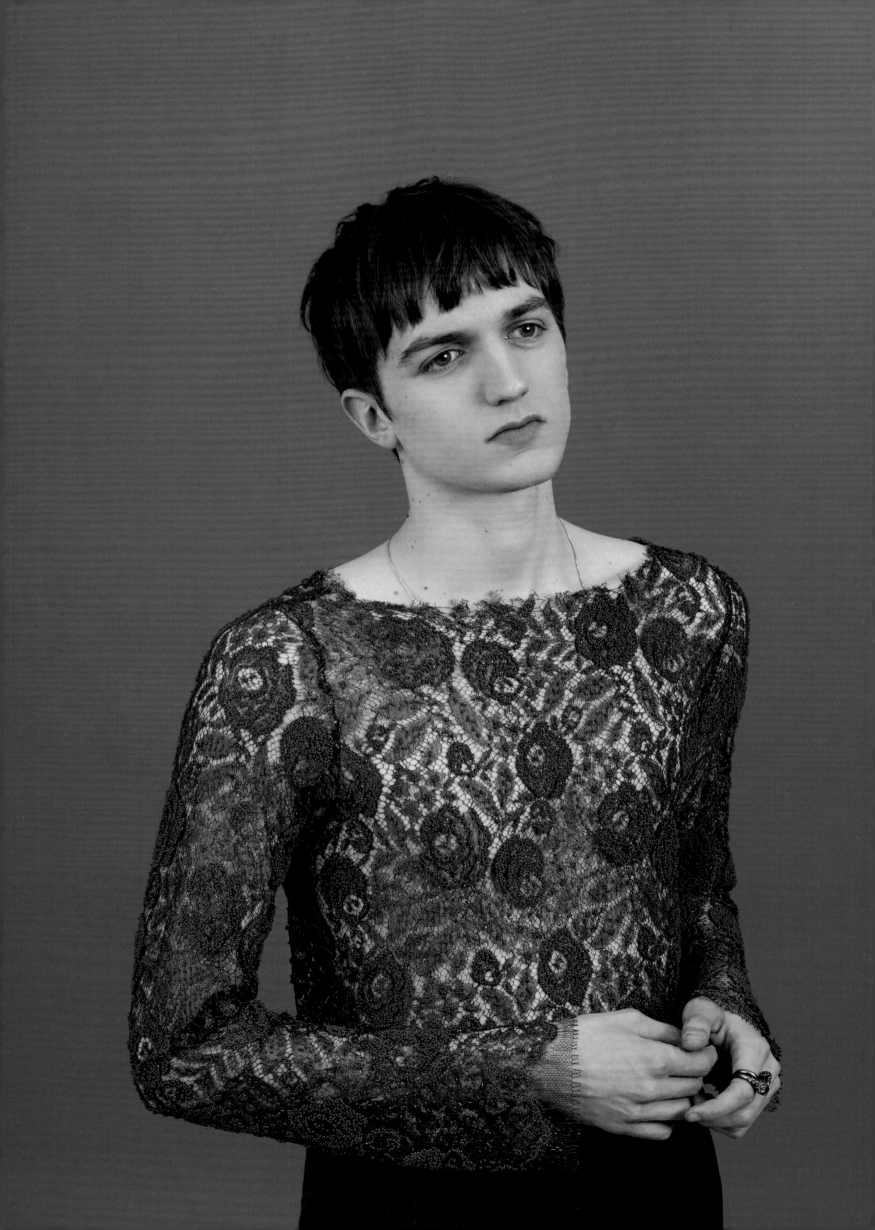

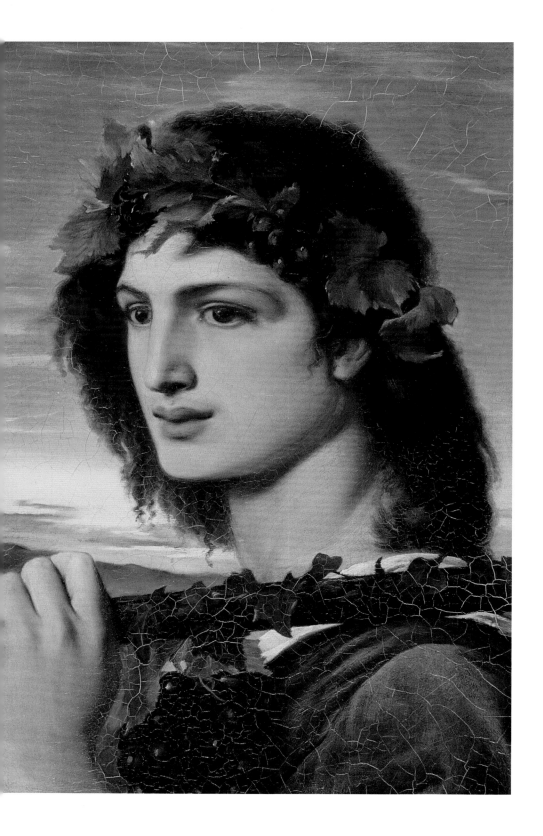

Above: Simeon Solomon, *Bacchus*, oil on paper laid on canvas, 1867
Opposite: Luka Sabbat, *Hercules Universal*, 2015. Photograph by Daniel Riera

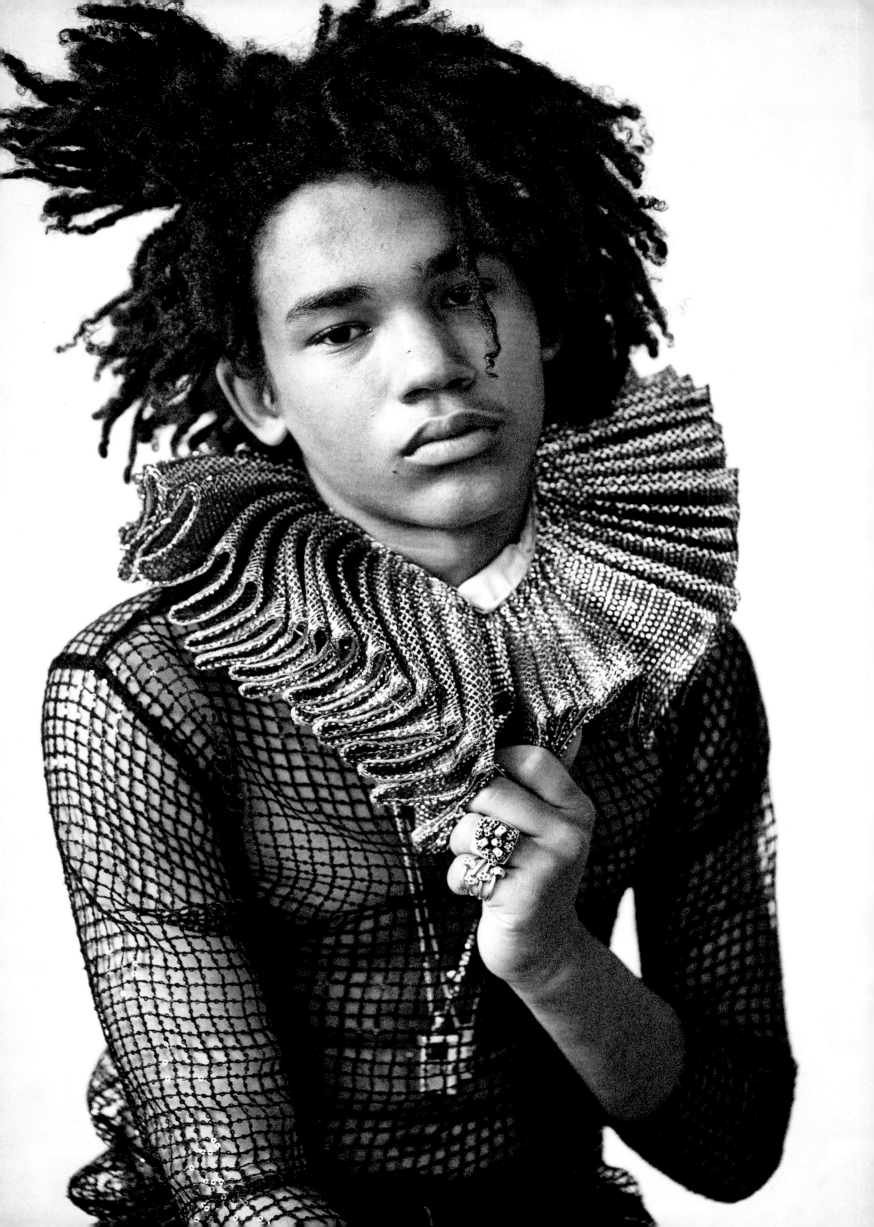

Andreja Pejić, *Dossier*, 2011. Photograph by Collier Schorr

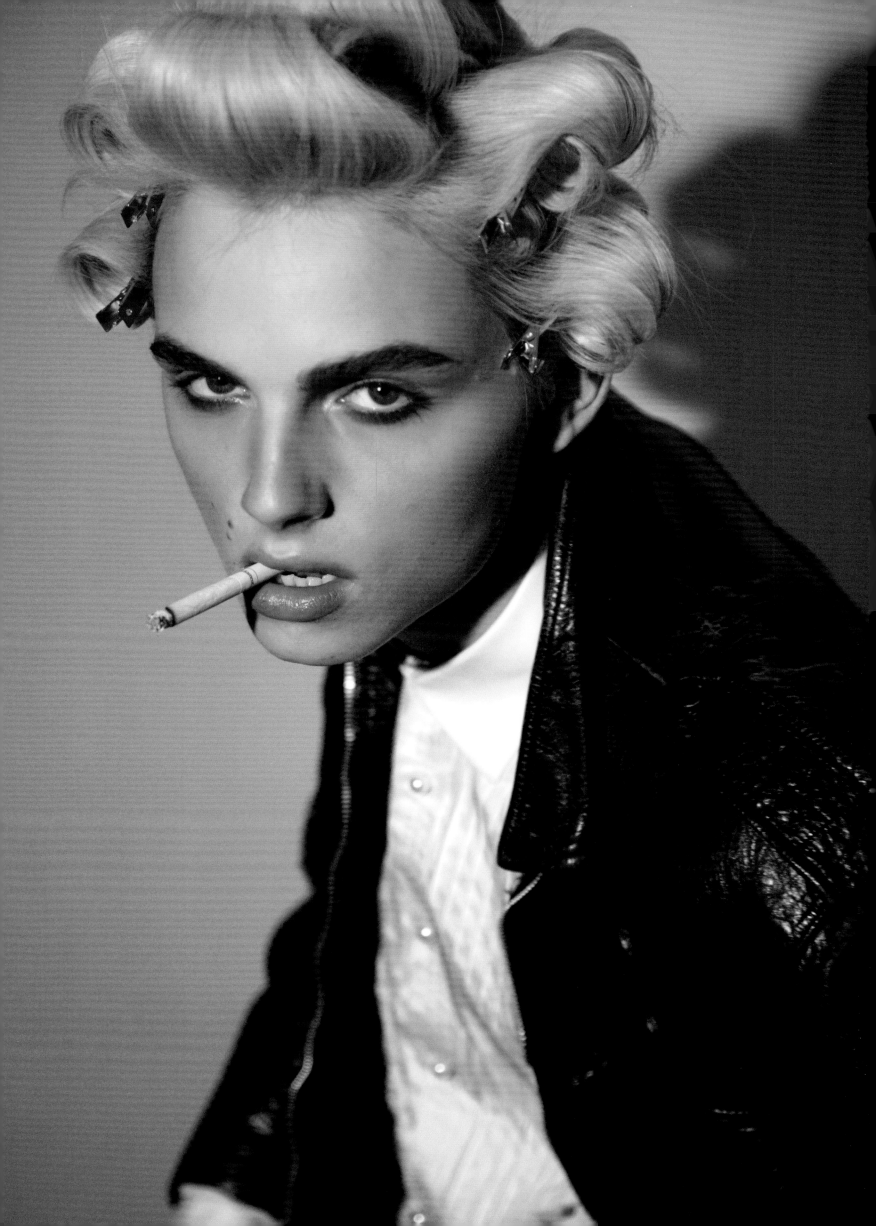

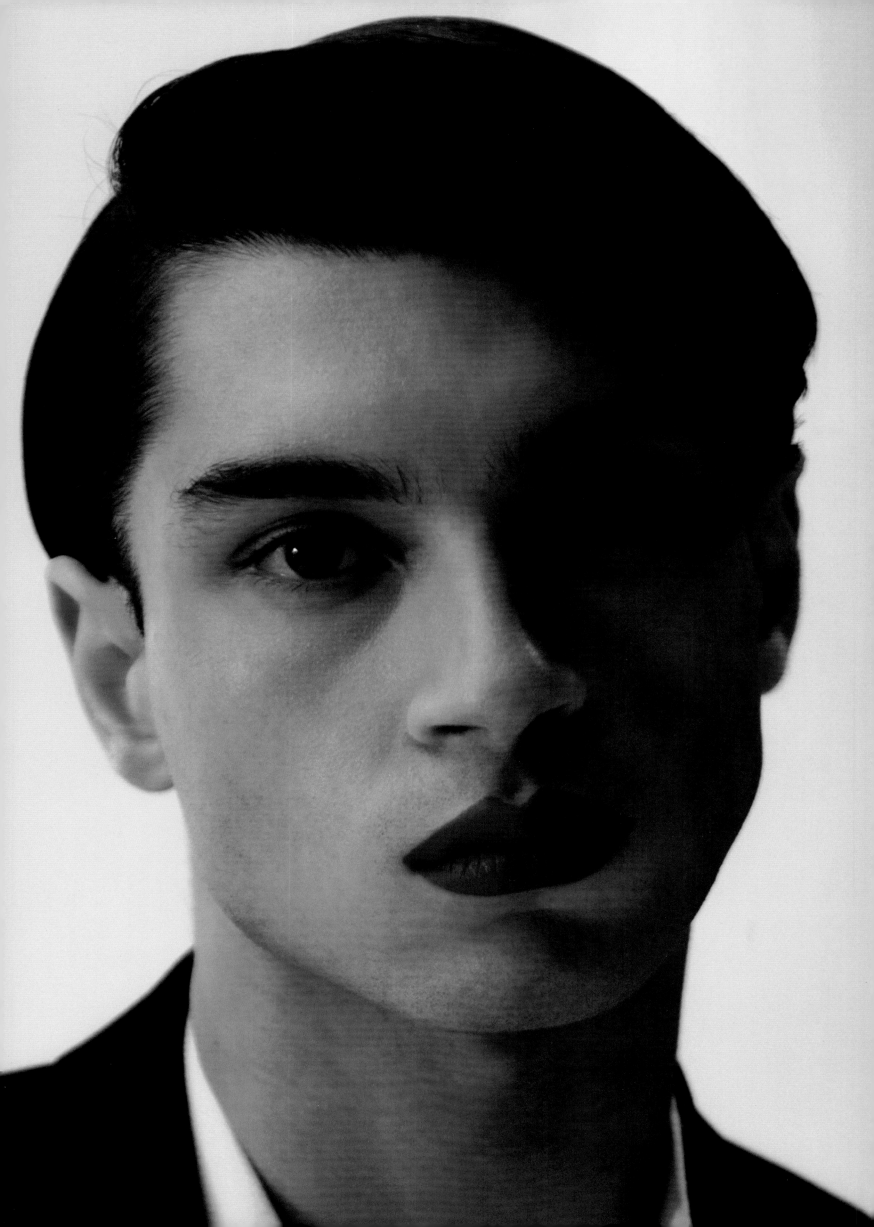

Oliverbizhan Azarmi, *Man About Town*, 2016.
Photograph by Max von Gumppenberg and Patrick Bienert

Jana Knauerova and Andreja Pejić, *Vogue* Turkey, 2010. Photograph by Matthew Brookes

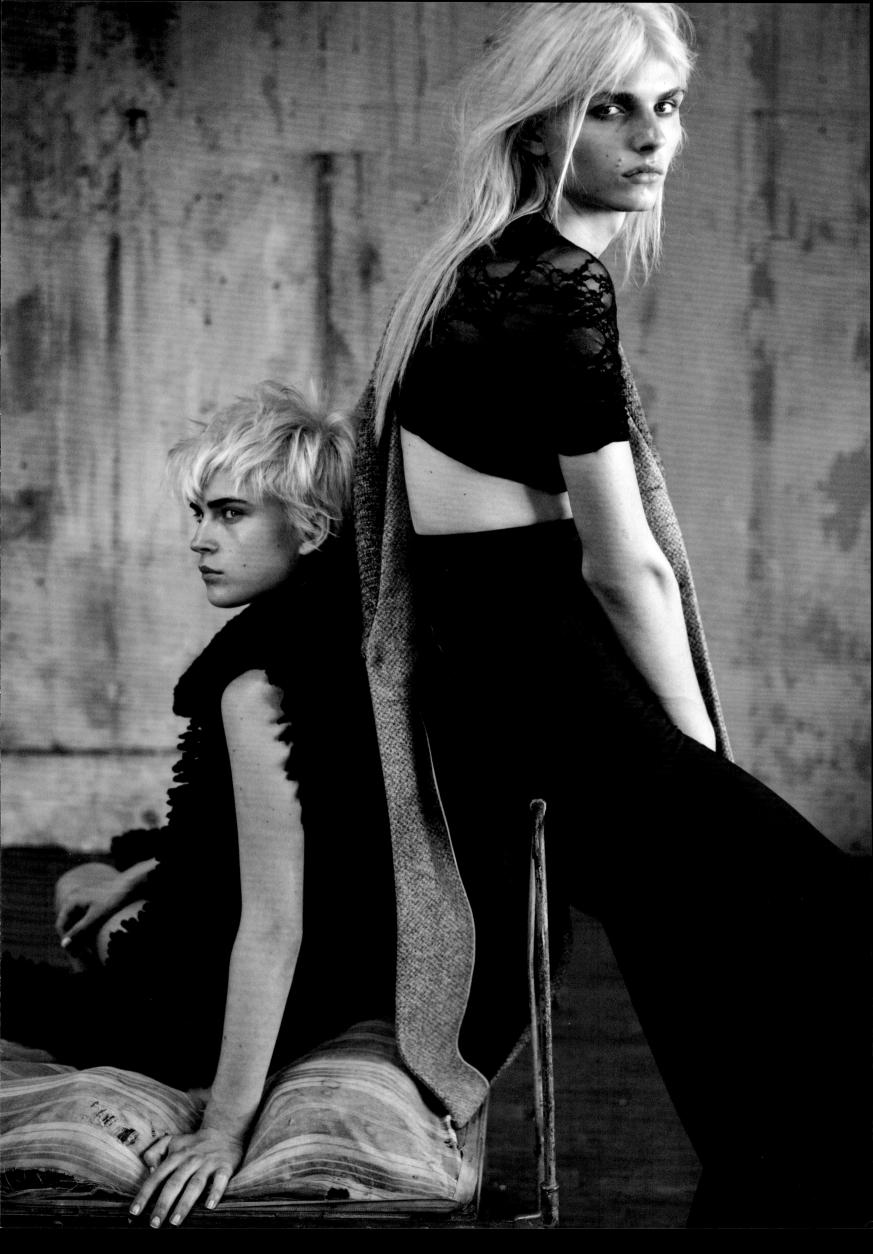

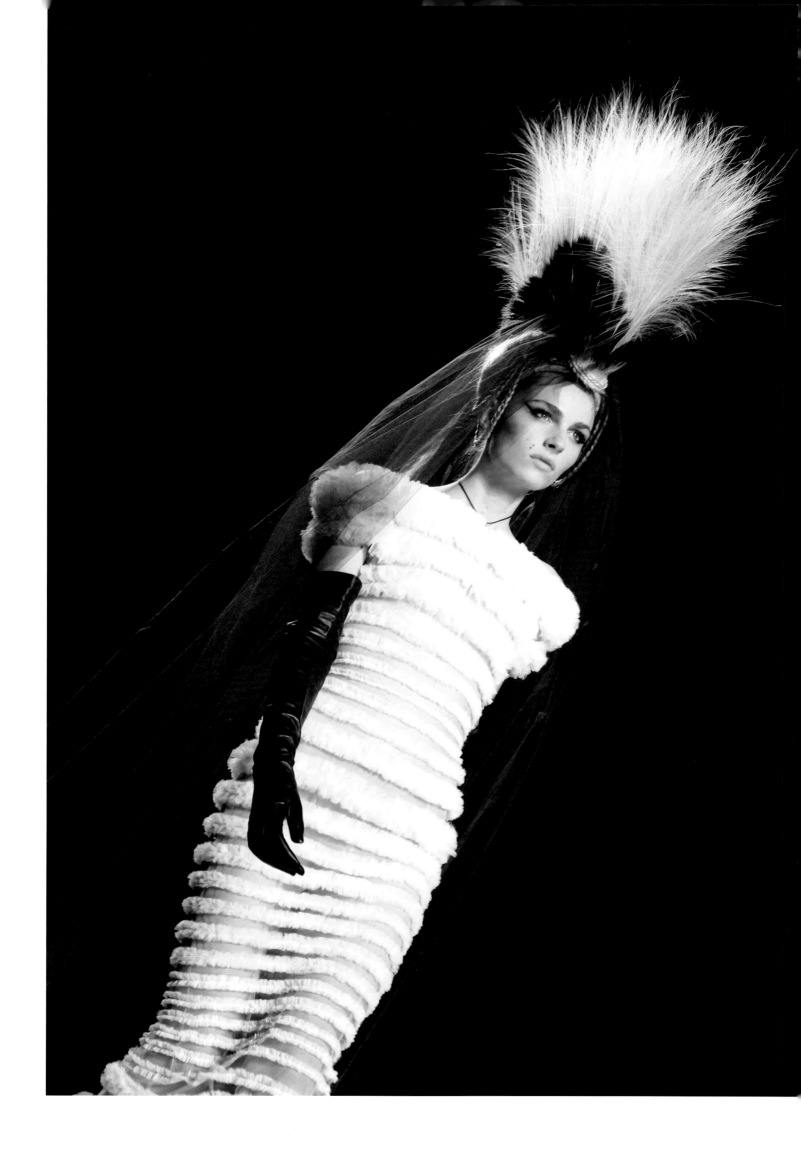

Andreja Pejić for Jean Paul Gaultier, Paris Haute Couture Fashion Week, January 2011

Notes

BENEATH THE VEIL

p. 8 'influential essay "The Five Sexes: Why Male and Female Are Not Enough" (1993)': Suzanne J. Kessler, *Lessons from the Intersexed* (New Brunswick, NJ: Rutgers University Press), 1998, p. 90.

p. 8 '"Gender" comes before "sex"': See Pascale Molinier, foreword to Anne Fausto-Sterling, *Les cinq sexes: Pourquoi mâle et femelle ne sont pas suffisants* (Paris: Payot, 2013), pp. 20, 23.

'A LENGTH OF HORSEHAIR TWINE'

p. 11 'the turn of Aristophanes': Plato, *Symposium*, 189c–193e.

p. 12 'the shameful act of reproduction': In the words of the ninth-century Neoplatonist John Scottus Eriugena: *On the Division of Nature (De divisione naturae)*, 777B.

p. 12 'to make a single whole': Sylvie Steinberg, *La confusion des sexes: Le travestissement de la Renaissance à la Révolution* (Paris: Fayard, 2001), p. 194.

A BODY OF IVORY

p. 13 'ambivalence and confusion between the sexes': Pliny, *Natural History*, VII, 3–4.

p. 13 'classical accounts of androgyny': Ovid, *Metamorphoses*, IV, 285–399. Translation by Brookes More (Boston, MA: Cornhill Publishing Company, 1933), pp. 145–47.

p. 13 'a state of disturbing indistinction': Luc Brisson, *Sexual Ambivalence: Androgyny and Hermaphroditism in Graeco-Roman Antiquity*, trans. Janet Lloyd (Berkeley, CA: University of California Press, 2002), pp. 59–60.

p. 14 'and in eunuchs': Johann Joachim Winckelmann, *The History of Ancient Art*, trans. G. Henry Lodge, Vol. II (Boston, MA: James Munroe and Company, 1849), pp. 53, 59, 74.

p. 14 'the seamless': Roland Barthes, *Mythologies*, selected and trans. Annette Lavers (London: Cape, 1972), p. 88.

p. 14 'a lily in a lake of glass': Ovid, op. cit., p. 145.

p. 15 'this was a masterpiece': Honoré de Balzac, *Sarrasine* (1830), reprinted in Roland Barthes, *S/Z*, trans. Richard Miller (New York: Farrar, Straus, Giroux, 1974), p. 238.

p. 15 'monument to his folly': Ibid., p. 252.

p. 15 'the boy is passive': Barthes, op. cit., p. 70.

THE INVERTED BODY

p. 16 'the male parts external': Jackie Pigeaud, *Ni l'un ni l'autre: L'Androgyne ou l'hermaphrodite* (Paris: Payot, 2014), p. 66.

p. 16 'falsity in deed': See Steinberg, op. cit., p. 19.

p. 16 'an intensely gendered social order': Thomas Laqueur, *Making Sex: Body and Gender from the Greeks to Freud* (Cambridge, MA: Harvard University Press, 1990), p. 115.

p. 17 'wanting to be penetrated': Ibid., pp. 4, 52.

p. 17 'a restore of the dowry': Sir Thomas Browne, *Pseudodoxia Epidemica; or, Enquiries into Very Many Received Tenets, and Commonly Presumed Truths* (London: Edward Dod, 1646), Bk III, Chap. XVII, pp. 146–47.

p. 17 'two incommensurable sexes': Laqueur, op. cit., pp. 7, 8, 106.

p. 17 'battles over gender and power': Ibid., p. 11.

p. 17 '"Or conversely," summarized Laqueur': Ibid., p. 79.

OPPOSING ANATOMIES

p. 18 'a primary foundational category': Ibid., pp. 5, 6, 154.

p. 18 'male dominion of women': Ibid., p. 196.

p. 18 'the rights of women': See Steinberg, op. cit., p. 271.

p. 18 'natural consequence of corporeal difference': Laqueur, op. cit., p. 243.

p. 19 'unto the Lord thy God': Deuteronomy 22:5.

p. 19 'by means of disguise': See Steinberg, op. cit., pp. 15, 19.

p. 19 'an eighteenth-century term, "instituted"': Ibid., p. 129.

p. 19 'albeit in a temporary fashion': See the works of the Russian philosopher and critic Mikhail Bakhtin, especially *Rabelais and His World*, trans. Hélène Iswolsky (Cambridge, MA: MIT Press, 1968), and *Problems of Dostoevsky's Poetics*, ed. and trans. Caryl Emerson (Minneapolis, MN: University of Minnesota Press, 1984).

p. 19 'difficult to give up': Steinberg, op. cit., pp. xi, 102.

p. 19 'dress ought to provide infallible information': Ibid., pp. 145, 160.

LIFE AS A NOVEL

p. 59 'until his death in 1725': See Alain Chevrier, *Histoire de Mademoiselle Rosette: Testament cassé d'un homme qui croyait être fille* (Paris: Gallimard, 2007).

p. 59 'the most reprehensible of tastes': Steinberg, op. cit., p. 48.

p. 59 'the end of the seventeenth century': Ibid., pp. ix, 79.

p. 60 'tasted in this life': *Mémoires de l'abbé de Choisy habillé en femme*, ed. Georges Mongrédien (Paris: Mercure de France, 1966), pp. 431–32.

p. 60 'the cause of growth and preservation': Steinberg, op. cit., p. 107.

p. 60 'only their original femininity': Ibid., p. 106.

p. 60 'little rouged master[s] and fop[s]': Abbé Jacquin, *De la santé* (Paris: Durand, 1762), p. 302.

p. 60 'possess feminine graces': Steinberg, op. cit., p. 171.

p. 61 'the mistake ceases': Ibid.

p. 61 'the delectable page boy': Joséphin Péladan, *Les idées et les formes de l'androgyne: Théorie plastique* (Paris: E. Sansot et Cie, 1910), p. 111.

CIVILIZATION AND ITS DISCONTENTED

p. 62 'the "civilizing process"': See Norbert Elias, *The Civilizing Process* (1939), trans. Edmund Jephcott, ed. Eric Dunning et al. (Oxford: Blackwell, 2000).

p. 62 'women could become like men': Laqueur, op. cit., p. 125.

p. 62 'yielding up the ghost': *The Book of the Courtier, from the Italian of Count Baldassare Castiglione, Done into English by Sir Thomas Hoby, Anno 1561*, ed. Walter Raleigh (London: David Nutt, 1900), p. 52 (Bk I, Chap. XIX).

p. 62 'to imaginary maladies': Steinberg, op. cit., p. 287.

p. 62 'make us into women': Jean-Jacques Rousseau, *Lettre à d'Alembert sur les théâtres* (Amsterdam: Marc Michel Rey, 1758), pp. 187–88.

p. 62 'inspires only crimes': Ibid., p. 100.

p. 62 'to hold ennui at bay': Louis-Sébastien Mercier, *Tableau de Paris*, new edn, Vol. III (Amsterdam, 1784), p. 60.

AN AMPHIBIOUS CREATURE

p. 63 'even more incredible things': *Mémoires sur la chevaliere d'Éon*, ed. Frédéric Gaillardet (Paris: E. Dentu, 1866), p. 198.

p. 63 'the malice of my enemies': Ibid., p. 193 (repeated p. xiii).

p. 63 'neither head nor tail': Ibid., p. 205 (repeated p. xiii); Charles d'Éon de Beaumont, *The Maiden of Tonnerre: The Vicissitudes of the Chevalier and the Chevalière d'Éon*, trans. Roland A. Champagne et al. (Baltimore, MD: The Johns Hopkins University Press, 2001, p. 133.

p. 64 'great harm would have resulted from this': *Mémoires sur la chevaliere d'Éon*, p. 197.

p. 64 'to quote Beaumarchais': Ibid., p. 284.

p. 64 'the hysterics of La Pompadour': Ibid., p. 198.

p. 65 'still mine by baptism': Ibid., pp. 208–9, 212.

p. 65 'on this matter for ever': Ibid., pp. 239–41, 282.

p. 65 'the date of her birth': Ibid., pp. 242–43, 248.

p. 65 'the most unfortunate of women': Ibid., pp. 249–50, 266.

p. 65 'my miraculous conversion': Ibid., p. 297.

p. 66 'right up to his death?': Ibid., p. 211.

PUER SENILIS

p. 66 'thirty-four as a *woman*': Ibid., p. 330.

p. 67 'had not been invited': Balzac, *Sarrasine*, in Barthes, op. cit., p. 226.

p. 67 'none other than La Zambinella': Ibid., pp. 225, 229, 231, 232.

p. 67 'The "decadent" androgyne': See Frédéric Monneyron, *L'Androgyne décadent: Mythe, figure, fantasmes* (Grenoble: Ellug, 1996).

p. 67 'the dissolute court of Henri III': J. K. Huysmans, *Against the Grain*, trans. John Howard (New York: Lieber and Lewis, 1922), p. 16.

p. 67 'more feminine, more divine': Philippe Jullian, *Dreamers of Decadence: Symbolist Painters of the 1890s*, trans. Robert Baldick (New York: Praeger, 1971), p. 46.

p. 67 'it grows old and dies': Nelly Emont, 'Les aspects religieux du mythe de l'androgyne dans la littérature de la fin du XIXe siècle', in Frédéric Monneyron (ed.), *L'Androgyne dans la littérature* (Paris: Albin Michel/Centre Culturel International De Cerisy, 1990), p. 38.

p. 68 'great knavery or great debauchery': Émile Zola, *Paris*, trans. Ernest Alfred Vizetelly (London: Chatto & Windus, 1898), p. 30.

p. 68 'webs with Eastern merchants': Walter H. Pater, *Studies in the History of the Renaissance* (London: Macmillan and Co., 1873), p. 118.

p. 68 'a terrible hermaphroditism': Rachilde, *Les hors nature: Mœurs contemporaines* (Paris: Société du Mercure de France, 1897), p. 194.

THE 'ANDROGYNOSPHINX'

p. 82 'related to the pointed arch': Péladan, op. cit., pp. 49–50.

p. 82 'young men and young women': Ibid., pp. 33–34, 60, 92.

p. 82 'grace more than lasciviousness': Joséphin Péladan, *La dernière leçon de Léonard de Vinci à son Académie de Milan (1499)* (Paris: E. Sansot et Cie, 1904), p. 60.

p. 82 '"the angel of Christianity," he proclaimed': Péladan, *Les idées et les formes de l'androgyne*, p. 80.

p. 82 'obtain an angelic form': Péladan, *La dernière leçon de Léonard de Vinci*, pp. 8–9.

p. 82 'St John the Baptist': Péladan, *Les idées et les formes de l'androgyne*, pp. 99, 106.

p. 82 'the very nature of harmony: the *indefinite*': Péladan, *La dernière leçon de Léonard de Vinci*, p. 11.

p. 82 'manifested in every dawn': Péladan, *Les idées et les formes de l'androgyne*, p. 21.

AMAZONS

p. 83 'the filthiness of Martial': Ibid., pp. 56, 105.

p. 84 'all this sentimental claptrap': Maurice Martin du Gard, *Les mémorables: 1918–1945* (Paris: Gallimard, 1999), pp. 217–18; Paul Léautaud, *Journal littéraire*, Vol. III, 1910–21 (Paris: Mercure de France, 1956).

p. 84 'self-described "congenital invert"': Radclyffe

Hall, *Your John: The Love Letters of Radclyffe Hall*, ed. Joanne Glasgow (New York: New York University Press, 1997), p. 50.

p. 85 'while women have to work at it': Grayson Perry, *The Descent of Man* (London: Allen Lane, 2016), p. 51.

FLAMING CREATURES

p. 86 'unpleasant aspects of reality': Cecil Beaton, *The Wandering Years: Diaries, 1922–1939* (London: Weidenfeld and Nicolson, 1961), p. 153.

p. 87 'the most beautiful creature I've ever seen': Hugo Vickers, *Cecil Beaton: The Authorized Biography* (London: Weidenfeld and Nicolson, 1985), p. 86.

p. 87 'eccentricity peculiar to them': Edith Sitwell, *The English Eccentrics* (London: Faber, 1933), pp. 20–21.

p. 87 'too magenta for my taste': Lytton Strachey, *The Letters of Lytton Strachey*, ed. Paul Levy and Penelope Marcus (London: Viking, 2005), p. 612.

p. 87 'a perplexed Rex Whistler': Cecil Beaton, *The Years Between: Diaries, 1939–44* (London: Weidenfeld and Nicolson, 1965), pp. 60–61.

p. 87 'were scarcely restrained': Philip Hoare, *Serious Pleasures: The Life of Stephen Tennant* (London: Hamish Hamilton, 1990), p. 350.

p. 87 'fat & appallingly painted': Hoare, op. cit., p. 342.

A CERTAIN MR FISH

p. 116 'the individual body as object': Grayson Perry, op. cit., p. 59.

p. 117 'the Peacock Revolution': Nik Cohn, *Today There Are No Gentlemen: The Changes in Englishmen's Clothes since the War* (London: Weidenfeld and Nicolson, 1971), p. 145; George Frazier, 'The Peacock Revolution', *Esquire* (October 1968), pp. 207–9.

p. 117 'the clients sign bills': Antony King-Deacon, 'Phenomenon for the Famous', *The Times*, 14 November 1969.

'LADIES AND GENTLEMEN…AND OTHERS'

p. 119 'on the concept of gender': See the catalogue of the exhibition, featuring work by Urs Lüthi, Jürgen Klauke, Luigi Ontani and Luciano Castelli among others: Jean-Christophe Ammann and Marianne Eigeenheer (eds.), *'Transformer': Aspekte de Travestie* (Lucerne: Kunstmuseum Luzern, 1974).

p. 119 'his 1970s heyday': David Sinclair, 'Station to Station', *Rolling Stone* (10 June 1993), pp. 56–64.

p. 119 'Fashion doesn't exist any more. Only clothes': Geoffrey Aquilina Ross, *The Day of the Peacock: Style for Men, 1963–1973* (London: V&A Publishing, 2011), p. 163.

p. 119 'an aspect of ourselves?': Christian Schlatter, *Les années 80: La création en France* (Paris: Flammarion, 1984), pp. 3–4.

p. 120 'Everything starts from there': Ibid., p. 114.

p. 120 'They are fighters': Ibid., p. 92.

p. 121 'any more than some garments do': Pauline Weber, 'Féminin-Masculin: Androgynie et mixité des genres chez Gaultier', Grand Palais online magazine, 15 May 2015, http://www.grandpalais.fr/fr/article/feminin-masculin-androgynie-et-mixite-des-genres-chez-gaultier.

THE LATEST MODE

p. 153 'the beautiful is always bizarre': Charles Baudelaire, *Curiosités esthétiques* (Paris: Michel Lévy Frères, 1868), p. 216.

p. 154 'this will be the norm': Carine Bizet, 'J. W. Anderson, jeune espoir de la mode sans etiquette', *Le monde*, 25 July 2014.

p. 154 'and astrakhan overcoats': Yari Fiocca, *Fucking Young!*, issue 7, *Obsession* (autumn-winter 2015–16), pp. 166–67.

p. 155 'a few weeks later': Vanessa Friedman, 'Jaden Smith for Louis Vuitton: The New Man in a Skirt', *The International New York Times*, 6 January 2016; Ray Siegel, *CR Fashion Book*, issue 8, *Made in America* (spring-summer 2016).

p. 155 'gender comes before sex': Molinier, op. cit., pp. 12, 20, 21.

p. 155 'the level of basic biology': Anne Fausto-Sterling, 'The Five Sexes, Revisited', *The Sciences*, Vol. 40, no. 4 (July–August 2000), p. 20.

p. 155 'a "so-so" body': Molinier, op. cit., p. 31.

p. 155 'a binary classification': Anne Fausto-Sterling, 'The Five Sexes: Why Male and Female Are Not Enough', *The Sciences*, Vol. 33, no. 2 (March–April 1993), p. 24.

p. 155 'under the clothes': Kessler, op. cit., p. 90.

p. 155 'than mere genitals can distinguish': Ibid., p. 86; Fausto-Sterling, 'The Five Sexes Revisited', p. 22.

p. 155 'or a tuxedo': Friedman, op. cit.

p. 156 'making things better': Casey Legler, 'I'm a woman who models men's clothes. But this isn't about gender', *The Guardian*, 1 November 2013.

p. 156 'Beautiful people are just beautiful': Motoko Rich, 'With Manicures and Makeup, Japan's "Genderless" Blur Lines between Pink and Blue', *The International New York Times*, 5 January 2017.

p. 156 'as Barthes famously called Japan': See Roland Barthes, *Empire of Signs*, trans. Richard Howard (London: Cape, 1983).

p. 156 'before the "semiological chaos"': Friedman, op. cit.

p. 156 'a culture that had overcome sexual division': Fausto-Sterling, 'The Five Sexes', p. 24.

p. 157 'outside conventional categories': Robin Marantz Henig, 'Rethinking Gender', *National Geographic*, Vol. 231, no. 1 (January 2017), p. 59.

p. 157 'marred by a lack of youth': Witold Gombrowicz, *Diary*, trans. Lillian Vallee (New Haven, CT, and London: Yale University Press, 2012), pp. 46–47, 177, 613.

p. 157 'that which doesn't blossom, withers': Ibid., p. 176.

Picture Credits

111 Willy Vanderperre/Art + Commerce. Stella Tennant,
DNA Management

113 © The Cecil Beaton Studio Archive at Sotheby's

114 Willy Vanderperre/Art + Commerce. Tom Wells, Storm

123 Michael Putland/Getty Images

124 Mark and Colleen Hayward/Redferns/Getty Images

125 Alasdair McLellan/Art Partner. Philip Kesselev,
Tomorrow Is Another Day

126 Trinity Mirror/Mirrorpix/Alamy Stock Photo

127 Max Von Gumppenberg and Patrick Bienert.
Pip Paz-Howlett; Lachlan Mackie

129 © Anthony Crickmay/Victoria and Albert Museum,
London

130 Roger Bamber/Rex/Shutterstock

131 Alasdair McLellan/Art Partner. Oliver Pallister, Supa
Model Management

132–33 Mike Randolph/Rex/Shutterstock

134–35 Sebastian Faena/LENS. Mica Arganaraz,
Viva Agency

136 Photo12/Alamy Stock Photo

137 Moviestore Collection Ltd/Alamy Stock Photo

138 Jack Mitchell/Getty Images

139 Tony Kim/Trunk Archive. Andreja Pejić,
The Society Management

140 Bettmann/Getty Images

141 Andrew Soule/Contour Style by Getty Images.
Jenna Earle, Next Management

142 David Sims/Trunk Archive. Agyness Deyn, The Lions

143 Graham Smith/PYMCA/Rex/Shutterstock

144 Janette Beckman/PYMCA/Photoshot

145 Paolo Roversi/Art + Commerce. Stella Tennant, DNA
Management; Guinevere Van Seenus, The Lions

146 Glen Luchford/Art Partner. Freja Beha Erichsen,
IMG Management

147 Deborah Feingold/Corbis via Getty Images

148–49, 150 Jean-Paul Goude

151 Josh Olins/Trunk Archive. Andrew Ruffin

152 Richard Burbridge/Art + Commerce. Sara Cumming,
IMD Modeling; Sang Woo Kim, Select Model
Management

159 Bruce Weber/Trunk Archive. Sarah Brannon, Storm;
Rianne Van Rompaey, Jean Campbell, Viva Agency;
Jaden Smith

160 Hervé Bruhat/Gamma-Rapho via Getty Images

161 Mika Ninagawa/Trunk Archive. Show Luo

162 Tim Walker. Little 'Coco' Jordan

163 Granger Historical Picture Archive/Alamy Stock
Photo

165 Collier Schorr/Art + Commerce. Ruth Bell,
The Society Management

166 Txema Yeste/Trunk Archive. Casey Legler

168–69 Jason Kibbler/Trunk Archive. Irina Kravchenko,
Women Management

170 Andrea Artemisio. Leonard Gaist, Marilyn Agency

172 Birmingham Museums and Art Gallery/
Bridgeman Images

173 Daniel Riera/Trunk Archive. Luka Sabbat,
Re:Quest Model Management

175 Collier Schorr/Art + Commerce. Andreja Pejić,
The Society Management

176 Max Von Gumppenberg and Patrick Bienert.
Oliverbizhan Azarmi, Nii Agency

179 Matthew Brookes/Trunk Archive. Jana Knauerova,
CZ Models; Andreja Pejić, The Society Management

180 Michel Dufour/WireImage/Getty Images. Andreja
Pejić, The Society Management

Acknowledgments

First of all I would like to thank Sophy Thompson, whose initiative lies behind this book, although any bias or errors are of course due entirely to me. My thanks are also owed to Lionel Le Forestier and Jonathan Krist, who regularly agreed to cast their critical gaze over the unfinished pages that I sent to them. Much gratitude goes to the sparkling Valérie Viscardi, as well as to Hélène Riché, Christian Lacroix and Jean-Paul Goude – such generous friends – and to Virginie Laguens, Pierre Bergé and Olivier Flaviano, Jean Paul Gaultier and Jelka Music for the help that they've given me throughout the writing of this book. I must also thank Jo Walton, Rosa Nussbaum, Sonya Dyakova, Johanna Neurath, Jessica Gallagher, Amanda Vinnicombe, Rebecca Pearson and the team at Thames & Hudson for the energy that they have devoted to making these pages as good as they can be.

Index

Page numbers in *italic* refer to illustrations.

191

PATRICK MAURIÈS is a writer and publisher. He is the author of over forty books, including novels, essays on literature, art and collecting, and notable titles on fashion and design. He has written books on Christian Lacroix, Karl Lagerfeld, Louise de Vilmorin, René Gruau, Yves Saint Laurent, Jean-Paul Goude and Piero Fornasetti, many published by Thames & Hudson. He is a regular contributor to *Vogue, Purple Magazine, L'Officiel, World of Interiors* and *AD*.

On the cover: Willy Vanderperre/Art + Commerce. Tom Wells, Storm

Text translated from the French by Barbara Mellor

Androgyne: Fashion + Gender © 2017 Thames & Hudson Ltd, London
Text © 2017 Patrick Mauriès
Copyright details for illustrations appear in the Picture Credits, p. 186

Design concept by Sonya Dyakova
Design and layout by Rosa Nussbaum

First published in 2017 in the United States of America by
Thames & Hudson Inc., 500 Fifth Avenue, New York, New York 10110

www.thamesandhudsonusa.com

Library of Congress Control Number 2017931783

ISBN 978-0-500-51935-6

Printed and bound in China by Artron Art (Group) Co. Ltd